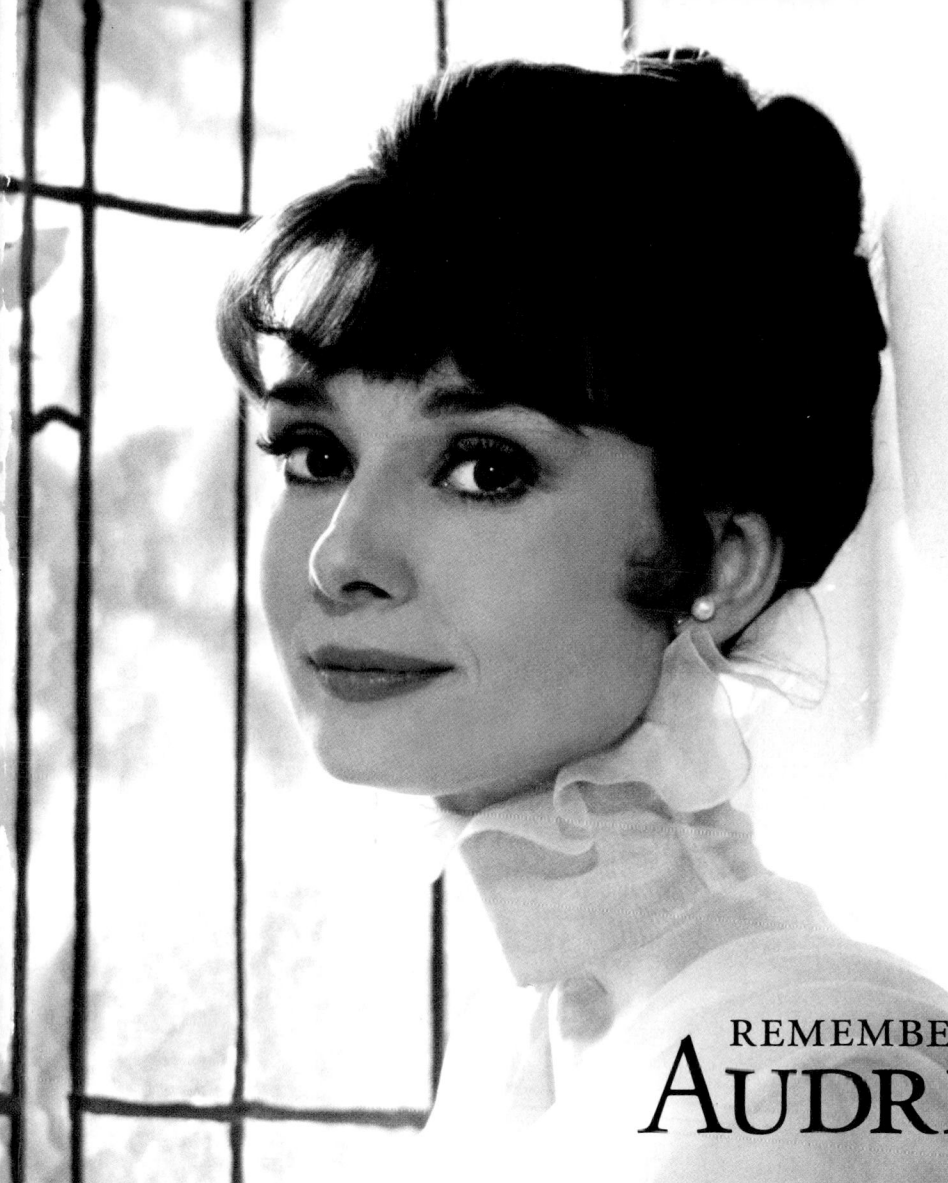

REMEMBERING
AUDREY

Photographs by
BOB WILLOUGHBY

LIFE GREAT PHOTOGRAPHERS SERIES

LIFE Books

EDITOR Robert Sullivan
DIRECTOR OF PHOTOGRAPHY
Barbara Baker Burrows
CREATIVE DIRECTOR Mimi Park
DEPUTY PICTURE EDITOR
Christina Lieberman
COPY Danielle Dowling, Parlan McGaw

PRESIDENT Andrew Blau
BUSINESS MANAGER Roger Adler
BUSINESS DEVELOPMENT MANAGER
Jeff Burak

EDITORIAL OPERATIONS
Richard K. Prue, David Sloan (Directors),
Richard Shaffer (Group Manager), Brian Fellows,
Raphael Joa, Angel Mass, Stanley E. Moyse,
Albert Rufino (Managers), Soheila Asayesh,
Keith Aurelio, Trang Ba Chuong, Charlotte Coco,
Osmar Escalona, Kevin Hart, Norma Jones,
Mert Kerimoglu, Rosalie Khan, Marco Lau,
Po Fung Ng, Rudi Papiri, Barry Pribula,
Carina A. Rosario, Christopher Scala,
Diana Suryakusuma, Vaune Trachtman, Paul Tupay,
Lionel Vargas, David Weiner

TIME INC. HOME ENTERTAINMENT

PUBLISHER Richard Fraiman
GENERAL MANAGER Steven Sandonato
**EXECUTIVE DIRECTOR, MARKETING
SERVICES** Carol Pittard
DIRECTOR, RETAIL & SPECIAL SALES
Tom Mifsud
DIRECTOR, NEW PRODUCT DEVELOPMENT
Peter Harper
ASSISTANT DIRECTOR, BRAND MARKETING
Laura Adam
ASSISTANT GENERAL COUNSEL
Robin Bierstedt
BOOK PRODUCTION MANAGER
Jonathan Polsky
DESIGN & PREPRESS MANAGER
Anne-Michelle Gallero
MARKETING MANAGER Joy Butts

SPECIAL THANKS TO Bozena Bannett,
Glenn Buonocore, Suzanne Janso, Robert Marasco,
Brooke Reger, Shelley Rescober, Mary Sarro-Waite,
Ilene Schreder, Adriana Tierno, Alex Voznesenskiy

**COPYRIGHT 2008
TIME INC. HOME ENTERTAINMENT**

ISBN 10: 1-60320-040-1
ISBN 13: 978-1-60320-040-0
Library of Congress Number: 2008903295

"LIFE" is a trademark of Time Inc.

We welcome your comments and suggestions
about LIFE Books. Please write to us at:
LIFE Books
Attention: Book Editors
PO Box 11016
Des Moines, IA 50336-1016

If you would like to order any of our hardcover
Collector's Edition books, please call us at
1-800-327-6388 (Monday through Friday,
7:00 a.m.–8:00 p.m., or Saturday,
7:00 a.m.–6:00 p.m., Central Time).

Classic images from the pages and covers of
LIFE are now available. Posters can be ordered at
www.LIFEposters.com.

Fine art prints from the LIFE Picture Collection
and the LIFE Gallery of Photography
can be viewed at www.LIFEphotographs.com.

Please visit the photographer, Bob Willoughby,
at www.willoughbyphotos.com.

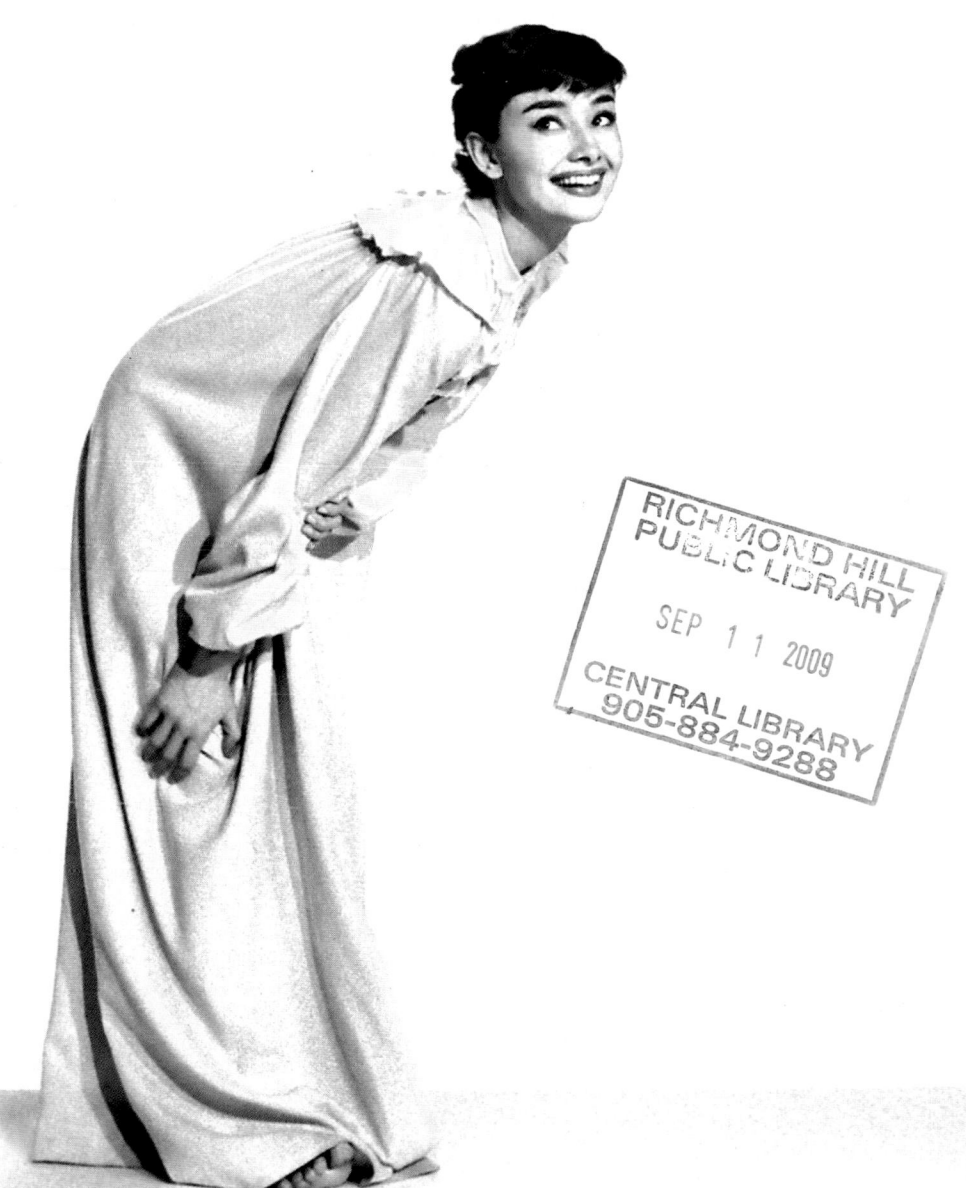

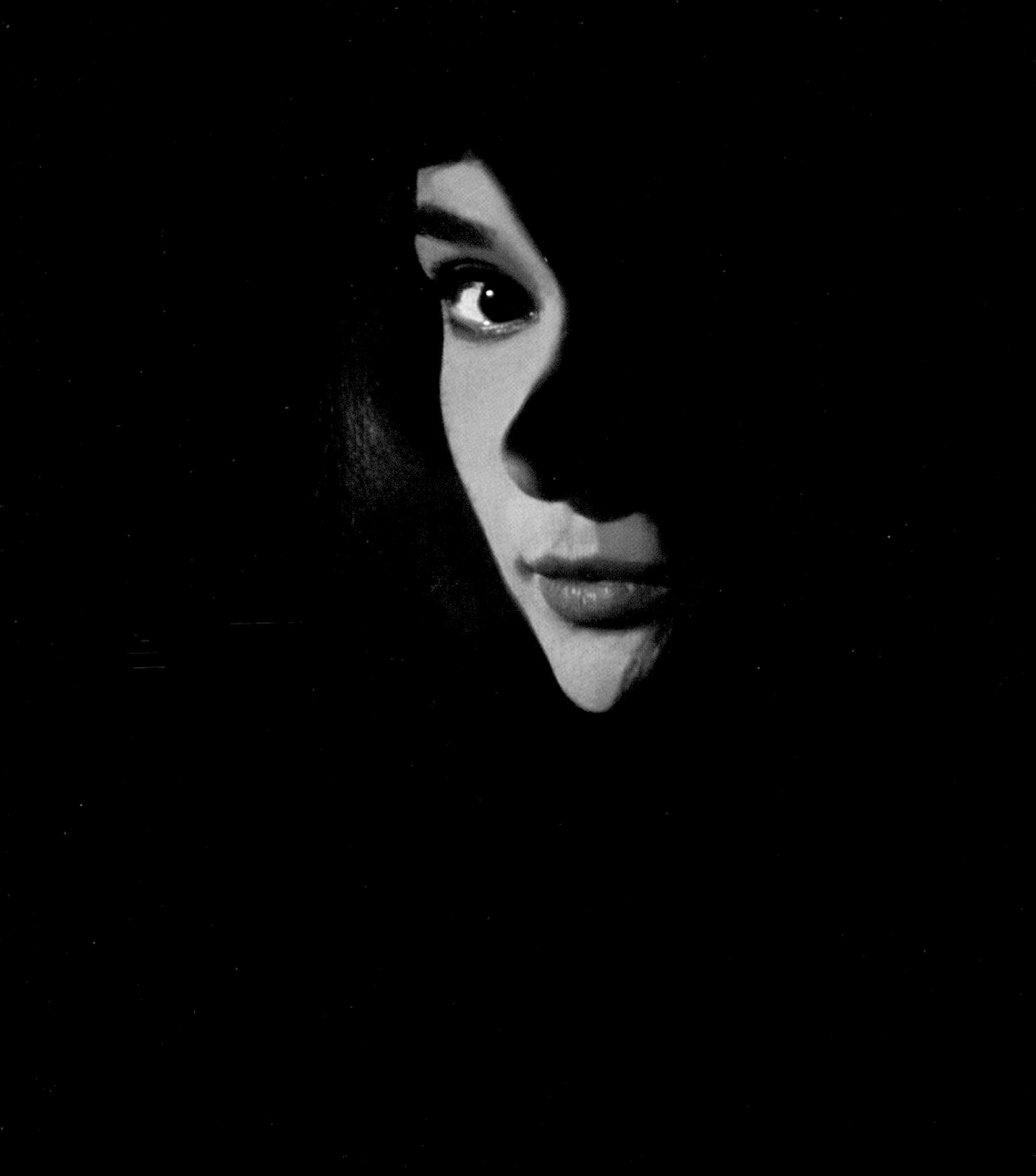

REMEMBERING
AUDREY

VISIONS OF AUDREY:

PAGES 6–7: *Audrey at a portrait shoot at Paramount Studios in 1953*
PAGES 8–9: *Greeting a visitor that same year*
PAGES 10–11: *In her costume for the stage play* Gigi
PAGES 12–13: *In the film* Green Mansions
PAGES 14–15: *At her rented villa in France during the making of* Paris When It Sizzles
PAGES 16–17: *With her tame fawn, Pippin*
PAGES 18–19: *At home in Beverly Hills with her first husband, Mel Ferrer*
PAGES 20–21: *As Eliza Doolittle in* My Fair Lady

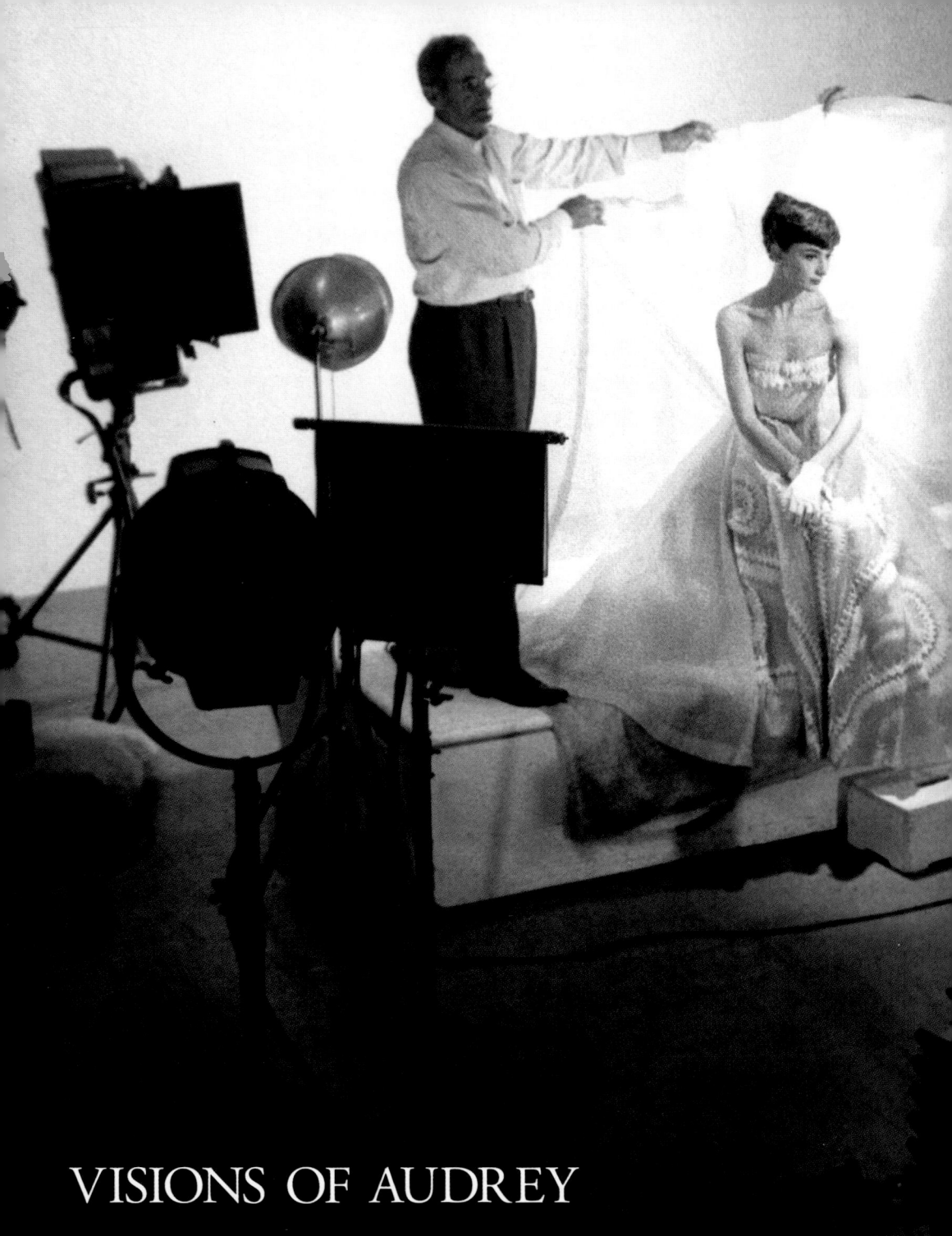

VISIONS OF AUDREY

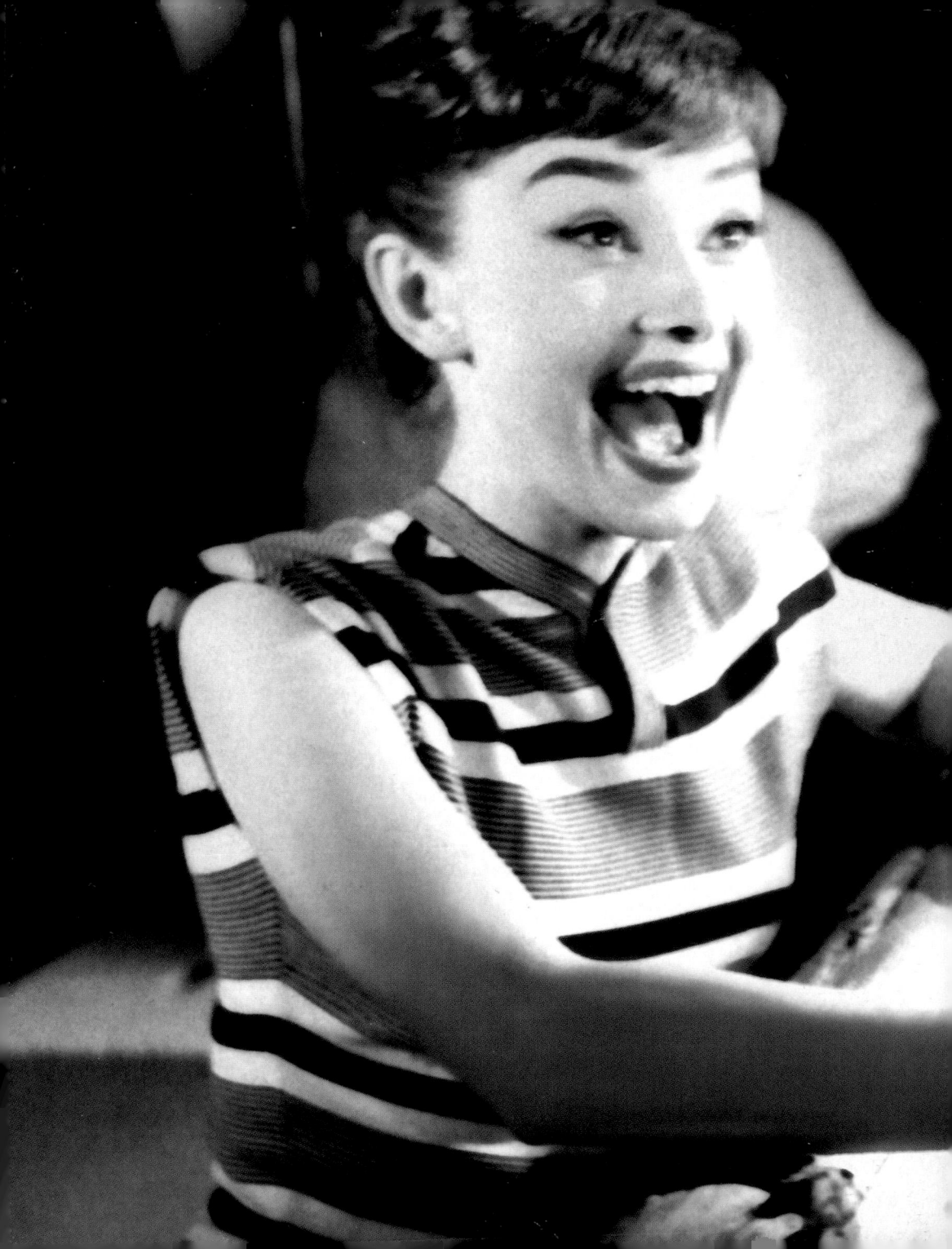

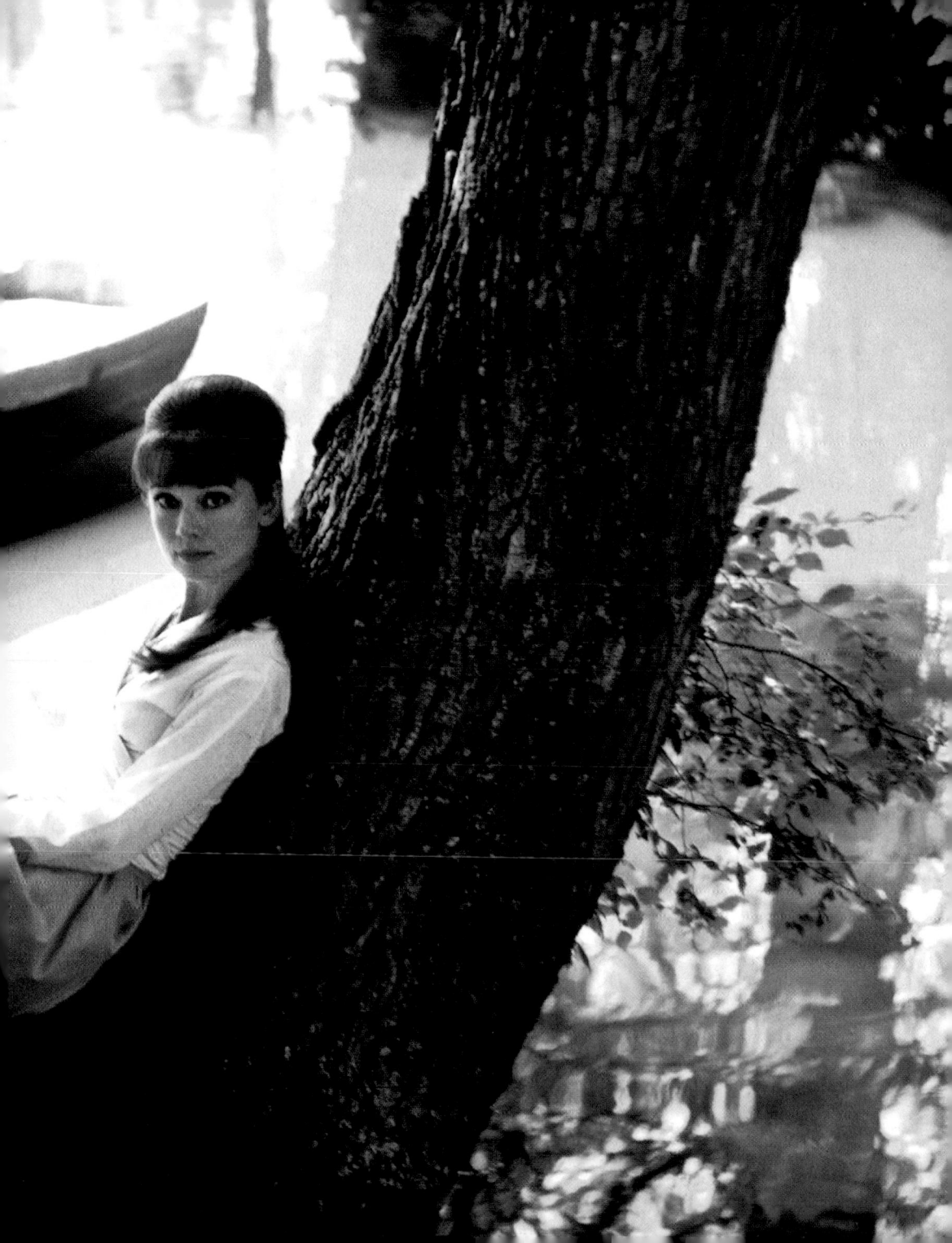

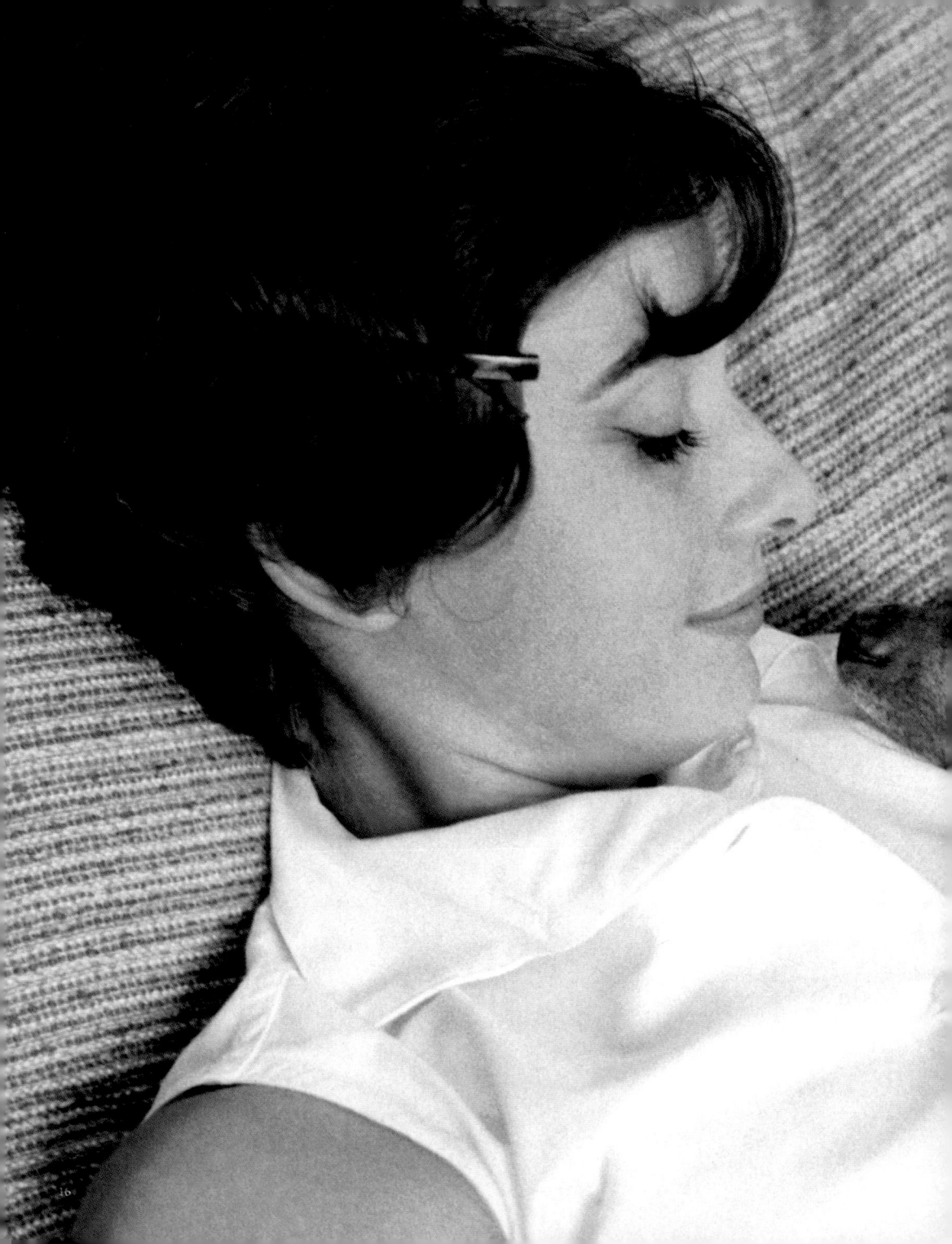

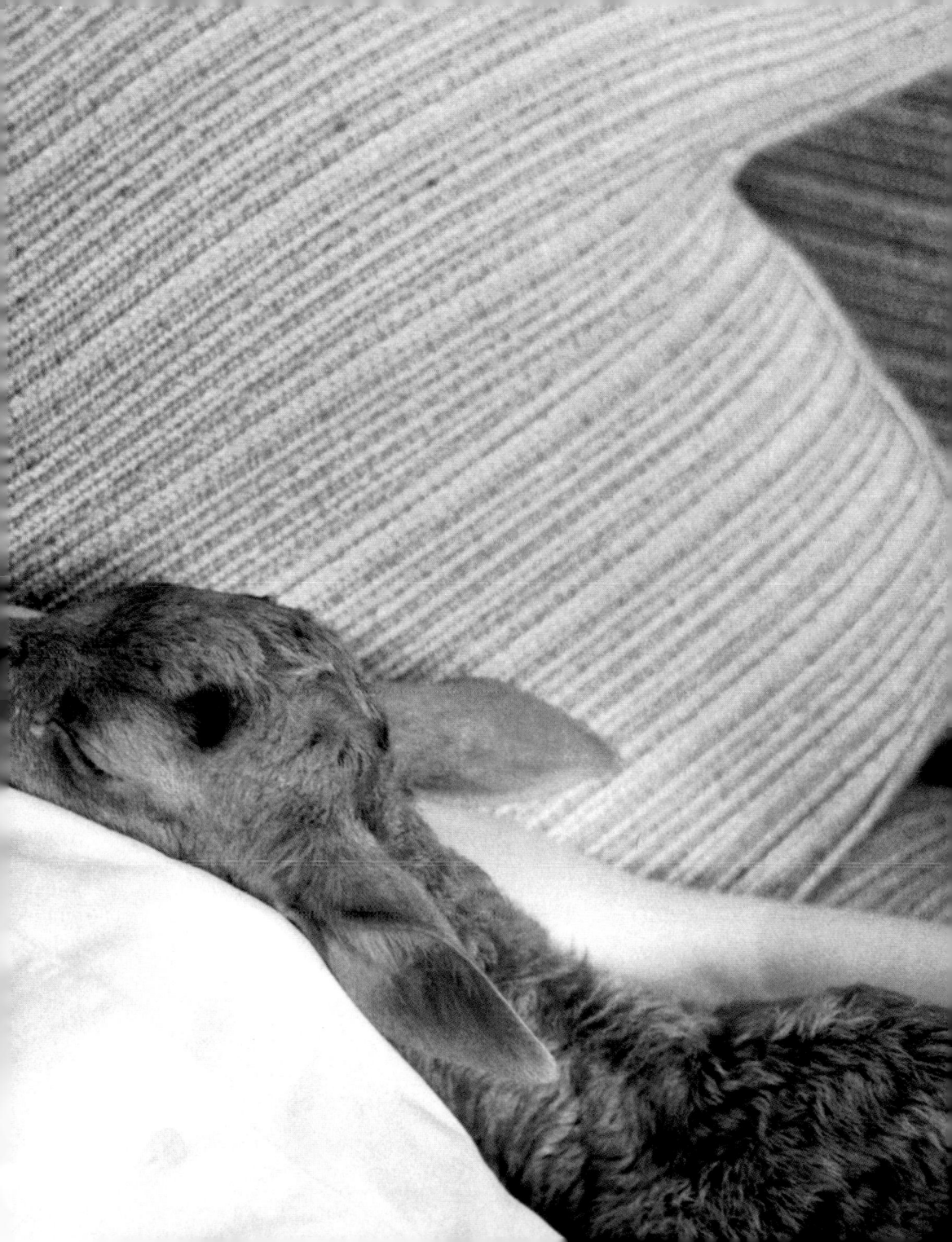

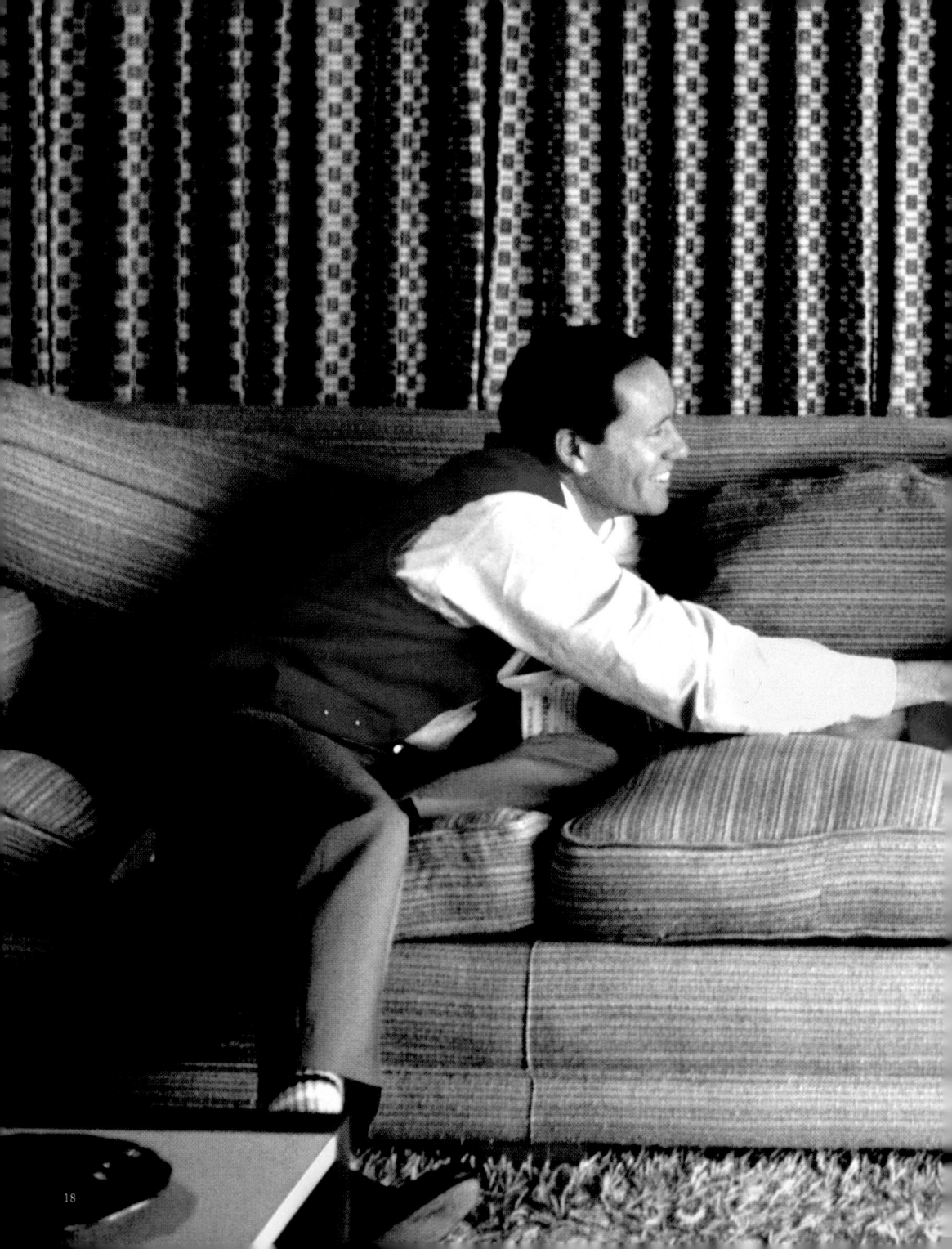

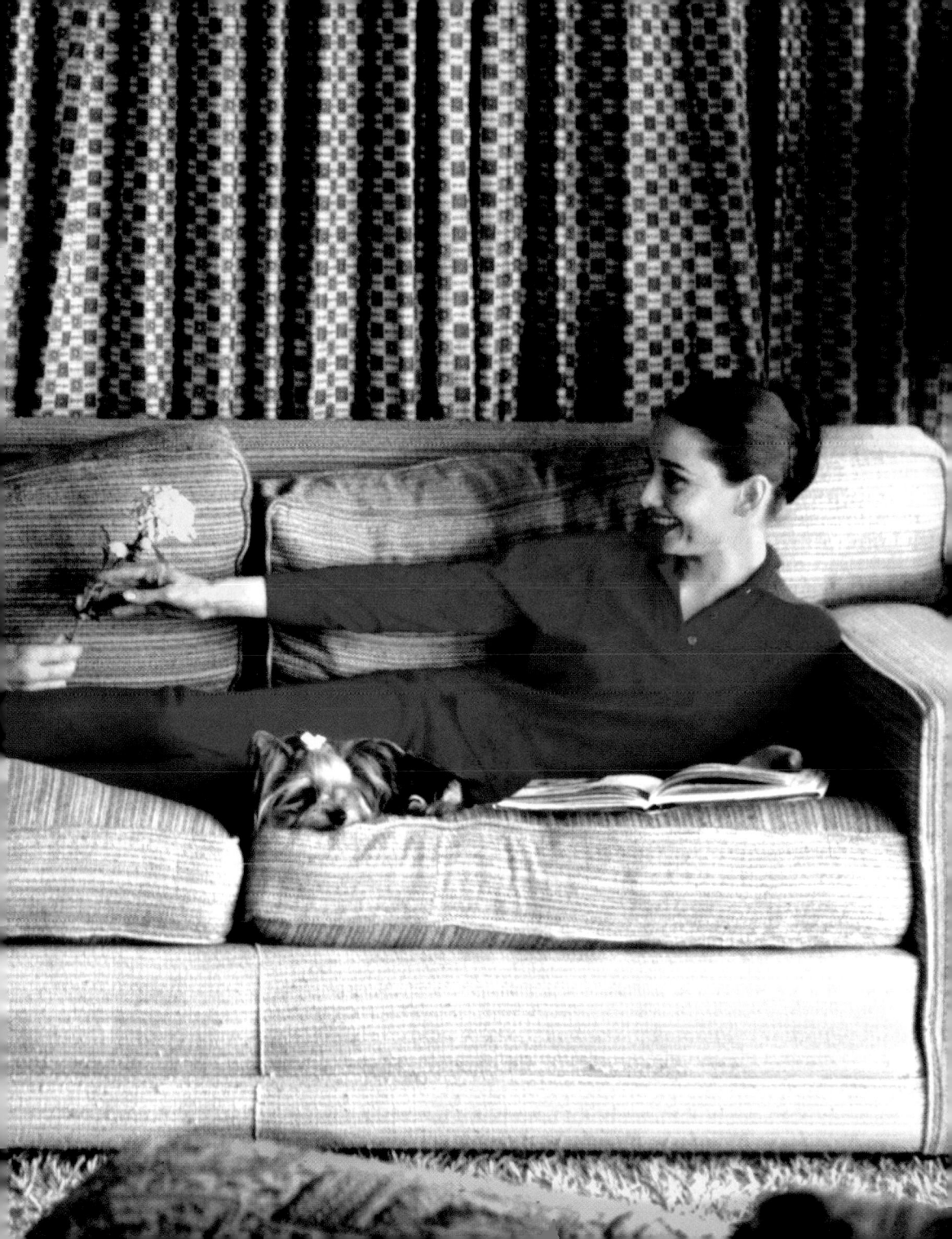

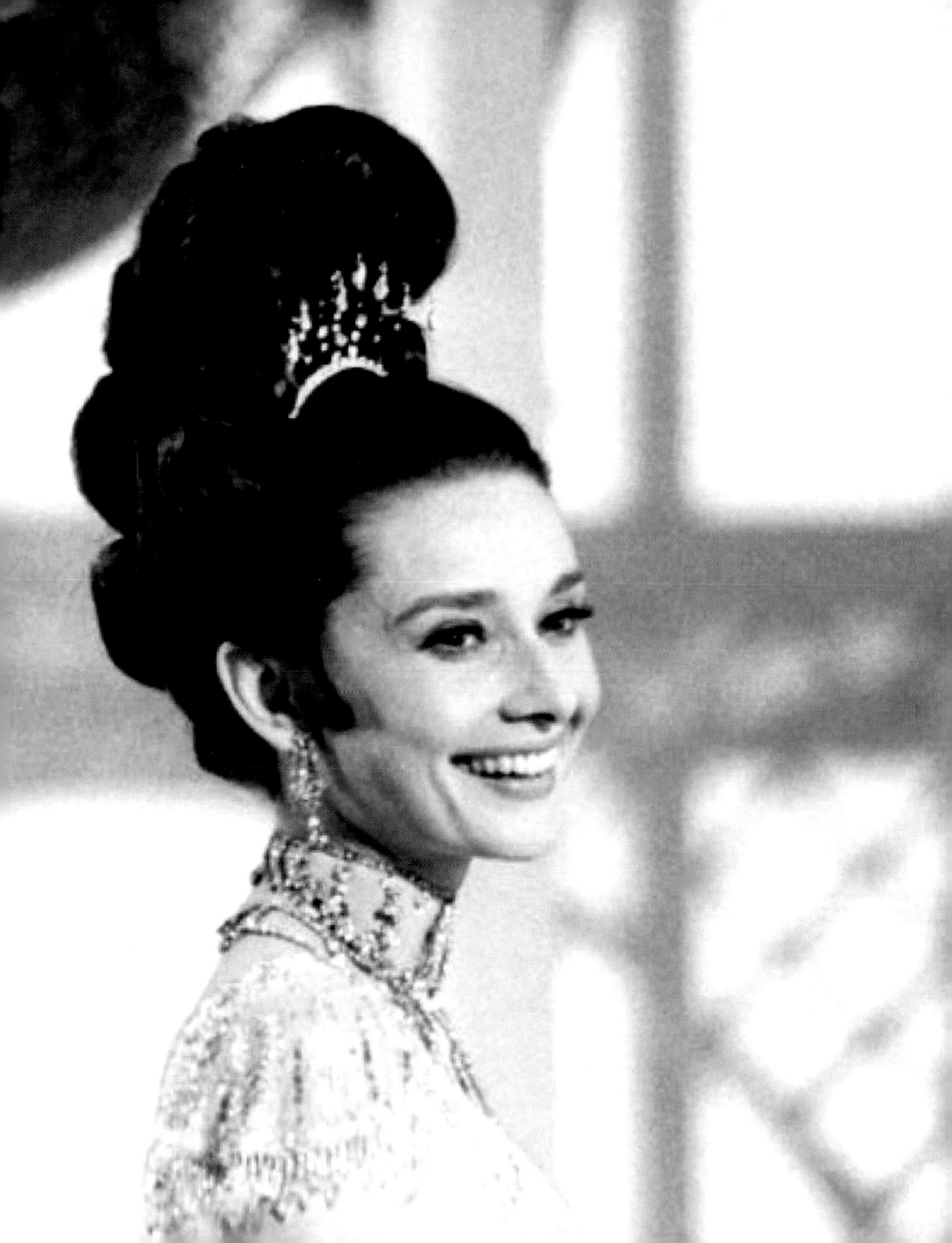

PROLOGUE
WHEN BOB MET AUDREY

They came from two vastly different worlds.

She, the one who would become the famous movie star, was born on May 4, 1929, in the ancient, romantic, storied Belgian city of Brussels to a father who was a wealthy British banker and a mother who was a bona fide Dutch baroness. He, the fellow who would build a career as a renowned photographer, had been born two years earlier in the sun-dappled Southern California city called Los Angeles—the la-la land that was then starting to feel its oats.

That the paths of Audrey Kathleen Hepburn (née Ruston) and Robert Hanley Willoughby might one day cross and that their subsequent friendship would produce wonderful memories—many of them captured by Willoughby's deftly aimed camera—could never have been predicted.

But then Audrey's life has always read as a fairy tale, full of emotional trials and felicitous twists of fate. And so perhaps this, too, could have been assumed. Just when her fairy tale reached its vivid best, along came a gentleman who could render it beautifully. Immortally.

BOB WILLOUGHBY WASN'T THERE, of course, for the earliest chapters—no photographer was, really, beyond family members, friends or school-portrait makers. And that's too bad because those chapters were every bit as dramatic as her years of celebrity.

Although Audrey's early childhood revolved around the axes of opulence and status, neither would endure. Her parents divorced in 1935, and Audrey relocated to London with her mother. There she attended a girls' school and developed an affection for ballet and the theater. In 1939, her family moved again, as Audrey, her mother and her two stepbrothers left London for Arnhem, a lovely old city in her mother's native land of the Netherlands. From 1939 to 1945, Audrey attended the Arnhem Conservatory, where she pursued, among other interests, a growing love of ballet.

But these were not happy years. In 1940, Germany invaded the Netherlands. Audrey's name was changed to Edda von Heemstra, since Audrey Ruston was a very English-sounding name, which was a liability, a thing to be lost, at least for the duration of the conflict.

As a teenager during the war, Audrey felt anxious and unhappy. She found her only real joy in dancing and used her talent to raise money for the Dutch Resistance, giving recitals in clandestine locations throughout Arnhem. "The best audience I ever had," she later recalled, "made not a single sound at the end of my performance."

In 1944, the tide of the war turned against the Nazis, and they viciously tightened their grip on the countries that they occupied. The Netherlands was already experiencing a winter famine when the Germans seized food and fuel for their own purposes. Audrey suffered

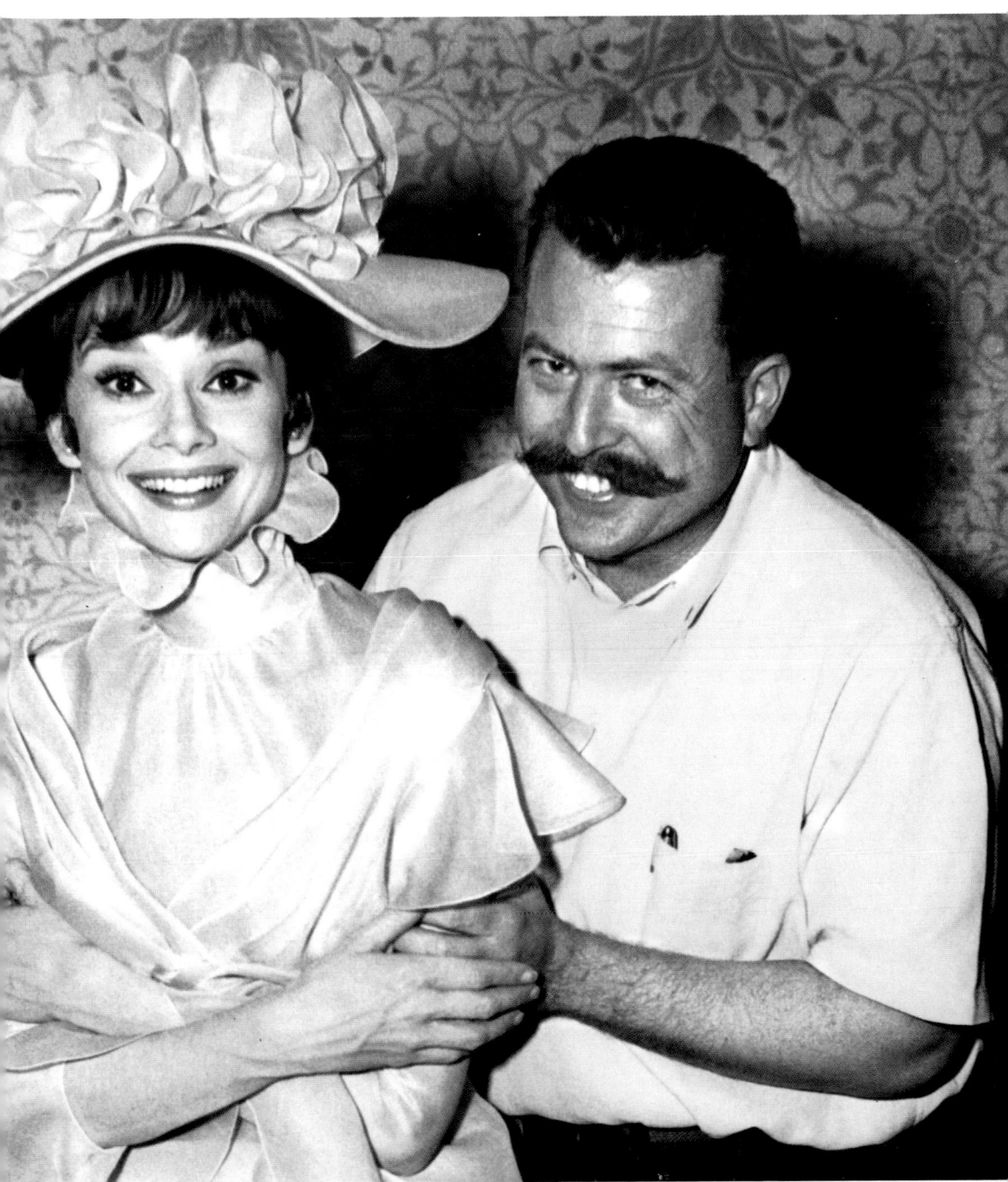

23

Joke Quarles van Ufford

malnutrition, anemia and frequent bouts of depression during this period. Others close to her suffered much worse. One of her stepbrothers was sent to a German labor camp, and an uncle and one of her mother's cousins were shot for their participation in the Resistance. "I have memories," Audrey said many years later. "More than once, I was at the station seeing trainloads of Jews being transported, seeing all these faces over the top of the wagon. I remember very sharply one little boy standing with his parents on the platform, very pale, very blond, wearing a coat that was much too big for him, and he stepped onto the train. I was a child observing a child.

"I was exactly the same age as Anne Frank. We were both 10 when war broke out and 15 when the war finished. I was given the book in Dutch, in galley form, in 1946 by a friend. I read it—and it destroyed me. It does this to many people when they first read it. But I was not reading it as a book, as printed pages. This was my life. I didn't know what I was going to read. I've never been the same again, it affected me so deeply.

"We saw reprisals. We saw young men put up against the wall and shot, and they'd close the street and then open it, and you could pass by again. If you read the diary, I've marked one place where she says, 'Five hostages shot today.' That was the day my uncle was shot. And in this child's words I was reading about what was inside me and is still there. It was a catharsis for me. This child who was locked up in four walls had written a full report of everything I'd experienced and felt."

Arnhem suffered not only Nazi persecution but Allied bombings as well. And then, suddenly, the hell was over—and Audrey had survived. When the United Nations relief units arrived, she put too much sugar in her first bowl of oatmeal, and it made her sick.

She desperately longed to dance professionally. In pursuit of this dream, she moved to Amsterdam and studied under Sonia Gaskell. Three years later, she was back in London on a ballet scholarship, training this time with the renowned Marie Rambert. Said Rambert later: "She was a wonderful learner. If she had wanted to persevere, she might have become an outstanding ballerina."

But Audrey's family was broke, and both modeling and acting promised to pay better than dancing could. Audrey made the difficult decision and shifted gears.

Her first screen role was as a KLM stewardess in the often overlooked 1948 educational gem *Nederlands in 7 lessen,* known internationally (when it was known at all) as *Dutch in Seven Lessons.* It wasn't her finest performance, but it wasn't her last, either.

Soon after that, she was performing in West End musicals such as *Sauce Piquante* and *High Button Shoes.* Her career started to take off very quickly at this point. She landed small movie roles in dramas and comedies, then was tapped to play the lead in the stage play *Gigi* on Broadway. That show opened at Thanksgiving time

major studios, even as he continued to work for the photo departments of many major magazines. His pictures were never out of print for a week during his two decades in the movie business; he worked on more than 100 films in all, including such classics as *From Here to Eternity, The Man With the Golden Arm, Who's Afraid of Virginia Woolf?, The Graduate, The Lion in Winter* and, of course, *My Fair Lady*. The images that you remember of James Dean, Frank Sinatra, Richard Burton, Peter O'Toole—and, of course, Audrey Hepburn—are most likely Willoughby's. *Popular Photography* magazine called him the man "who virtually invented the photojournalistic motion-picture still."

Willoughby pioneered other things, as well, including the first remote-controlled camera for on-set still pictures and the first still-camera sound blimp in 1963. But by 1972, he was ready for a change. He moved to Ireland with his wife, Dorothy, their four children—Christopher, Stephen, David and Catherine—and Dorothy's mother, Quig. Clan Willoughby lived for 17 years in a castle on Courtmacsherry Bay in the sublime south of that charming country. In these years, Willoughby translated early Irish poems, among other artistic pursuits; he published a book of them, *Voices of Ancient Ireland*, which was illustrated with his photographs. He published other books of photography and helped prepare exhibitions of his work. Through the years,

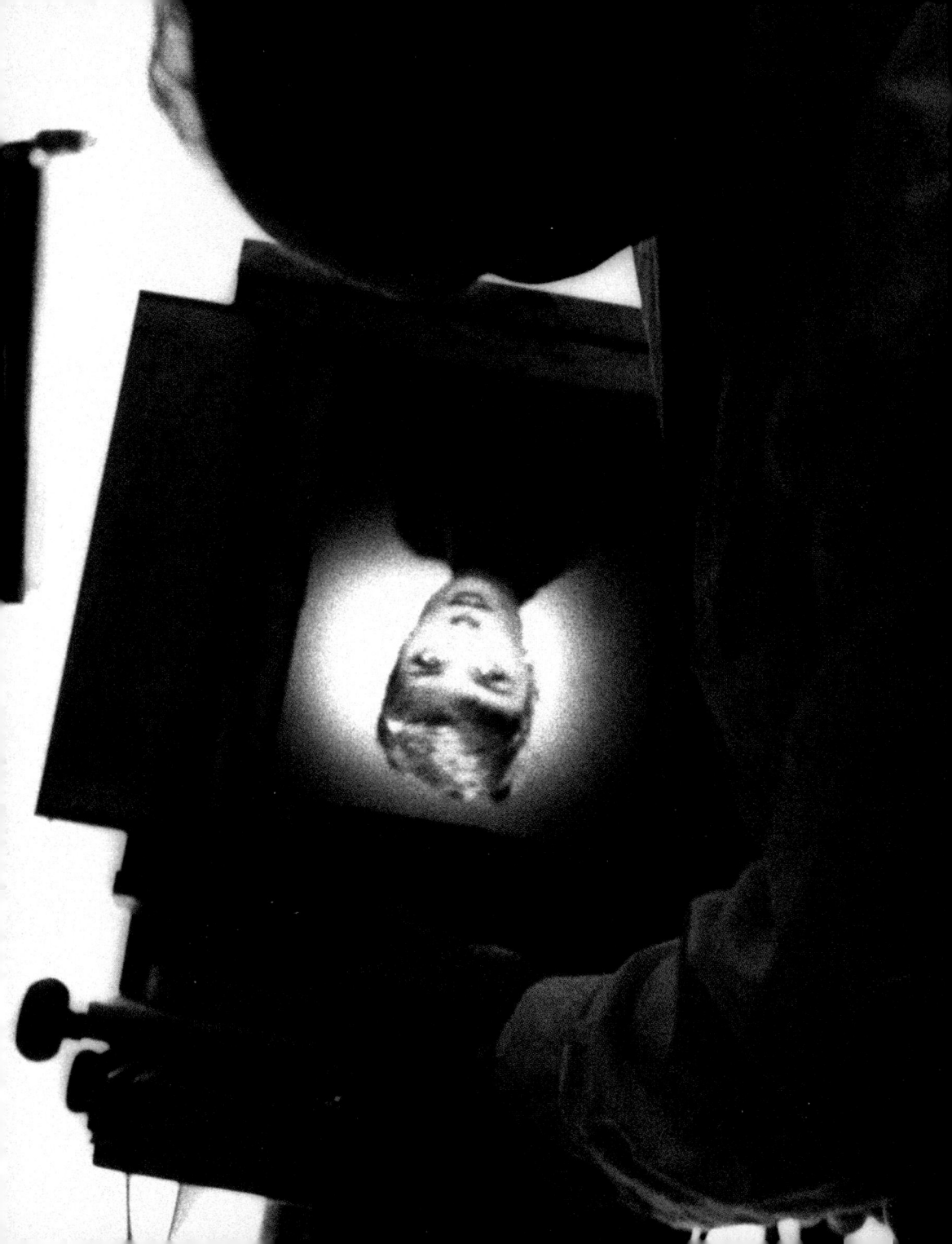

his reputation as a portraitist continued to grow, and by now his work has been featured in 500 museums in more than 50 countries throughout the world and is in the permanent collections of, among many other places, New York City's Museum of Modern Art film department, the National Portrait Gallery in Washington, D.C., as well as London's National Portrait Gallery, the Bibliotheque Nationale in Paris—and, of course, the Academy of Motion Pictures Arts and Sciences in Beverly Hills, Calif.

With their children and grandchildren scattered hither and yon, Willoughby and Dorothy relocated again, this time to the south of France. Willoughby continues to shoot, exhibit and publish books, including the one you hold in your hands.

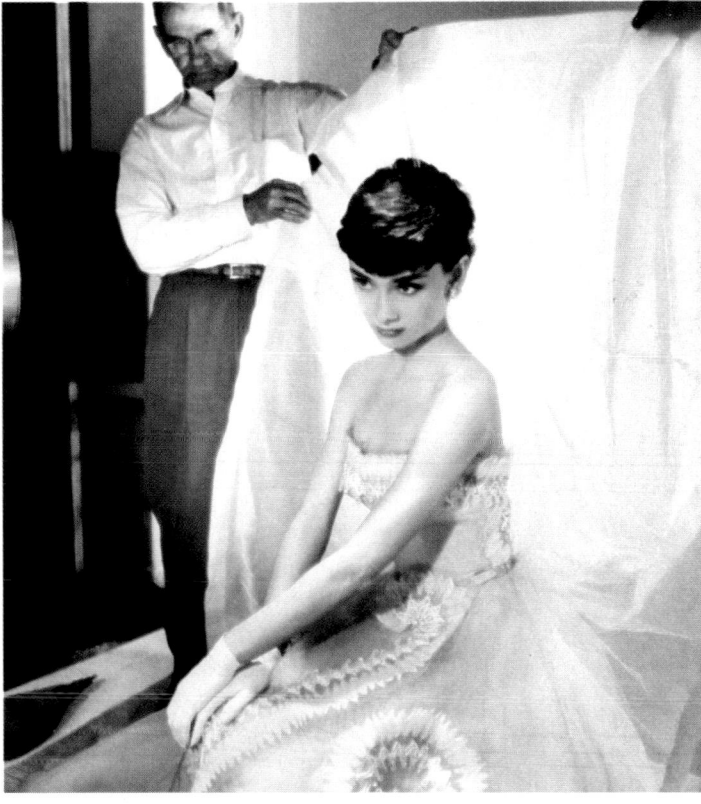

ABOVE AND OPPOSITE
*Audrey posing for—
and seen through—the lens
of Bud Fraker*

N OW THEN: THAT FATEFUL morning in '53. Willoughby was at home when the phone rang. It was Charles Bloch, the ever-sensible agent, and he was pushing "one of those assignments," the ones involving the young starlets, or the young "actresses."

We'll let Willoughby pick up the story from there:

"He wanted me to go over to Paramount and cover the still session of a new young actress. She had just made a big impression on the studio brass in the William Wyler film *Roman Holiday.*

"When I arrived at the Paramount Still Department, I started talking with the head portrait photographer, Bud Fraker.

Bud was a terrific man and always nice to young photographers when they entered his realm. So I was talking to Bud, waiting for the arrival of the subject, when out of the dressing room floated this vision swathed in voile.

"Bud caught my look of admiration and helped me to close my open mouth. 'She's something, isn't she?' he said, look-

PROLOGUE
WHEN BOB MET AUDREY

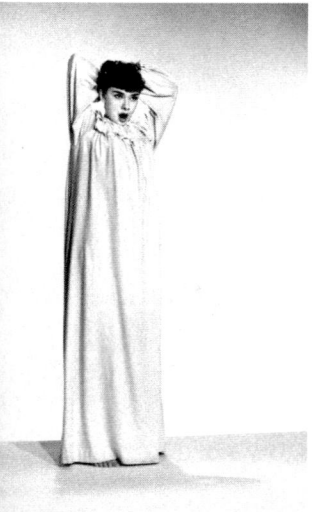

ing first toward this beauty and then back at me. He took his position behind the huge 8 x 10 studio portrait camera. As he began to work, I, having regained a modicum of composure, began to sort out my own equipment.

"I always watched how other photographers lit their subjects, for I had originally apprenticed in a portrait studio. But in this instance, my eyes kept drifting back to that face. It was a different face, for sure, but . . . I couldn't *quite* put my finger on what it was. It was definitely something special.

"It was only after Bud finished shooting her in that dress that anyone thought to introduce me. I heard someone say, 'Bob, this is Audrey Hepburn.' She took my hand and dazzled me with a smile

that God designed to melt mortal men's hearts. She had a voice filled with smiles. No little starlet, this.

"Needless to say, my early apathy for this assignment had traveled all the way up the meter to real enthusiasm. As the publicity people trotted in folks—celebrities, other actors—to meet Audrey, I was amazed at the ease and grace that this 24-year-old woman exhibited in dealing with them all. That amazing instant contact she always made was a remarkable gift, and I know from talking to others that it was felt by all who met her. She exuded a magic warmth. I hadn't yet seen *Roman Holiday,* but later, when I had, I realized that Audrey really was the princess she was portraying on the big screen.

"The session went on for most of the day, with a quick bite to eat that the studio provided from its commissary. Bud Fraker seemed tireless. I could see how energized he was by his subject. But if Bud was tireless, Audrey never stopped either—for his camera, or for mine. Out of one dress, into another; doing this and that for the public relations folks—all day long. Studio hairdressers, wardrobe ladies and makeup artists were all about. This was a big production, as Paramount was obviously going all out for its young Miss Hepburn. The final setup photograph of the day was in her own nightgown, which had a little *A* embroidered on it. Audrey didn't have to act tired, the yawn in that picture was spontaneous.

"Nevertheless, the Paramount publicity department wasn't about to let her rest. They whisked her over to the dressing

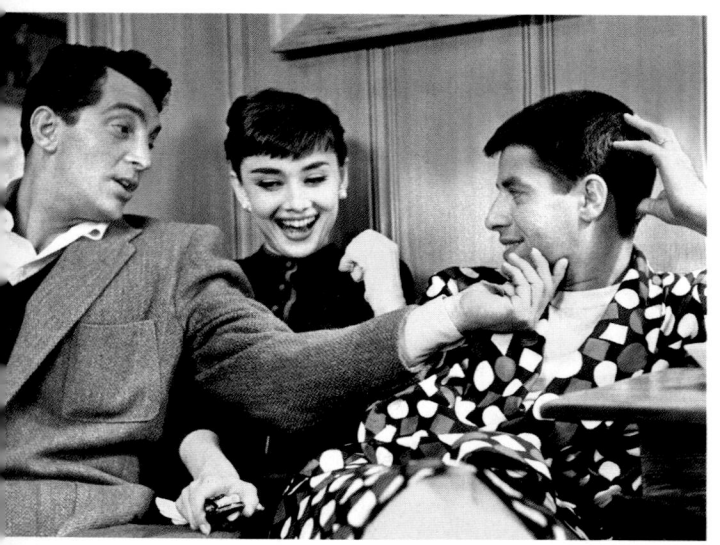

OPPOSITE, TOP
The last shot of the studio session

OPPOSITE, BOTTOM
*Martin coaxing a smile from
Lewis, if barely*

BELOW
*After a long day, all smiles and
heading home*

room of Dean Martin and Jerry Lewis, absolute kings of showbiz at the time, to take a few more photos.

"I really don't think Martin and Lewis were expecting the PR department, and even if they had in fact been informed, Jerry wasn't happy about the interruption. When he pulled a face for the studio's photographer, Dean had to scold Jerry and tell him to be nice. At the time, I'm sure neither of them could have imagined that this young lady would eclipse them both in the film world.

"The final chore was over, and Audrey was like a child released from school. She went skipping down the studio street as she headed to the car that would take her back to her room. I followed that car back to the Chapman Park Hotel on Wilshire Boulevard. I knew she must be exhausted, but she had said she was still game for me to come up and take a few more photographs. This was a part of her character that I would observe again and again in the years that followed: gracious to a fault and about as professional as anyone I've ever met.

"I helped her carry up her wardrobe, and she gathered her mail at the front desk as we went by. The clothes quickly went on the bed. They would be very carefully folded later, but first Audrey needed the sustenance of a letter from home. She was, at the time, touring with the stage play *Gigi*—that's what had brought her to L.A.—and some of my favorite pictures of her, including the one where she's reading that letter and another of her surrounded by azaleas, are

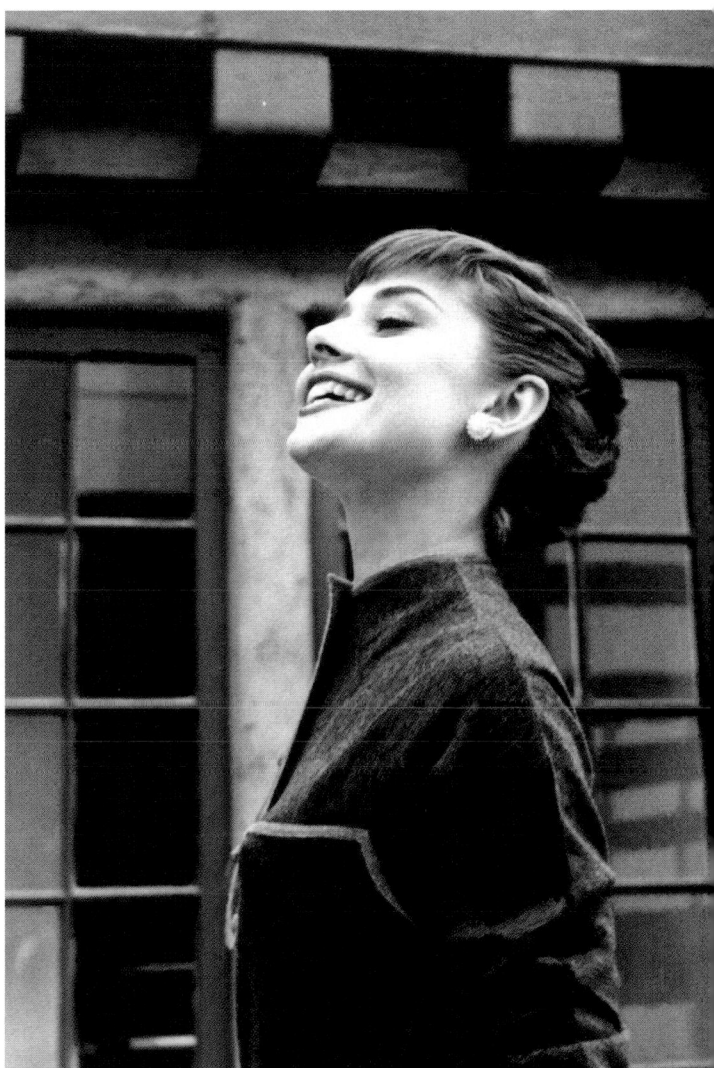

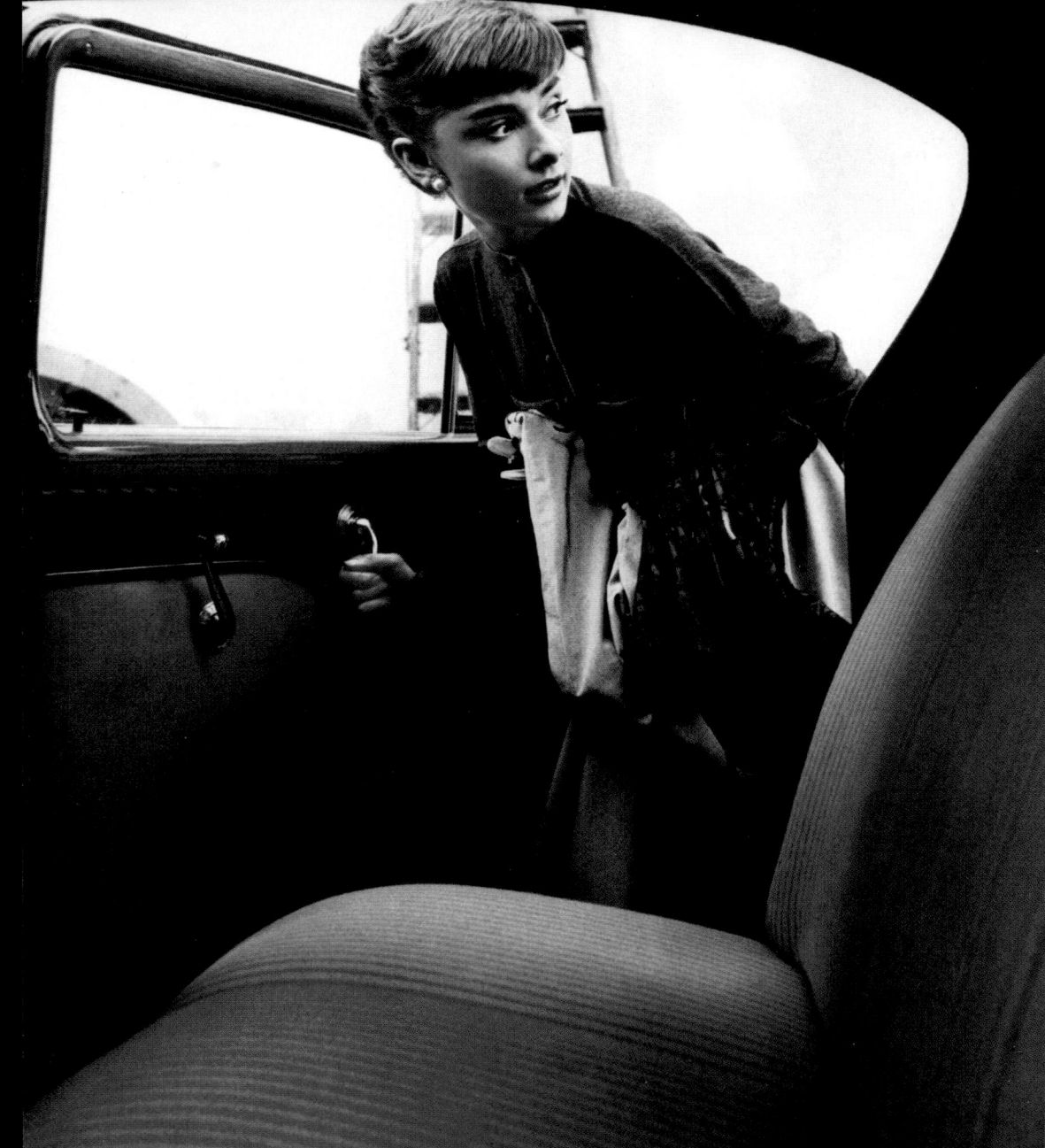

ones that we made, at the end of a very full day, where she is wearing Gigi's striped blouse."

QUITE A DAY IT HAD BEEN, AND then there was an interval. Willoughby continues his reminiscence: "It would be nearly five years before I would work with Audrey again. I had just returned from an assignment in the Far East, and MGM telephoned to ask if I would like to cover the film *Green Mansions*. Two years earlier, they had assigned me to photograph their film *Raintree County*, with Elizabeth Taylor and Montgomery Clift. I was able to get them an amazing amount of space in the world press, and since then, I had been traveling nonstop. The idea of a 'home' assignment was very appealing, and the best news of all was that the assignment would involve Audrey as the star. I remembered reading the William Henry Hudson book on which the movie was based and recalled it as romantic and even rather magical. On top of this, there would be Audrey. I immediately said yes.

"In the time since I had first been enchanted with her, our separate careers had both taken off. In 1954, I had had that experience at Warner Bros. with *A Star Is Born;* that was a fantastic opportunity for me and set off a chain reaction that really set the course of my life. And Audrey had by now become a truly major movie star, having won an Academy Award for *Roman Holiday*, not to mention a Tony

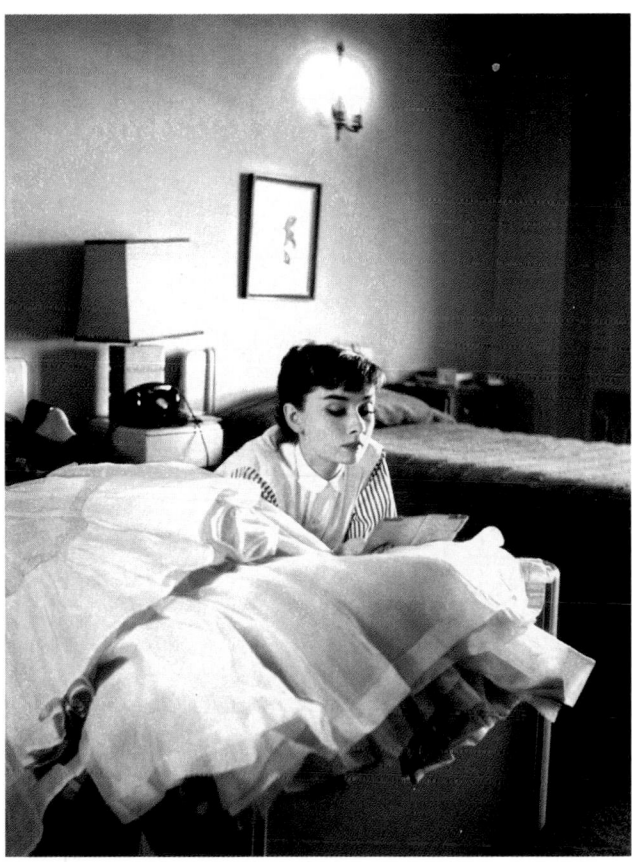

for her work on Broadway in *Ondine*.

"On the set of *Green Mansions*, Audrey greeted me so enthusiastically, it was as if I were an old friend. She introduced me to her husband, the director Mel Ferrer. It was so informal, it was just as if we had been working together only a few months

OPPOSITE
*Next and final stop,
the Chapman Park Hotel*

ABOVE
In her room—and in her Gigi
*blouse—concentrating
intently on a letter from home*

33

At the Willoughbys' home, Audrey with Christopher Willoughby and her son Sean Ferrer (far right)

before. The dazzling smile that warms one inside was at full power. It's an amazing ability to create that feeling in others. No wonder all of her leading men fell in love with her.

"This was when our relationship blossomed into a real friendship, right about this time.

"The year 1959 was a momentous one for both Audrey and myself. For Audrey, it wasn't good. She had been thrown from a horse while filming John Huston's *The Unforgiven* in Mexico and was badly injured. They rushed her home by air ambulance, and she was in the hospital for six weeks. Of course, everyone was very concerned for her, as it was reported she had broken her back in the fall.

"Audrey wasn't a hardy person to begin with, and this injury only magnified that. A few months later, she suffered a miscarriage, and it took some time to recover from that, too.

"So this time it wasn't about movie photography, this was personal. I went over to Audrey as soon as she was well enough to receive visitors at home. I'd like to try to re-create the vision I had when I walked into her bedroom. Everything was white—the bed, floors, rugs, walls, even her crisp and fresh nightgown. When she smoked, she put the ash in a little white ashtray on her white bedside table, and when she was finished, she wiped the ashtray clean with a white tissue and dropped it, of course, into a white wastebasket. It was the preciseness of her character, the way she did everything.

"She was the same Audrey. She had been

to our home so that the boys could meet. It was 1961, and Audrey and I were about to work once more with William Wyler, on *The Children's Hour*. It was a special time and a special visit. I made some pictures that day, and it's wonderful to see Audrey with the children. Children meant everything to her."

Then would be more visits— more visits, more films, more special and intimate moments. Willoughby would be there during the years of fame for the staged events, the backstage adventures and the private times spent with family and friends. Friends—a category to which he now belonged.

He was always curious about Audrey Hepburn, a regular woman—as regular and normal and friendly as any—who could "before one's eyes transform herself into a princess." In the totality of his work with Audrey, he caught that miraculous transformation. We see her this way and then—voilà—she is that way. She was always lovely, and she always seemed kind.

Audrey Hepburn became much more than a movie star; she became, ultimately, a transcendent citizen of the world, something we will discuss in the epilogue of this book.

Bob Willoughby was there to see the journey of the hero and to document it.

"A rare human being," he says, expressing his final thought on the matter, "whom I respected and loved."

Dear Dorothy — we think you are

MR. AND MRS. MELCHOR G. FERRER

so clever — Blessings and love to you all.

ABOVE
Dorothy and Audrey, Christopher and Sean—and a gracious note from Audrey

OPPOSITE
A portrait of the artist, from that first fateful session . . . when Bob met Audrey

badly hurt, but there was still that smile, like a warm embrace, to greet me. When she discussed the film and how the accident had happened, she never blamed anyone, never complained about the pain she was in. She had to wear a back brace when she had finally recovered sufficiently to be able to return and finish the film. But even then, she did not complain.

"She wanted to hear my news. I told her I had met a lovely Scottish girl when flying back to L.A. from New York at one point and had married her six weeks later. She was thrilled with the news and gave me a lovely kiss and made me promise to bring Dorothy over to meet her.

"As fate would have it, Audrey's and Dorothy's babies were born almost to the day. When the babies were just about 12 months old, Audrey and Mel came over

During the 1953 L.A. photo session, Bud Fraker places his subject just so (left). That same subject at the end of the day leaves the studio and heads for her hotel (right).

STILL DEPT.
PORTRAIT STUDIOS
1 AND 2

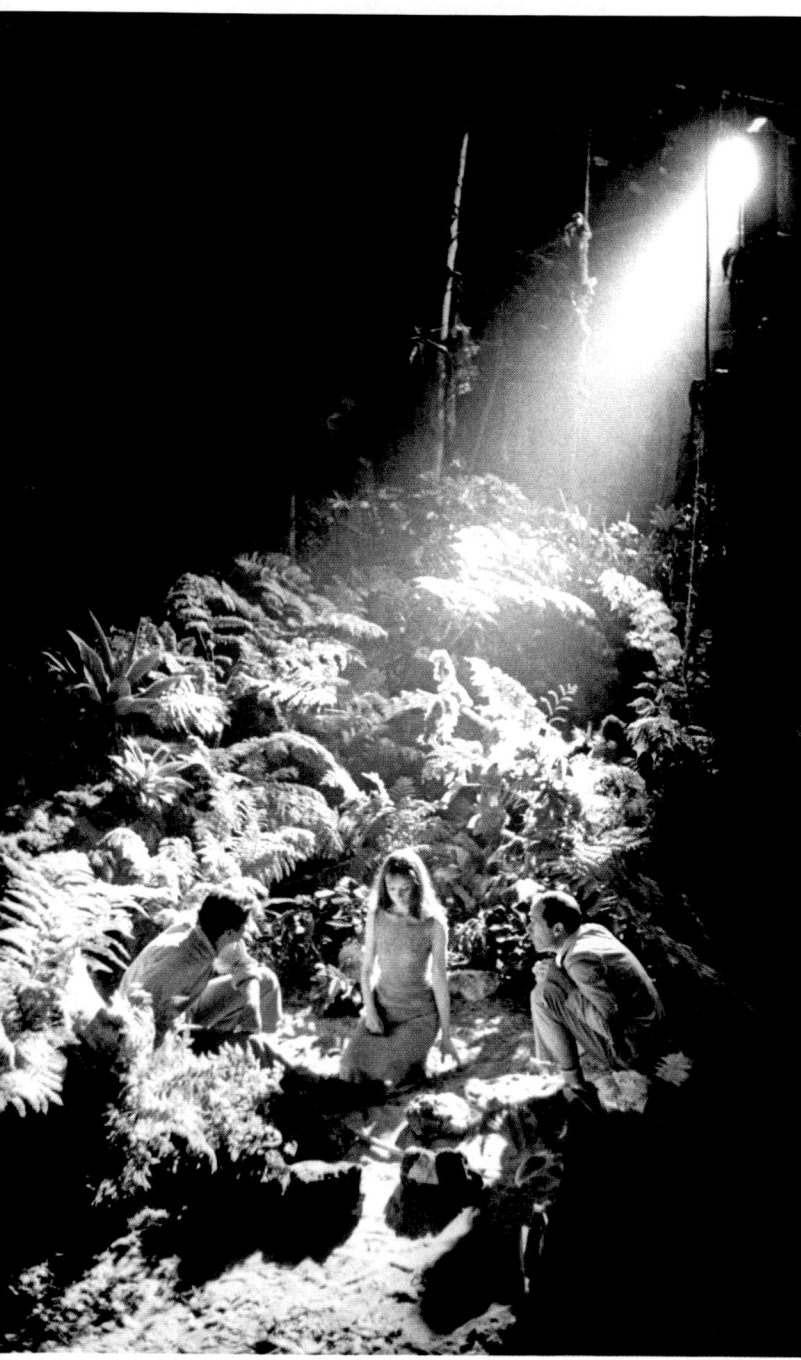

Director Mel Ferrer (right) maps out a scene for Audrey and Anthony Perkins. Opposite: Ferrer shares a semiprivate moment with Audrey, his wife as well as his star. Bob Willoughby remembers, "The set of Green Mansions *was a tropical garden populated with exotic plants, birds and animals, all created by the magicians that MGM had hired to fulfill the art director's visual fantasies. The smell of fresh earth and trees was a tranquil oasis in the concrete jungle of the MGM soundstages. It was a remarkable set; one would turn the corner and find Audrey Hepburn hidden in the leaves. I had never met Mel Ferrer before but knew his work as an actor. I was impressed that during the time I worked on the set, I never heard Audrey suggest that maybe the scene— the way Mel was setting it up—might be played differently. Audrey had worked with some of the best directors in the world, yet there was never an argument or a complaint to Mel, just trust and loyalty. There was a lovely contact between Audrey and Mel on the set—not as a director and an actress, but as a loving couple who cared for each other. These were some of the moments I felt it was important to record."*

Says Willoughby: "A different hat, a different expression, and—voilà!—from Rima the forest nymph to a Western belle. I liked and admired Audrey when I started that film, but soon I became a devoted fan and friend."

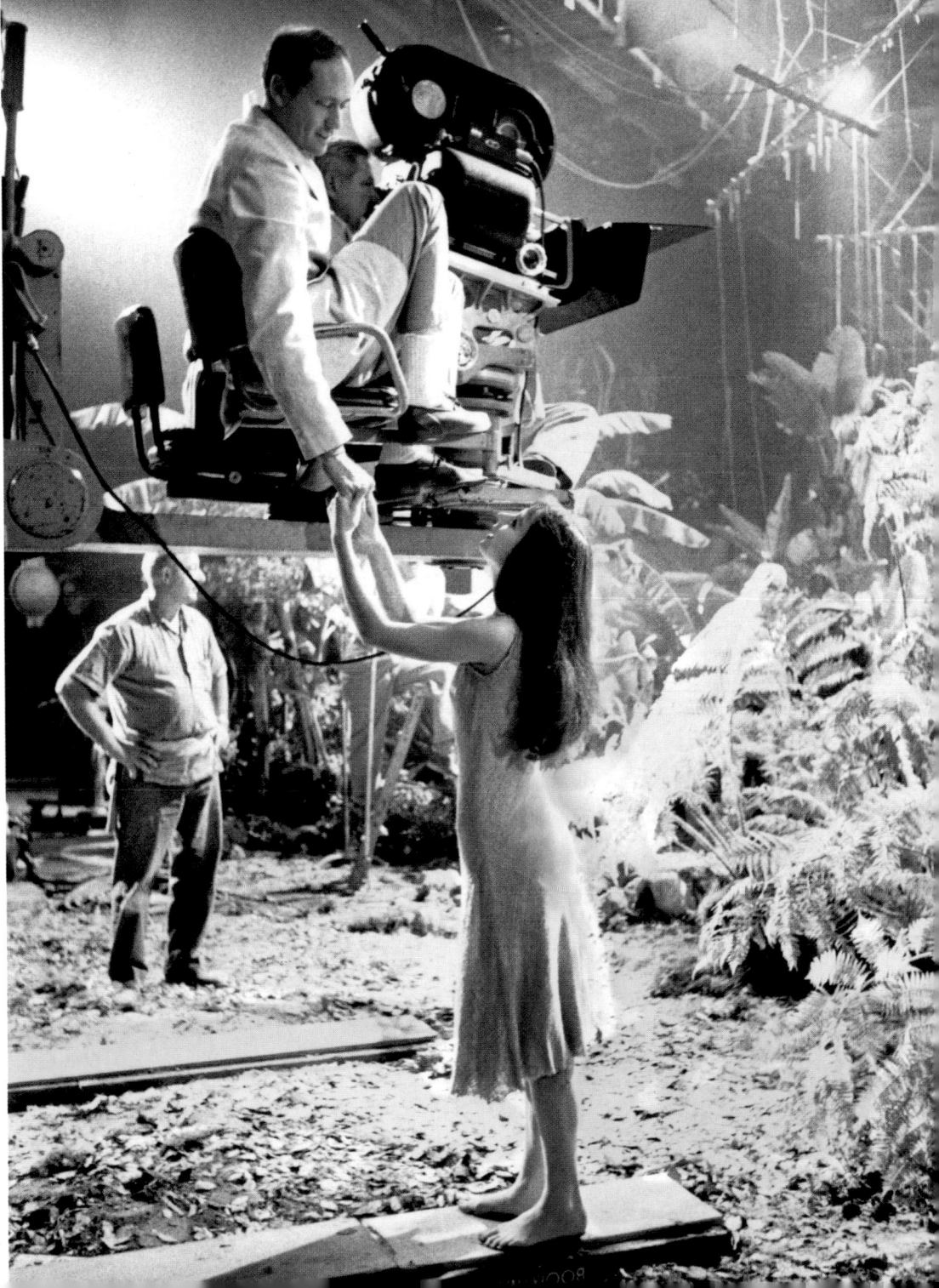

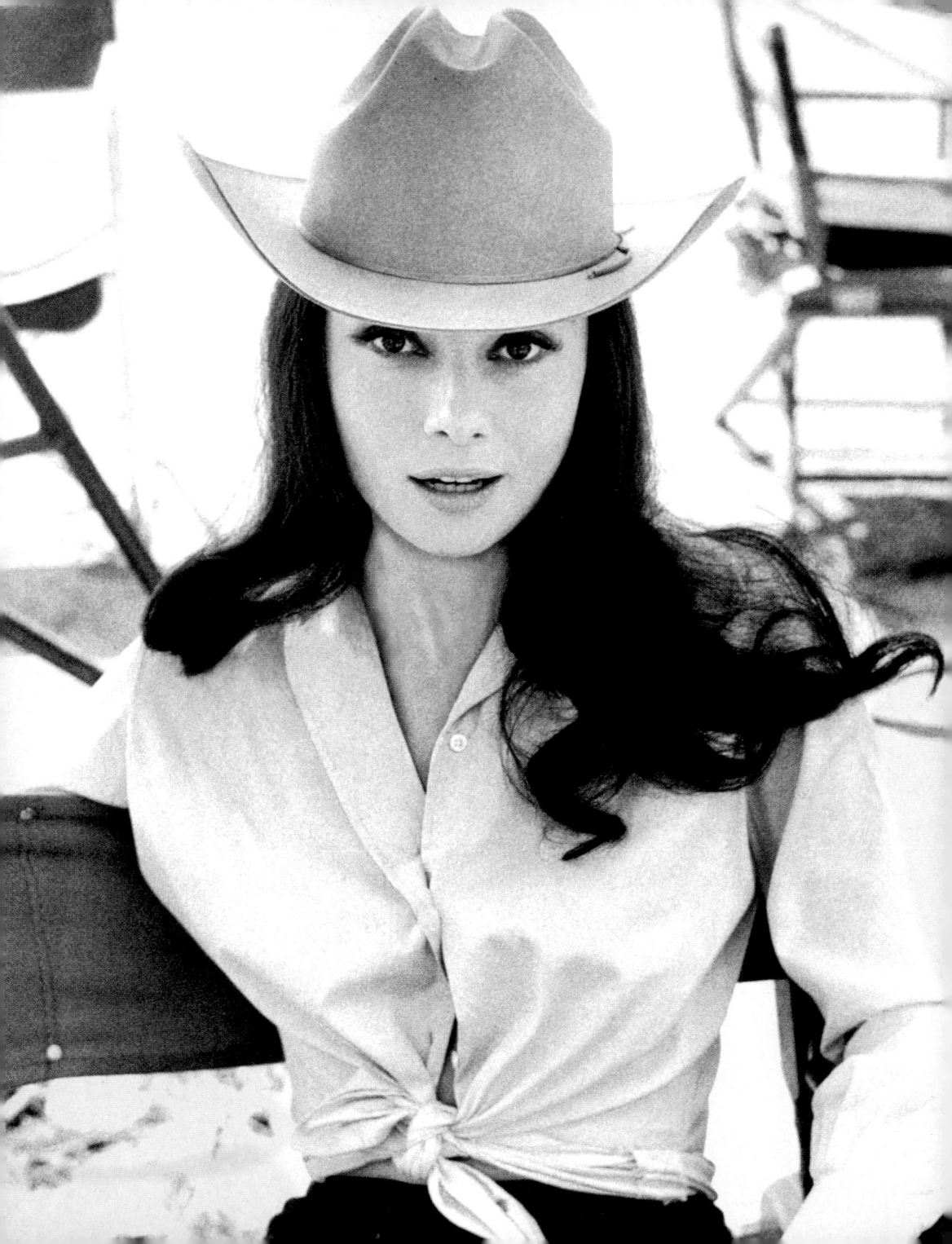

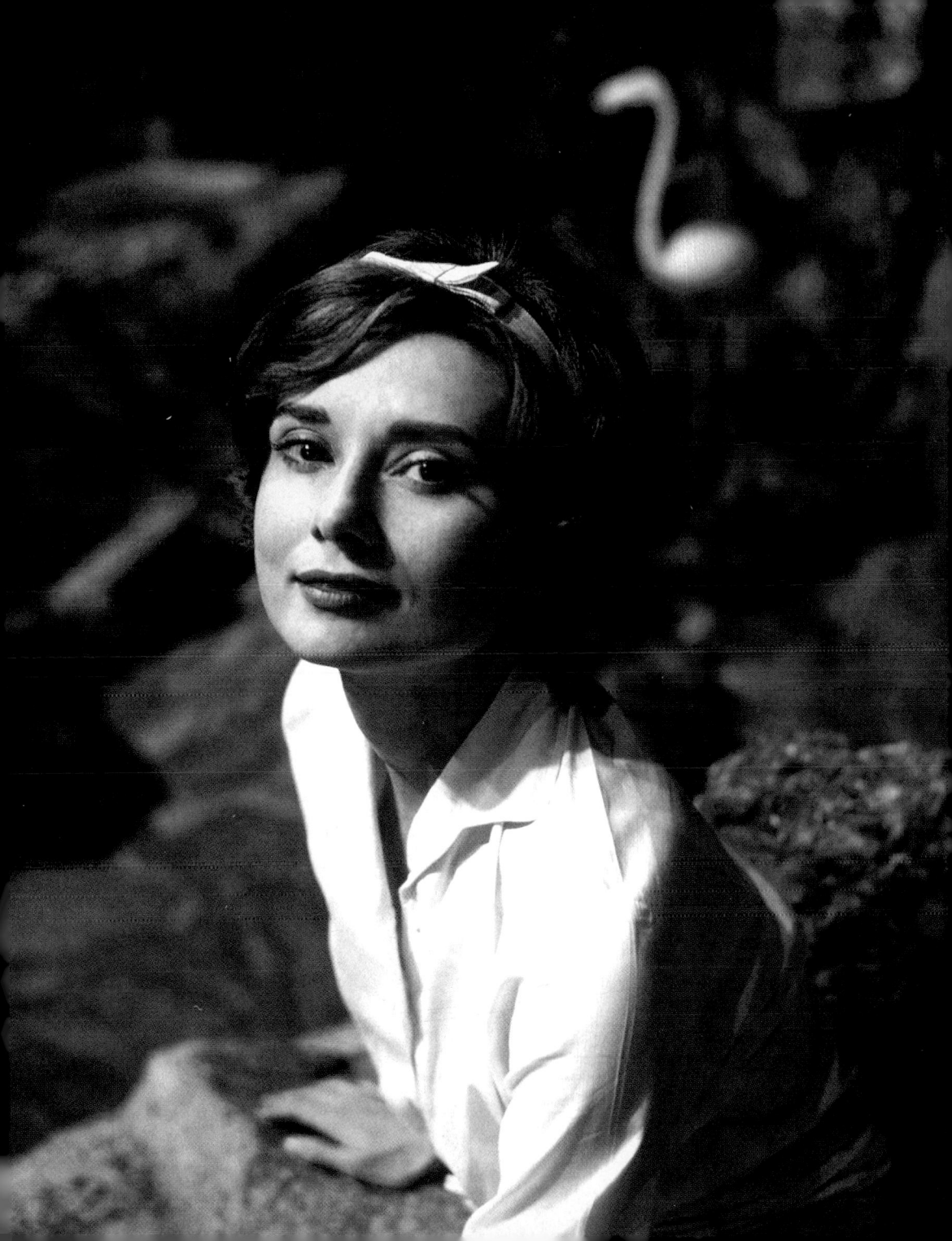

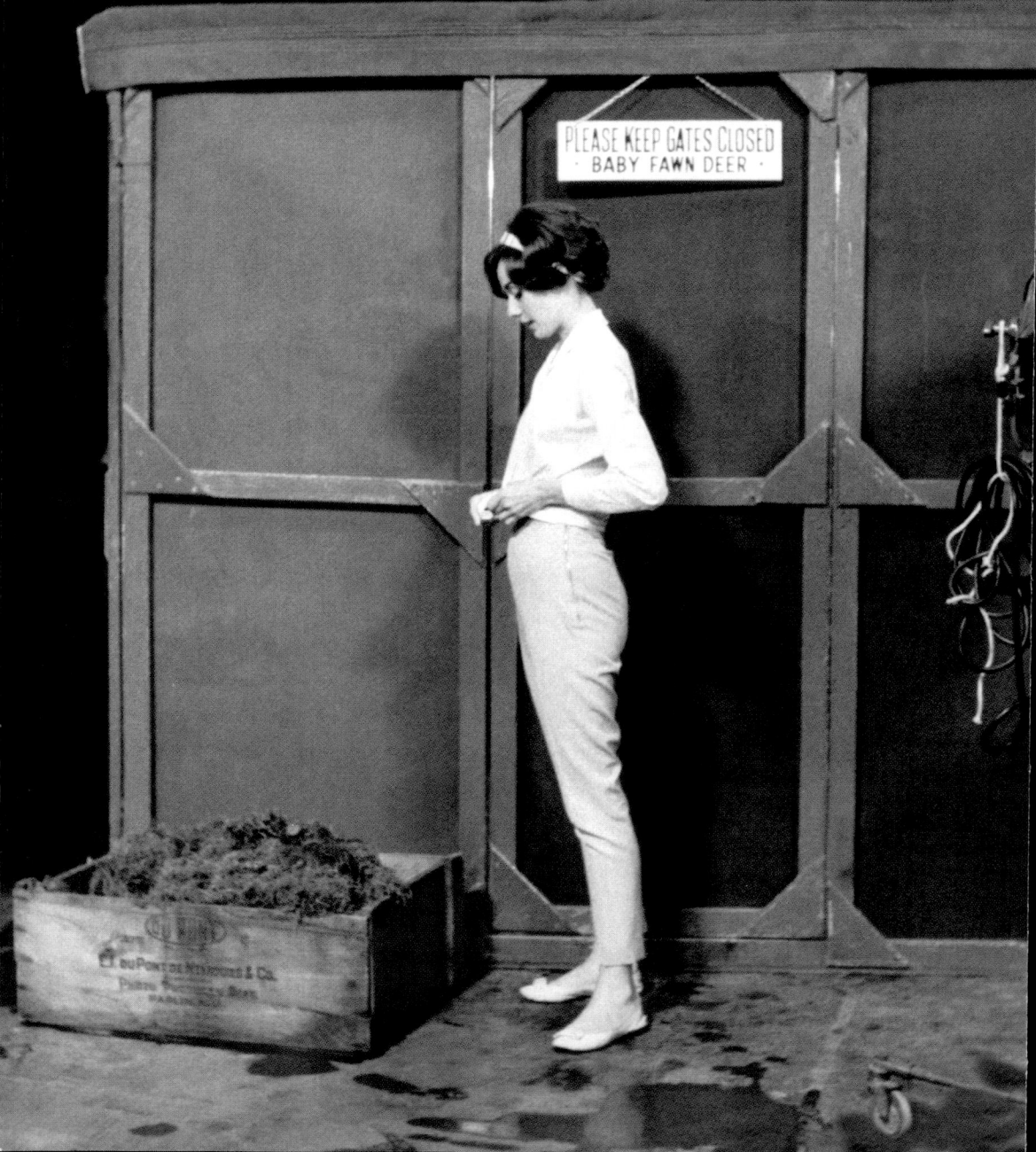

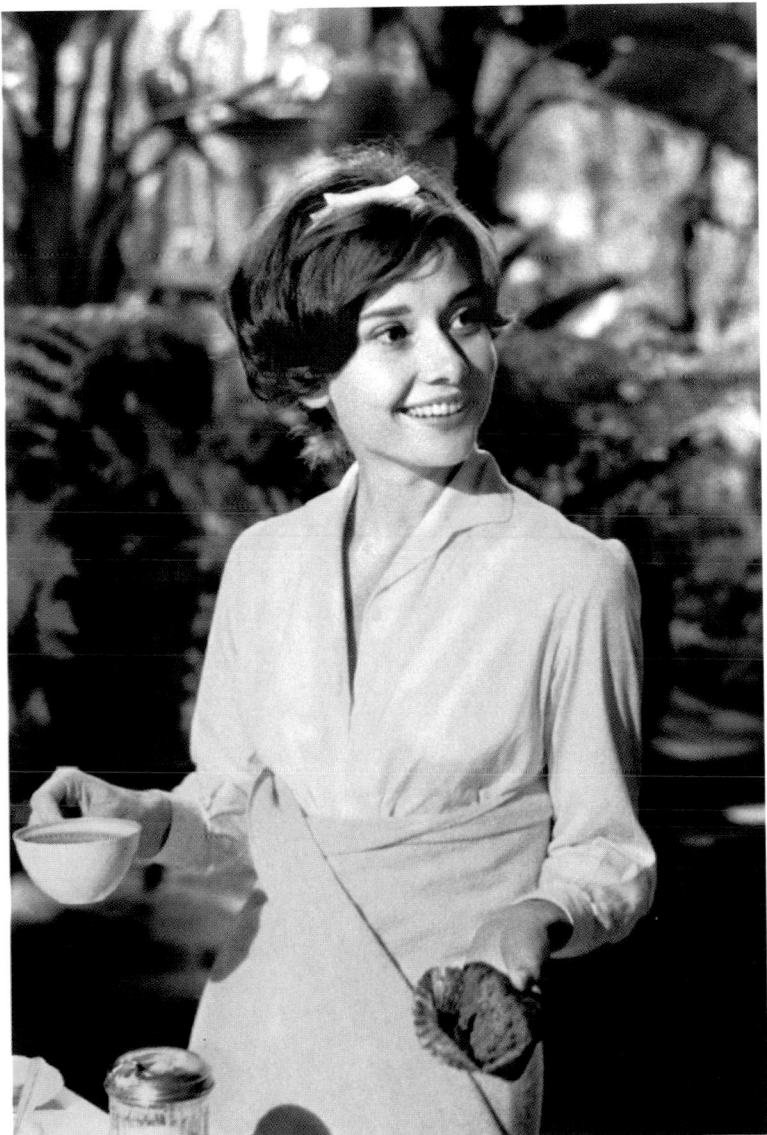

Enjoying a cup of coffee in the ersatz jungle (right) and hanging out in a curious precinct backstage (opposite). What's this, on the sign, about a fawn? Well, that would be Pippin, or Ip for short. Pippin was the name of a young deer that was featured in the film and was, before and during shooting, Audrey's constant companion. "Mel wanted to create the idea that the deer followed Rima, the character Audrey played, everywhere she went," says Willoughby. "If Rima was a forest sprite, a part of nature itself, then the animals must feel that she was part of their world and posed absolutely no threat. As for getting the deer to play its part, the animal trainers said that the only way to make it work was to take a very young fawn and live with it constantly—to establish a bond, so that it would get used to Audrey's touch and smell. Since Audrey was the only one allowed to feed it, I'm sure that Ip felt Audrey was its mother. It was no small thing, this close bonding, and I attributed it to Audrey's inner calm. They were literally in touch, something I had never seen before between a human being and a forest animal." On the following spread, Audrey, in character as Rima, is nuzzled by Ip, who is portraying a deer. To perfection, we might add.

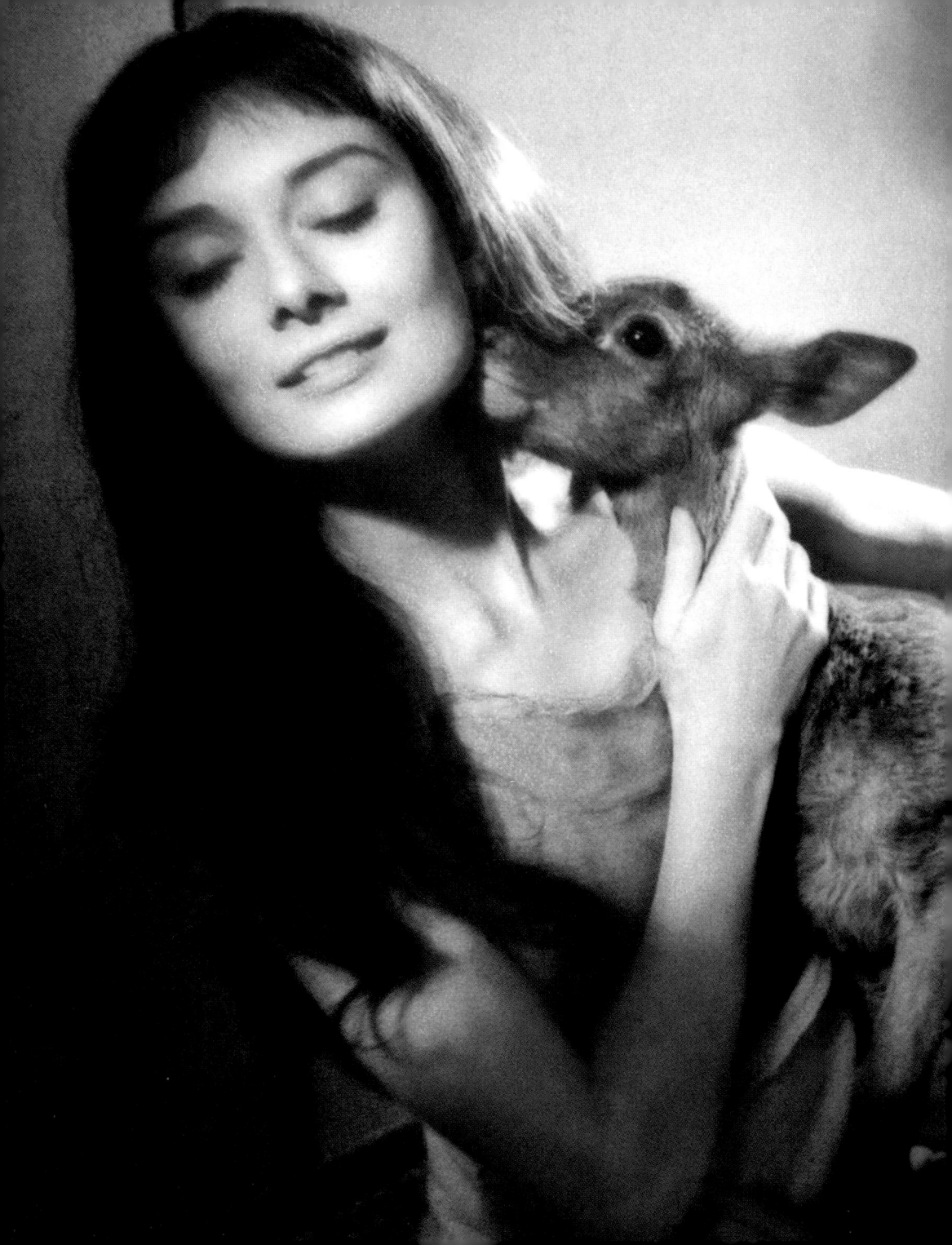

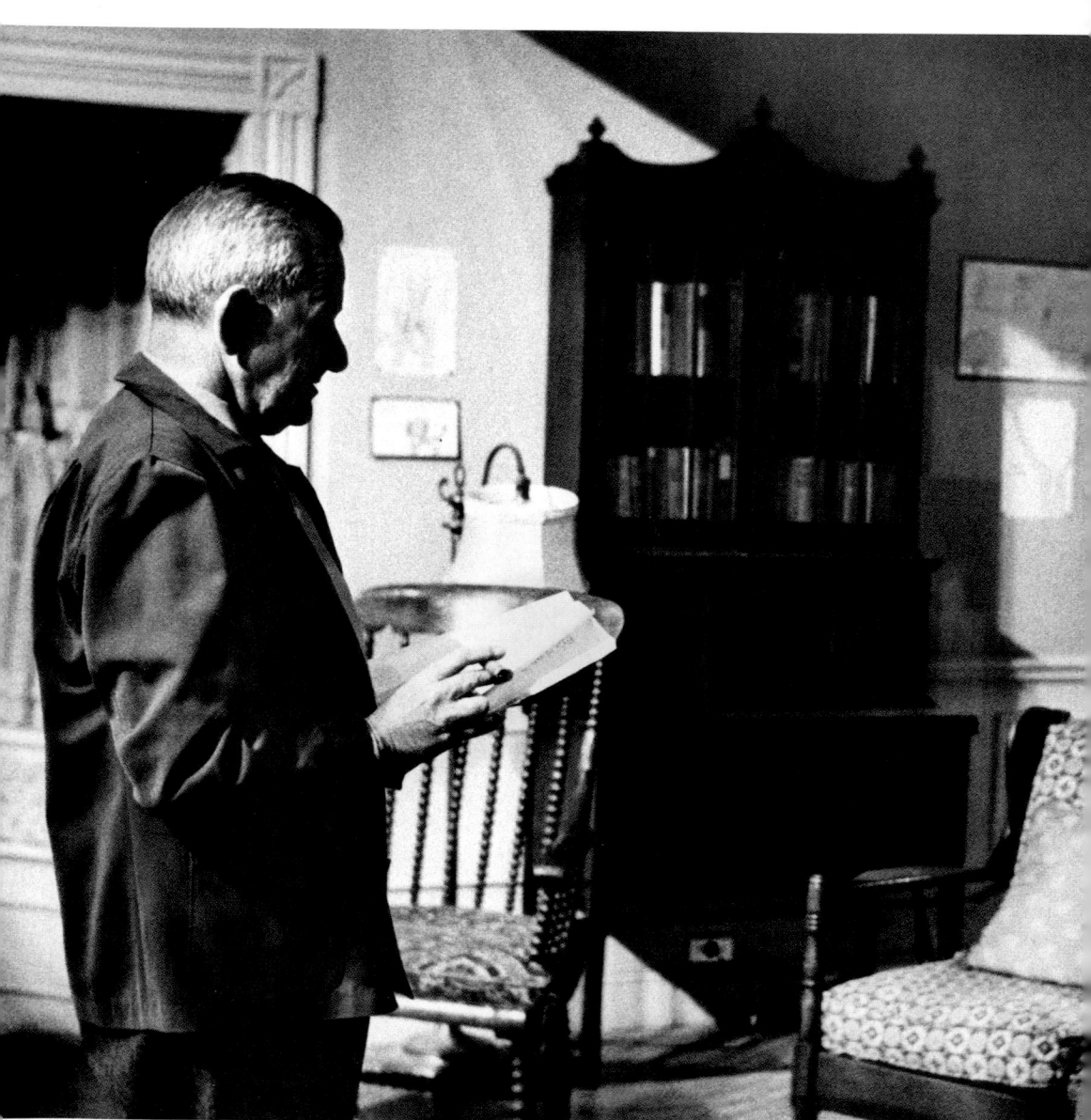

These are scenes from the set of the 1961 classic The Children's Hour, a drama in which a rumored affair between two women, played by Shirley MacLaine and Audrey, intrudes upon the relationship of Audrey's character and the man she truly loves, who is portrayed by James Garner. It is a story in which a child's malicious lie destroys the lives of three innocent people. In these pictures, director William Wyler gives firm instructions to his cast.

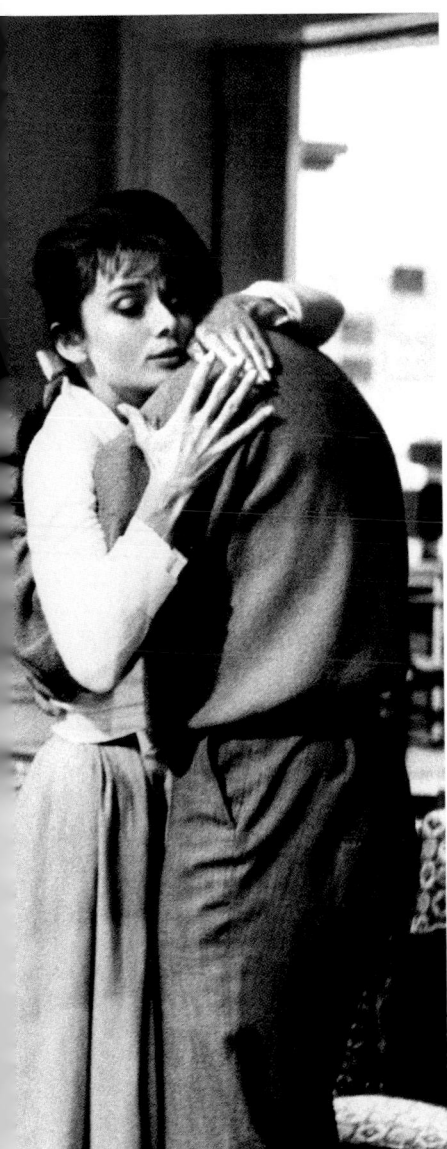

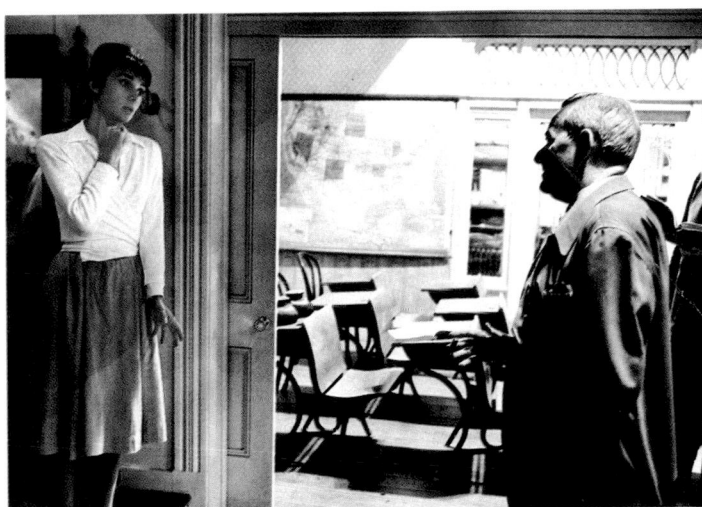

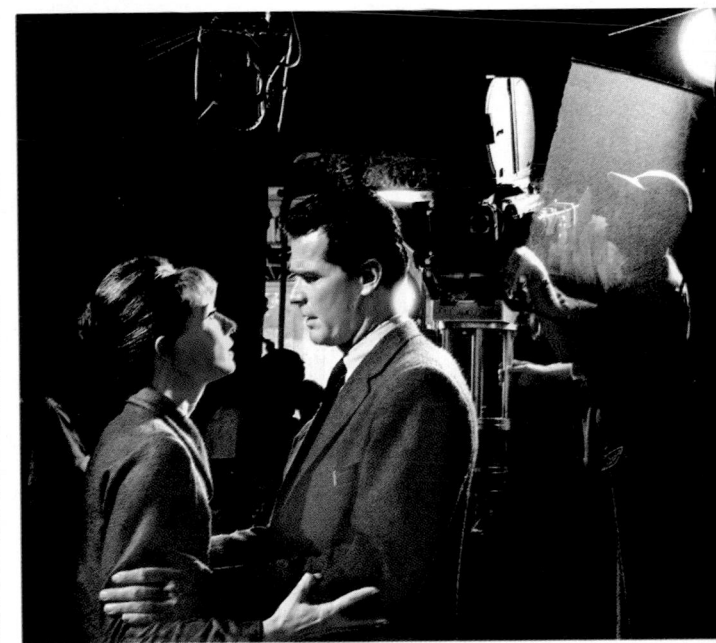

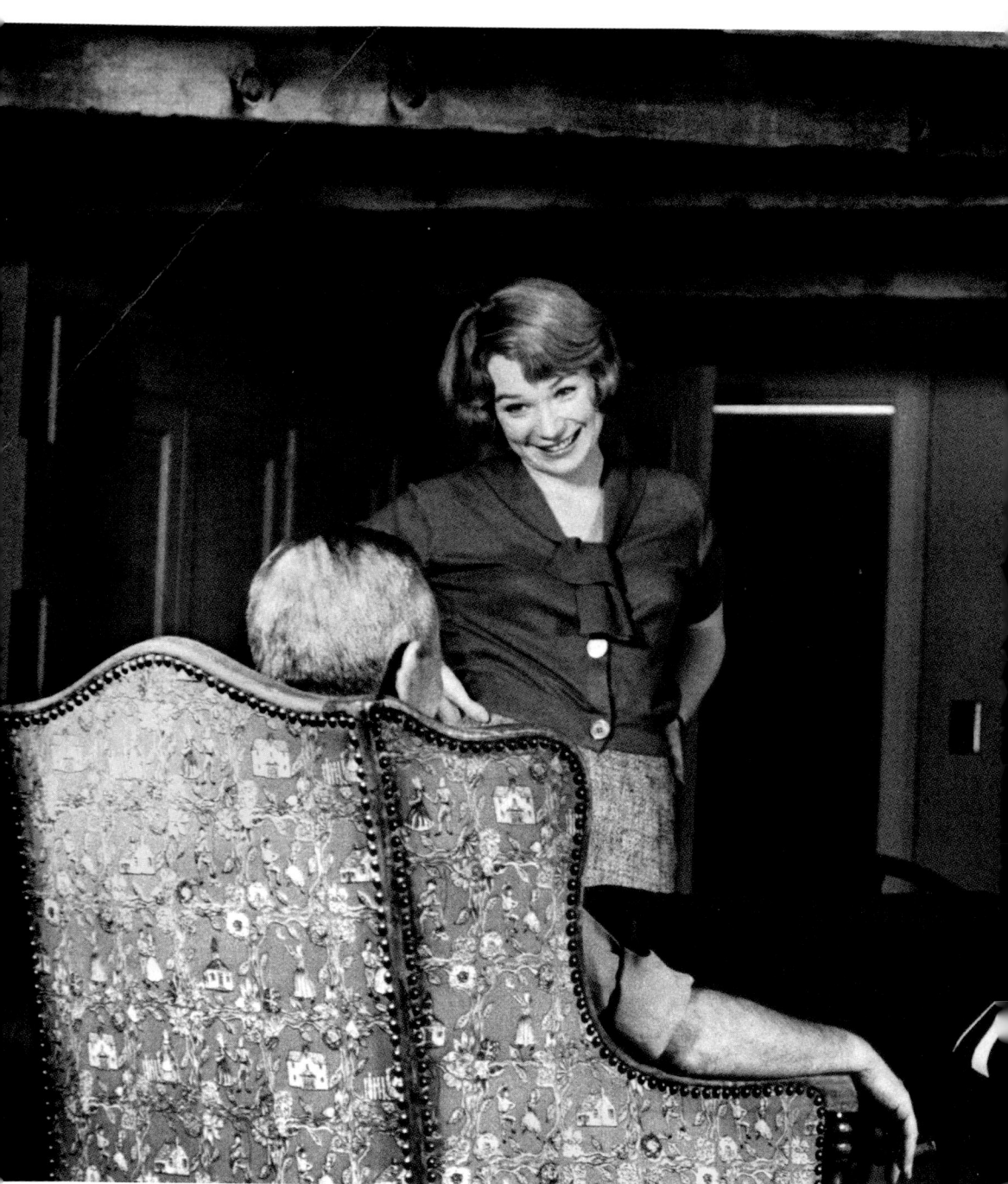

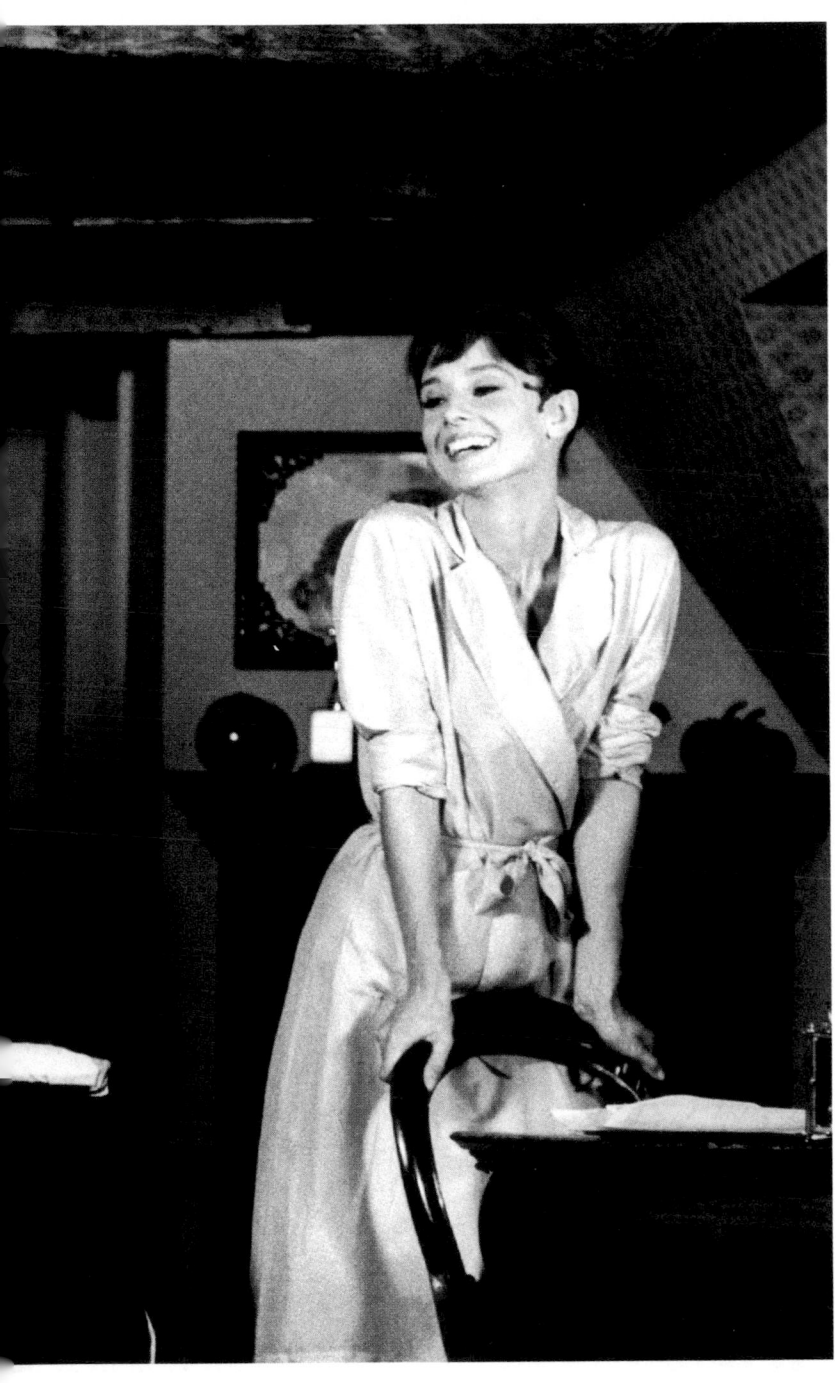

Wyler and his actresses enjoy a rare light moment. Says Willoughby: "Shooting on this film was downbeat and depressing, made even more grim by Wyler's directorial style. He would take all week to cover the angles of just one scene. The days wound on, with the same lines being repeated over and over. Keeping the dialogue fresh when it is repeated so often is difficult for any actor, and everybody seems to have his own way of dealing with the problem. I felt Audrey kept pushing herself deeper into the character, even in the rehearsals, looking for something to play on. Other times, she would just disappear, and when I went looking, I would find her hidden away in an unlit part of the set. She needed to get away from all the distractions and prepare herself to face the scene again." Whether or not working with Wyler was any fun for Audrey, it produced results: The Children's Hour was nominated for five Academy Awards. When asked what the director had taught her about her craft, Audrey answered most generously, "Everything."

You're about to see some terrific hats! After wrapping The Children's Hour, *Audrey, with Ferrer, packed up and flew to Gay Paree for a complete change of pace.* 'Paris When It Sizzles' *was Audrey's next film, and the Ferrers rented a lovely villa just outside Paris where they could live before and during the filming," Willoughby recalls. "It was really more like a château and had its own lake with resident swans. It gave Audrey a chance to rest up after* The Children's Hour, *and by the time she started rehearsals in the Boulogne Studios, she was looking terrific. From the first days on the set, the atmosphere was charged with good humor—what a change from the Goldwyn set for Audrey! For me, it was wonderful to have the opportunity to photograph vital people working together and having the time of their lives." Which is all very delightful, of course, but serves to prove that good cheer doesn't always translate into great art. Though* The Children's Hour *is seen today as a strong and pioneering film, the romantic comedy* Paris When It Sizzles *is regarded as a middling piece of fluff and hardly one of the high points of Audrey's career. Still, it afforded Willoughby a chance to photograph some sensational hats and great gowns adorning the world's loveliest leading lady.*

OPPOSITE

Audrey perches prettily on the camera boom, with director Richard Quine right behind her. "The rehearsals were great to photograph, as everyone was having a great deal of fun with the scenes," says Willoughby. "I think Audrey acted as a catalyst for this, for both Bill [Holden] and Dick seemed to have a little competition going for Audrey's attention. There can't be any doubt that she was having fun on this film. She was so effervescent and full of joy, so delicious, that I knew there were a few crew members on this film who would have liked to just scoop her up and take her home with them." Not that any did, of course.

RIGHT

She huddles during a chilly evening's work outside (with Quine in the background). One could argue that Audrey Hepburn never took a bad photograph, or even a mediocre one. Willoughby attests, "For a photographer, it was hard not to keep photographing her. Wrapped in a blanket to keep warm, she looked just amazing." Audrey's costar on Sizzles *was William Holden, who had also paired with her in the earlier, more successful romance,* Sabrina, *and who would remain a lifelong friend. "There was a great deal of chemistry flowing on the set," says Willoughby. "I was told that Bill and Audrey had a bit of a flutter when they were making* Sabrina. *Whether or not this is true, there was no question that Bill was in love with Audrey." The joie de vivre that permeated this production attracted not only happy onlookers but also other celebrities to the various shoots around town. On the following spread, the French movie star Capucine drops by and shares a laugh with Audrey and Holden (in the cowboy hat). "Not that they are in any way competitors for Bill," Willoughby says of this shot, "but this is an interesting group as Capucine was once a gleam in Bill's eye as well."*

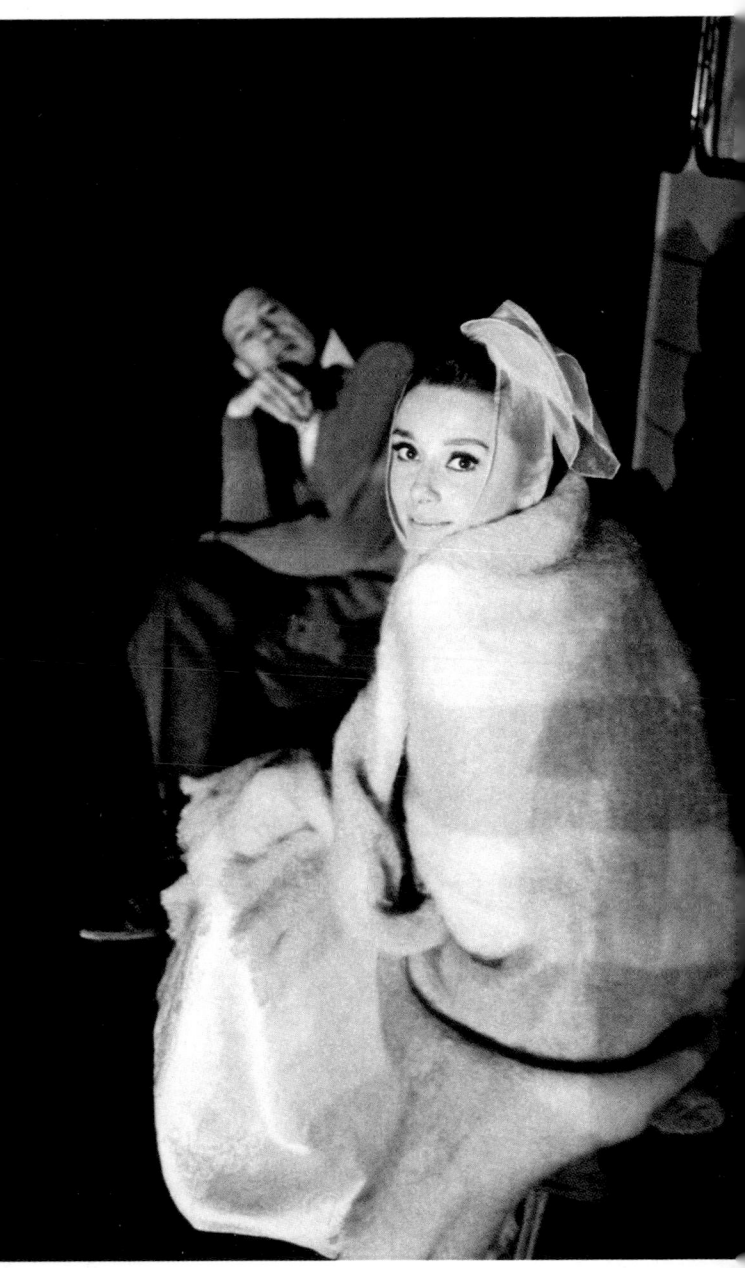

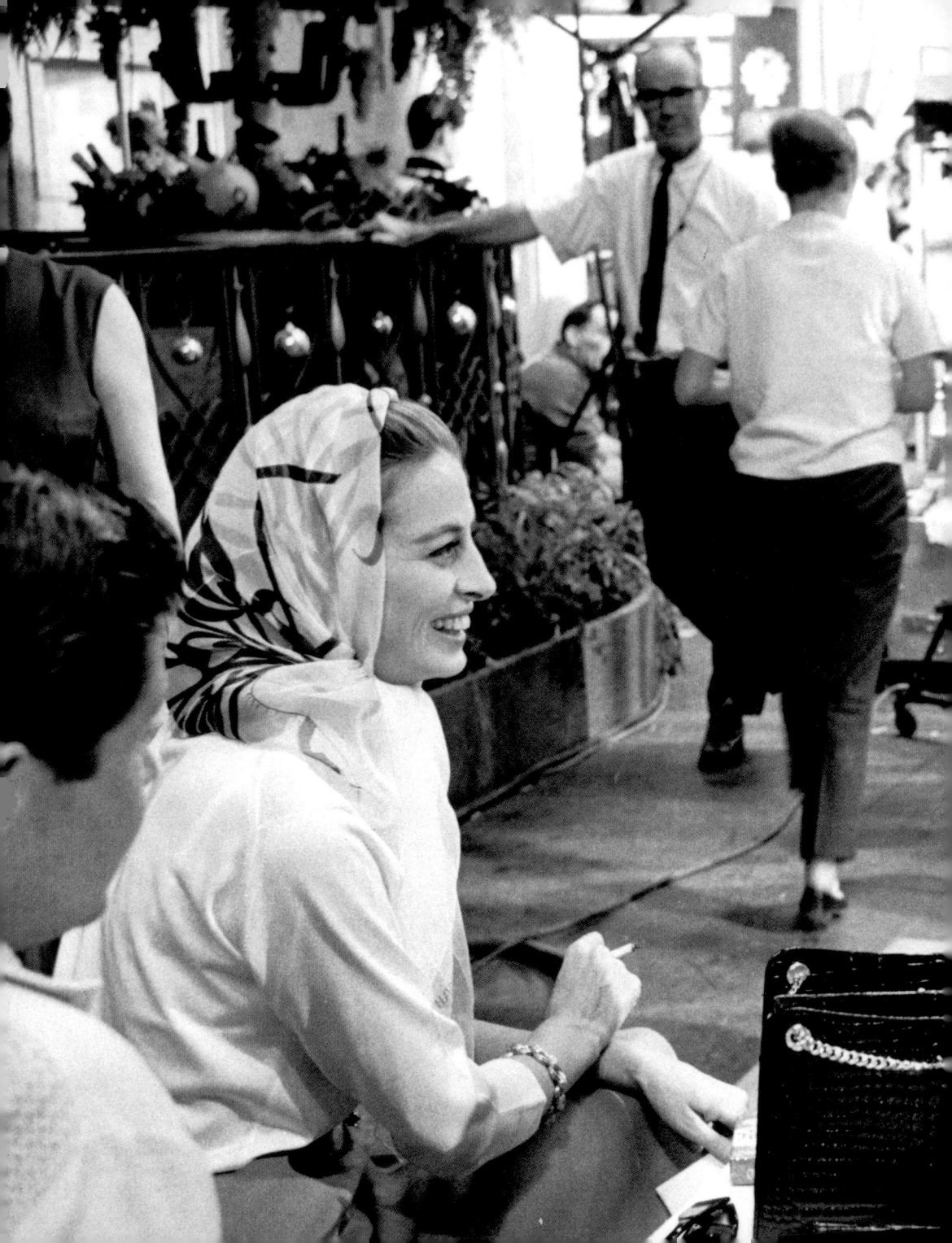

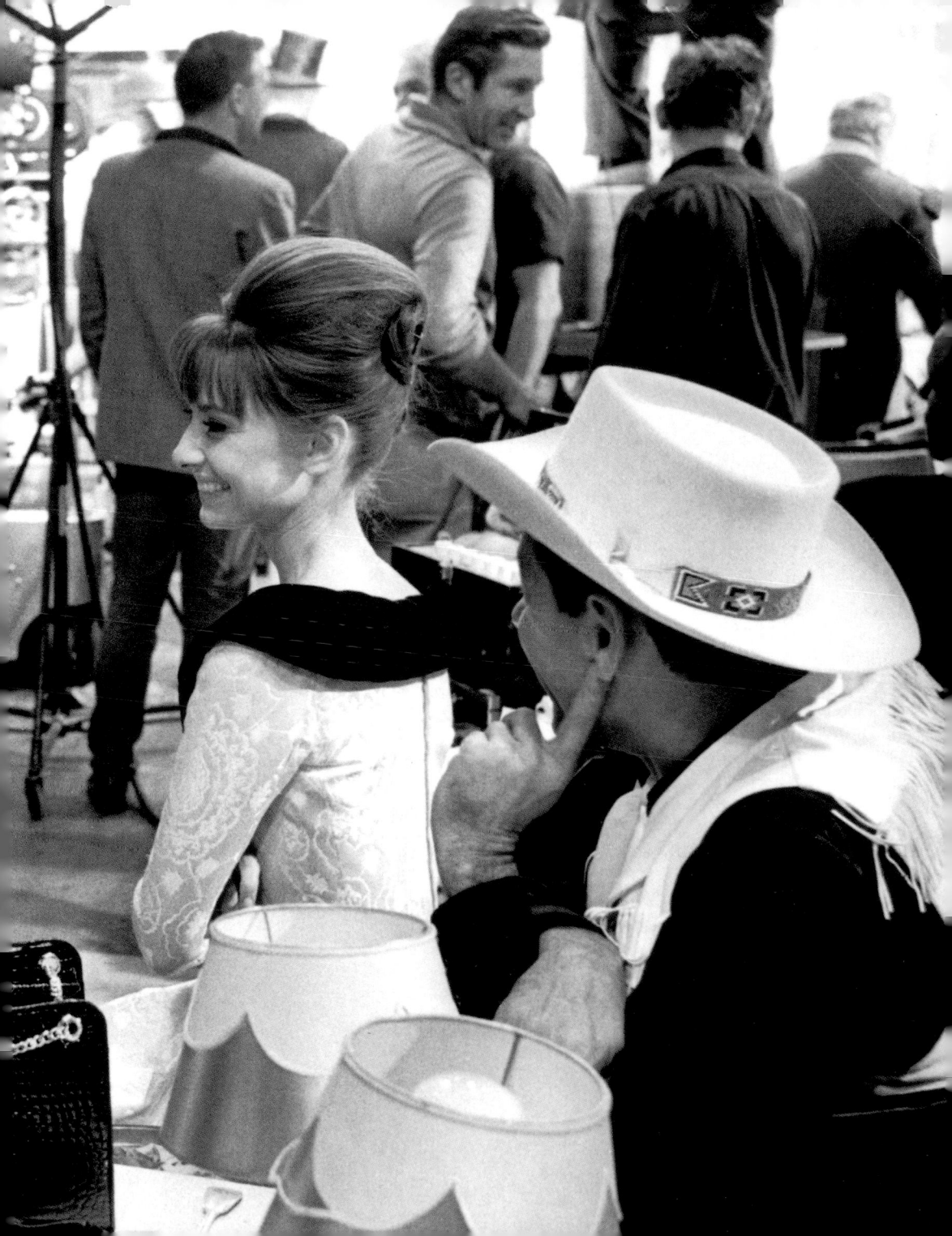

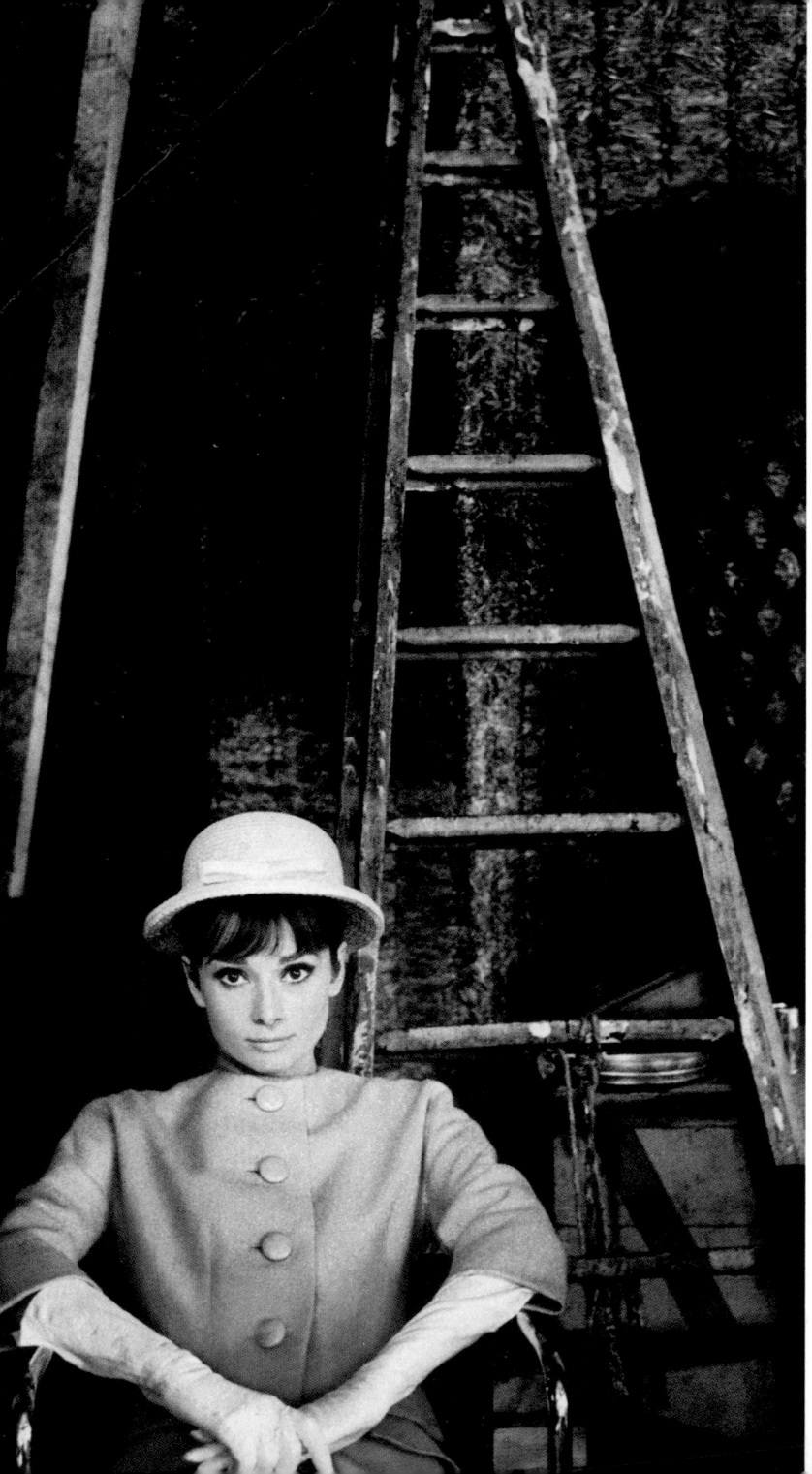

"She could sit next to an old ladder on the set and look terrific," says Willoughby. Indeed, she could, and it certainly didn't hurt that on Paris When It Sizzles, and on many another Audrey Hepburn film, the clothes (including those hats!) were designed by Hubert de Givenchy, the storied French couturier with whom Audrey enjoyed a collaboration leading to an ultimate, absolutely quintessential display of feminine beauty—the world's most smashing woman wearing the world's most smashing fashions. Audrey so loved Givenchy's designs that she often asked upon signing to star in a film that he be brought aboard—and he was, sometimes to design only her costumes. Speaking of costumes: Get a load of the one on the following spread, also from Paris When It Sizzles. We leave it to you to decide whether this was one of Givenchy's finer efforts. (By the way, the man behind Audrey on the left is the famous British playwright Noel Coward, who played Alexander Meyerheim in the film. Holden is in the cowboy hat.)

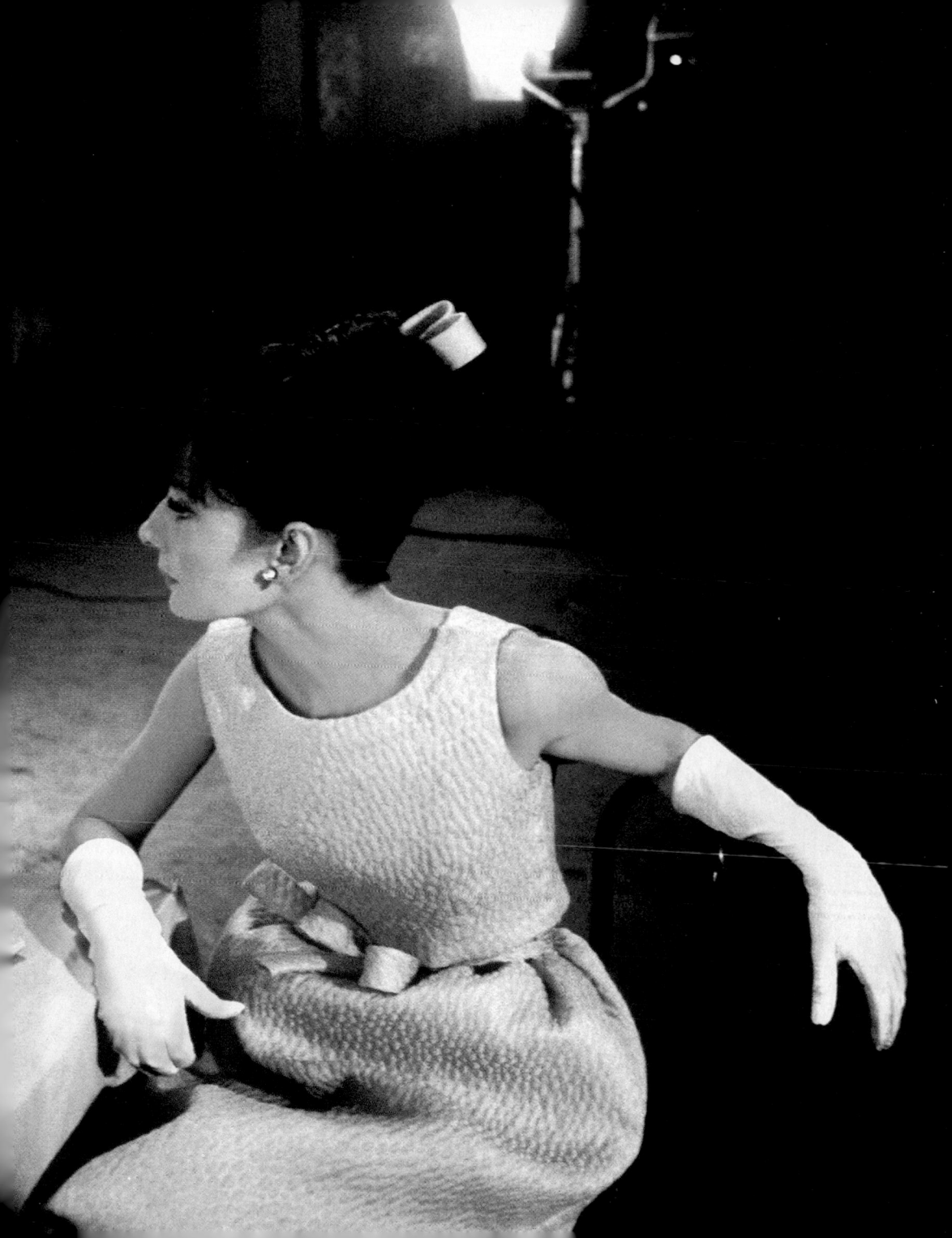

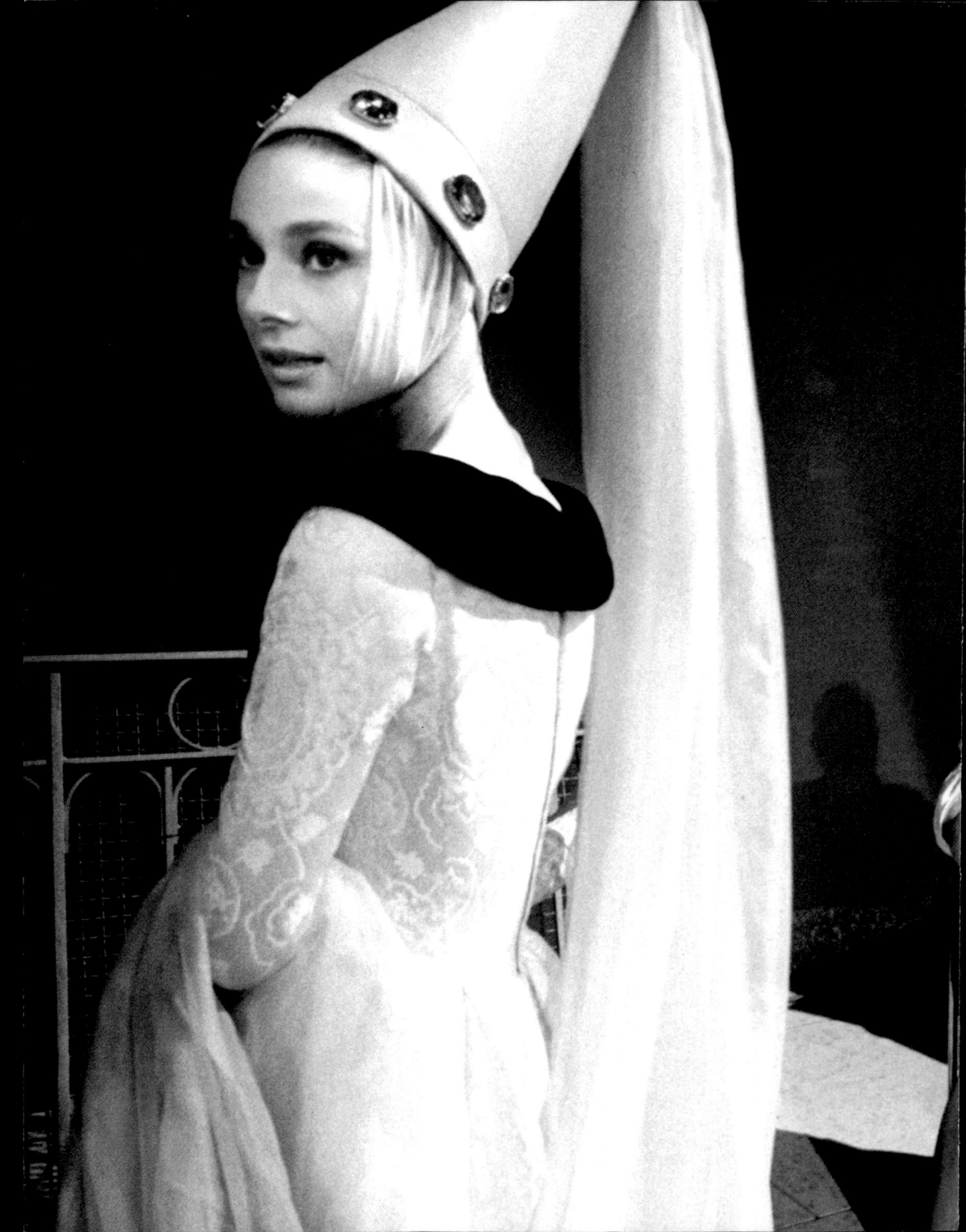

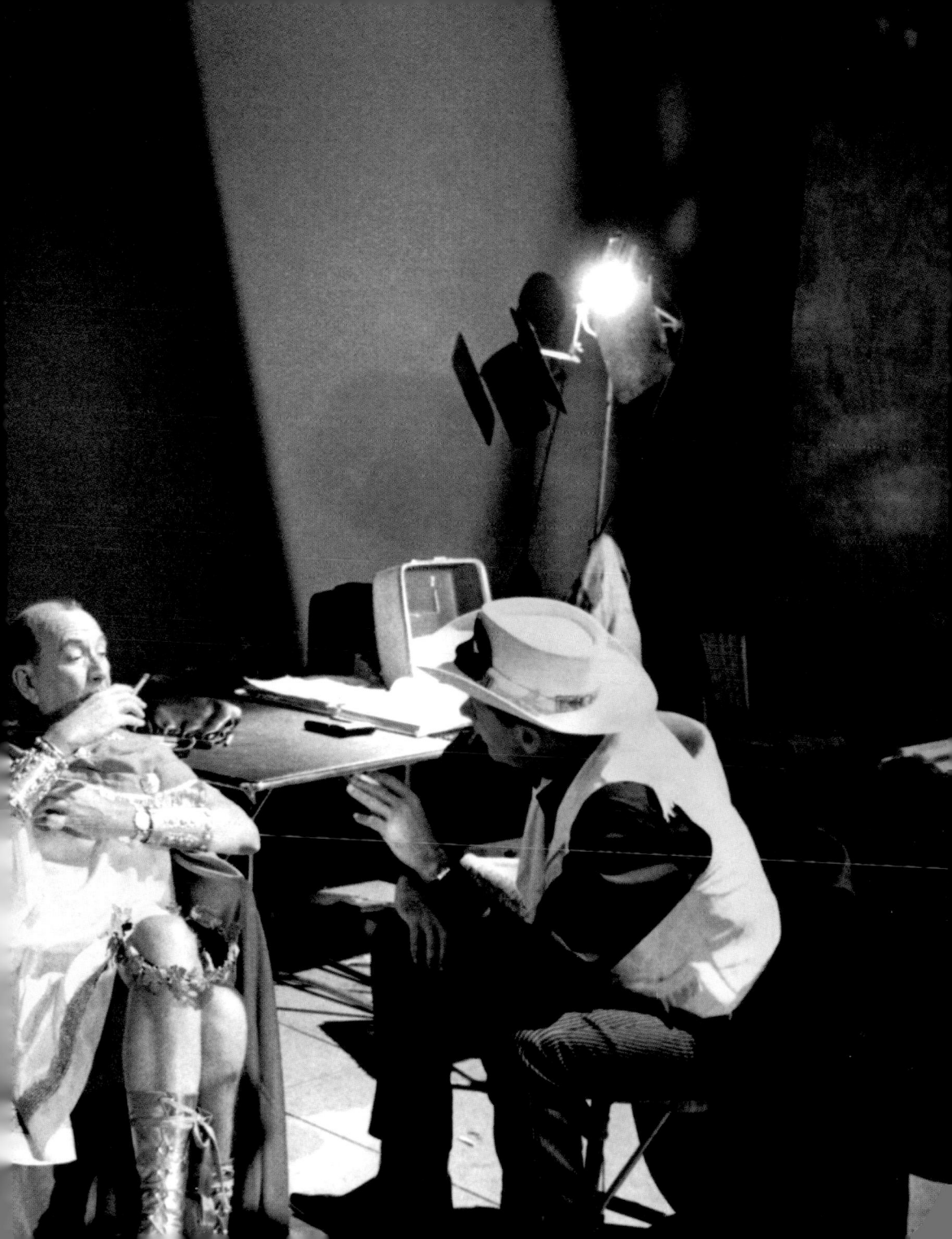

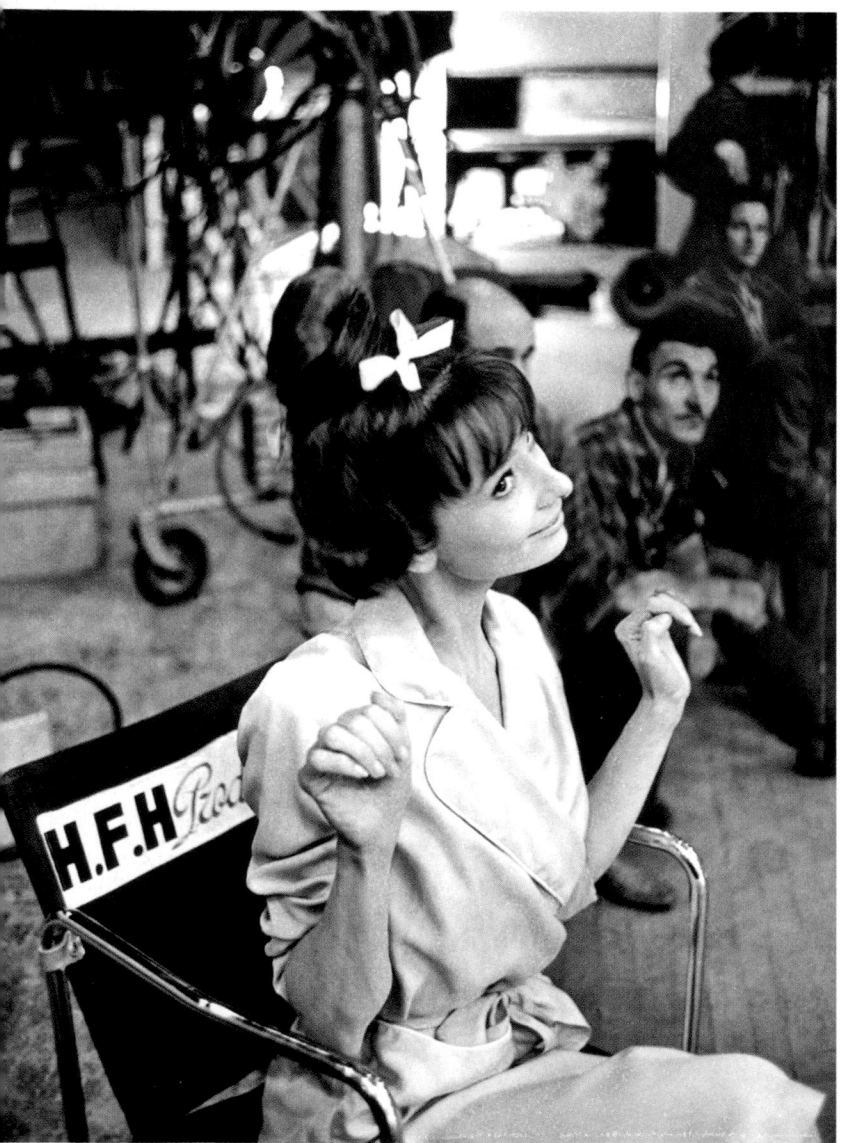

On the opposite page, Audrey is wearing Givenchy's landmark version of the little black dress, while her beloved Yorkie Mr. Famous assumes the position of the famous in Audrey's folding chair. At left, Audrey imitates Famous's often-deployed begging technique. The lucky dog was present on lots of movie shoots; many have said that Audrey loved animals nearly as much as she did children. And, of course, men: On the following spread, she and Bill Holden enact a swoon, rather convincingly, as director Richard Quine looks on, rather intently—perhaps forlornly? On the spread after that, we leave Paris for London—or at least a movie-set facsimile of it—and arrive at My Fair Lady. The musical was released in the same year as Sizzles (1964) and dwarfed it in the historic annals of film. Julie Andrews had portrayed Eliza Doolittle in the stage version of the Lerner and Loewe classic but lost the screen part to Audrey. An early promise that producer Jack Warner made to Audrey—that she could sing her own songs (as she's doing here)—was broken when Marni Nixon was contracted to perform Eliza's vocals. This slight, which was not revealed to Audrey until the end of the production, dogged the star during Oscar season. The statuette that year went to . . . Julie Andrews for her role as Mary Poppins. Touché!

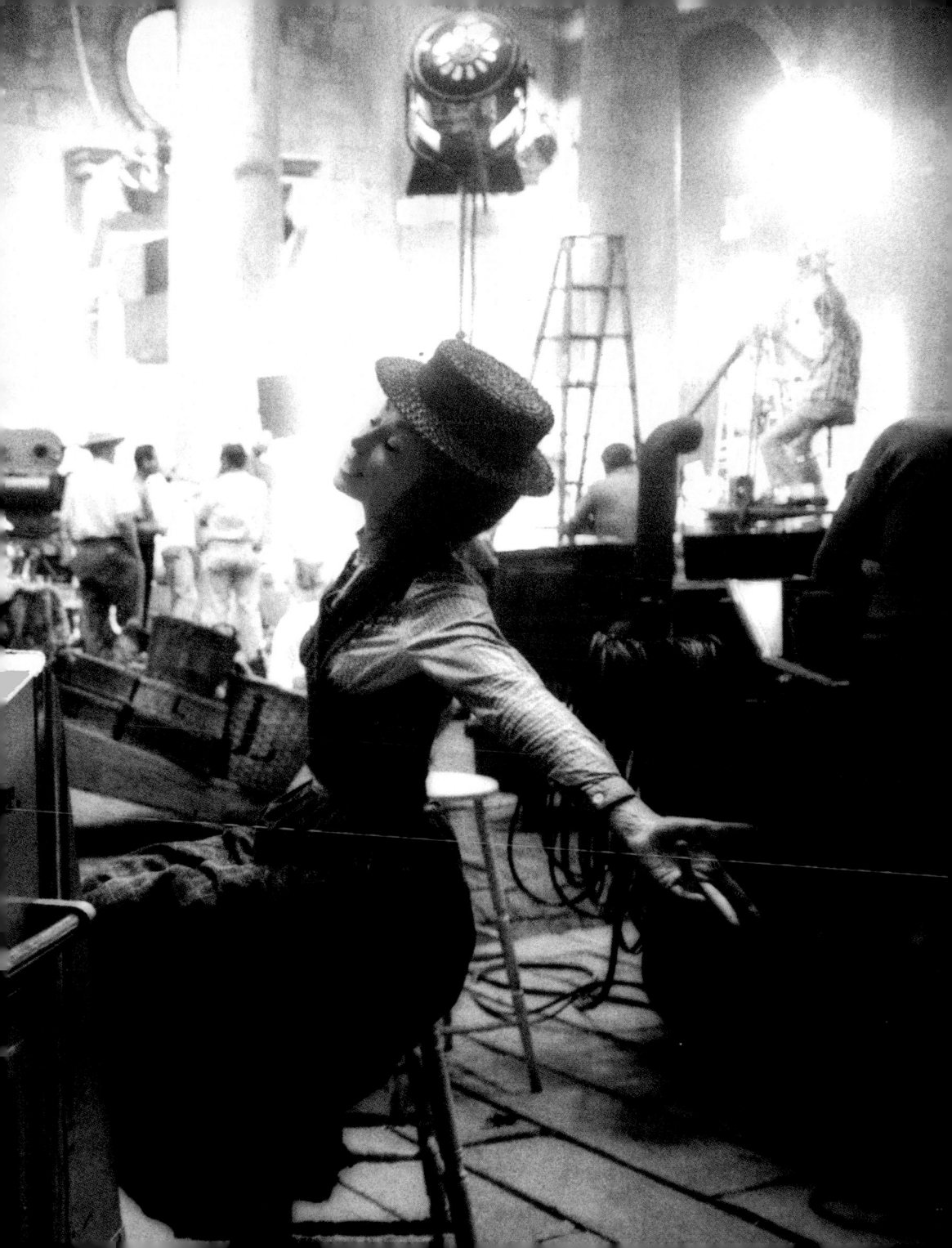

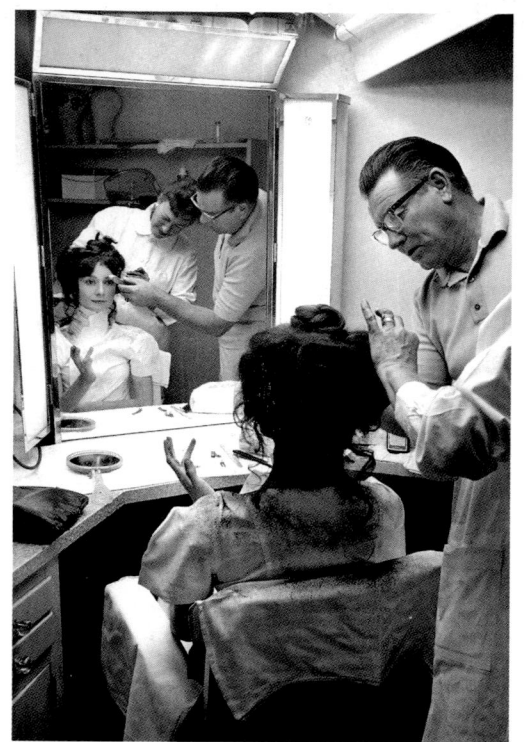

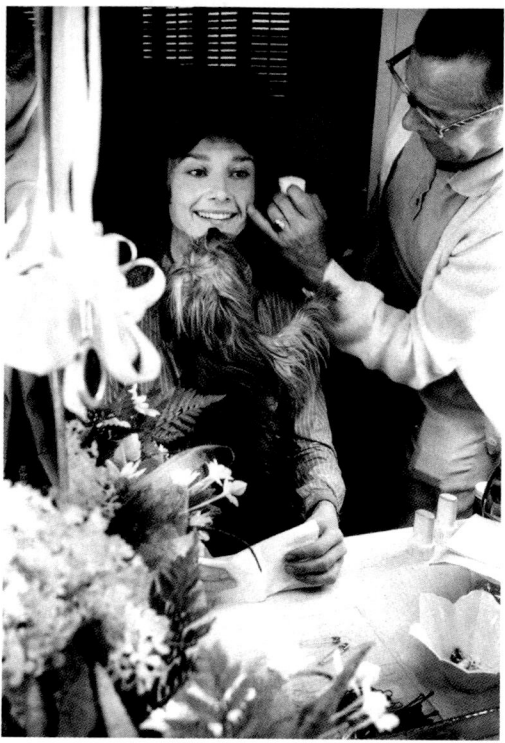

Bob Willoughby remembers: "Because the film was to show Eliza transformed, it was to be shot in sequence. They had to start with the scruffy and dirty Eliza. Audrey's call for makeup was seven o'clock in the morning to be ready for nine on set. This meant getting up at 5:30 to be in the Warner Bros. makeup department just before seven. I was surprised to see so many people ready for the day. Frank McCoy and Dean Cole, Audrey's makeup man and hairdresser, got straight to work as soon as she swept in with her new Yorkie, Assam, under her arm. To make Eliza appropriately grotty, they would curl her hair tightly to make it look frizzy, coat it with Vaseline to keep it matted all day, then rub in the makeup people's dirt. After filming was completed for the day, all of this had to be undone. So, up at 5:30 and home after shooting between 7:30 and eight in the evening, with luck. Not quite as glamorous a life as one might have believed film stars lead."

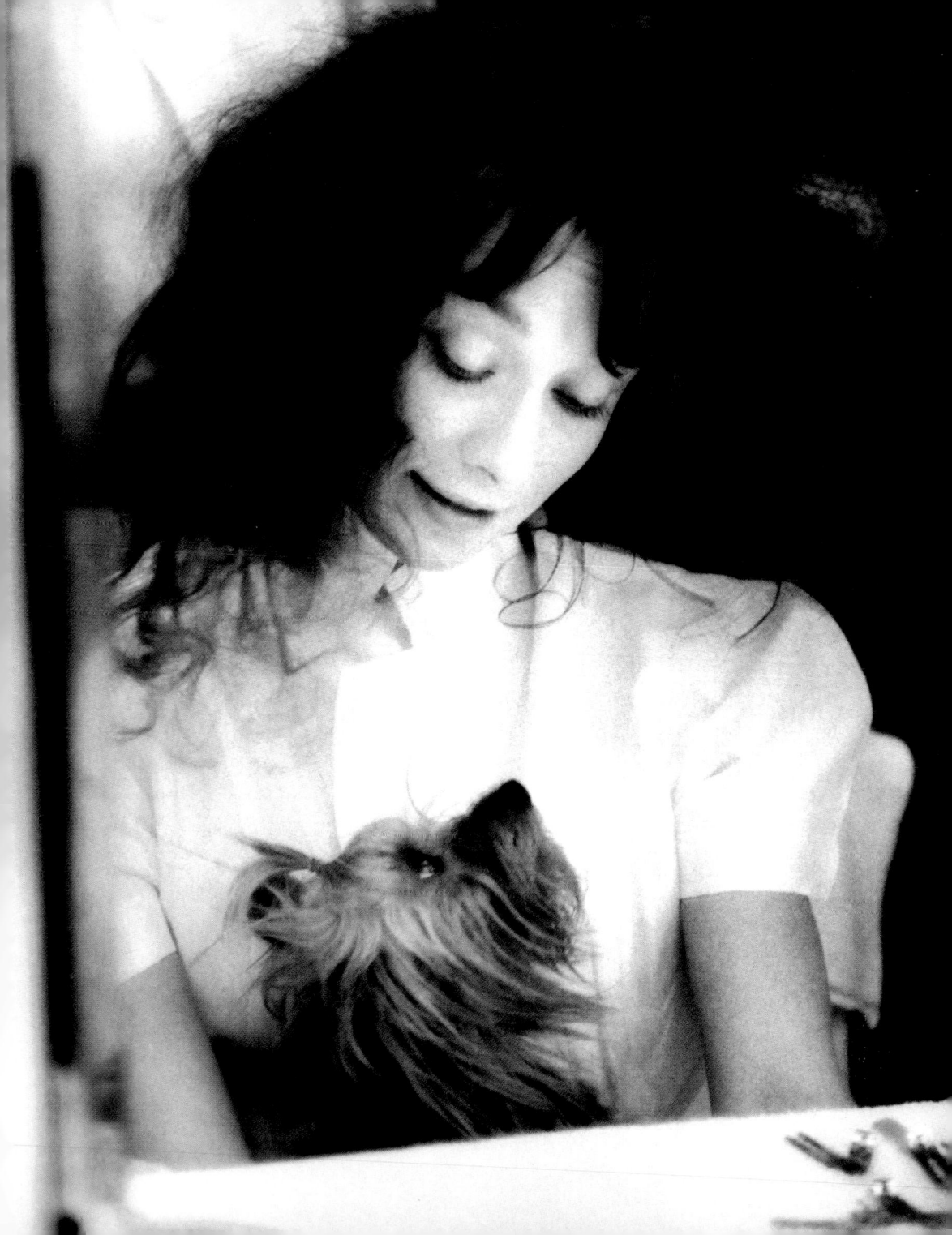

For the early scenes of poor Eliza peddling flowers in the rain, Audrey gets spritzed to make certain that she appears thoroughly sodden and bedraggled.

London's famed Covent Garden was re-created on the Warner soundstage, and now it is deluged in "rain." Says Willoughby, "The camera crew is sheltered from the special effects as they shoot the close-ups, but Audrey spent the best part of the day soaked to the skin."

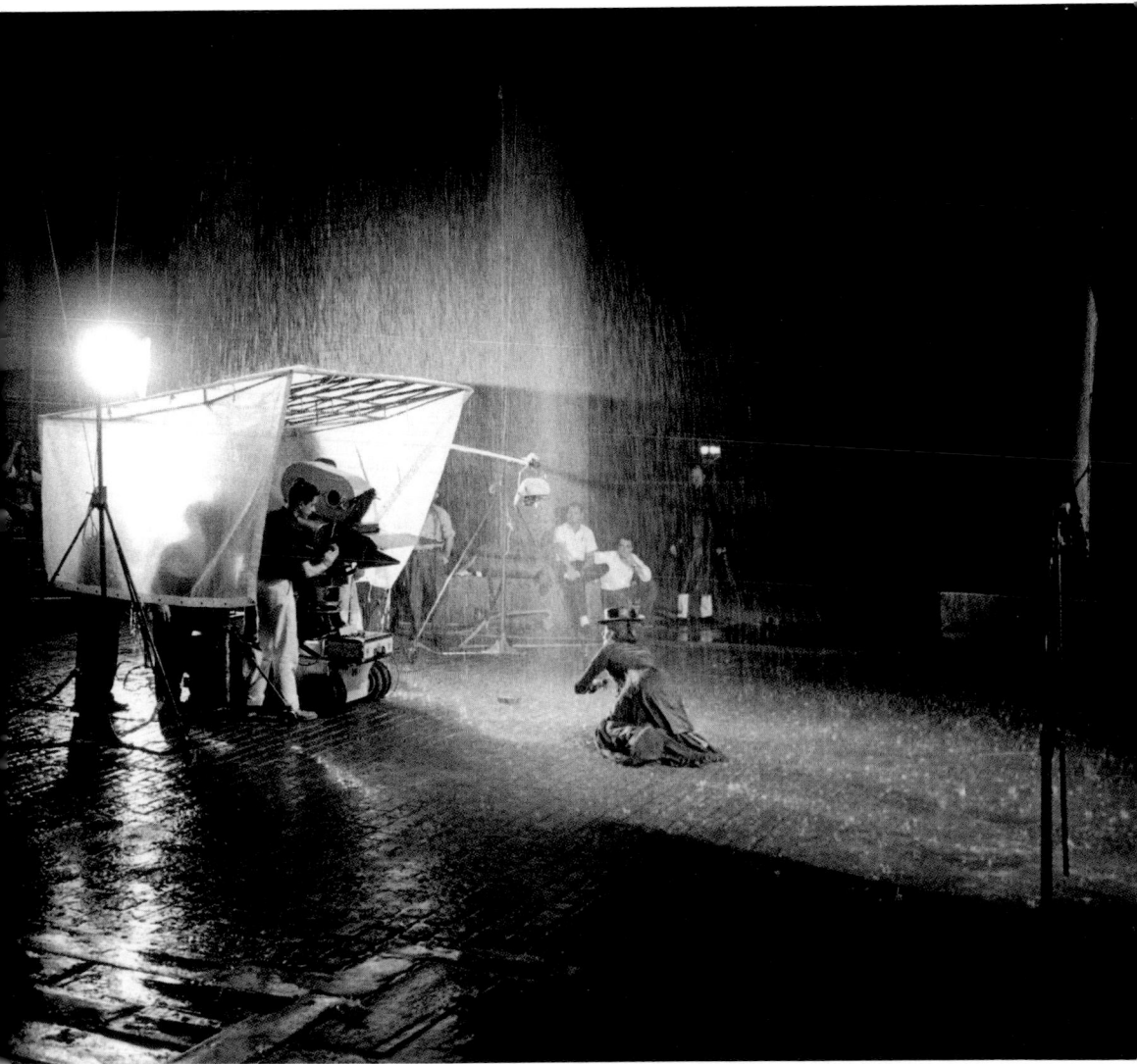

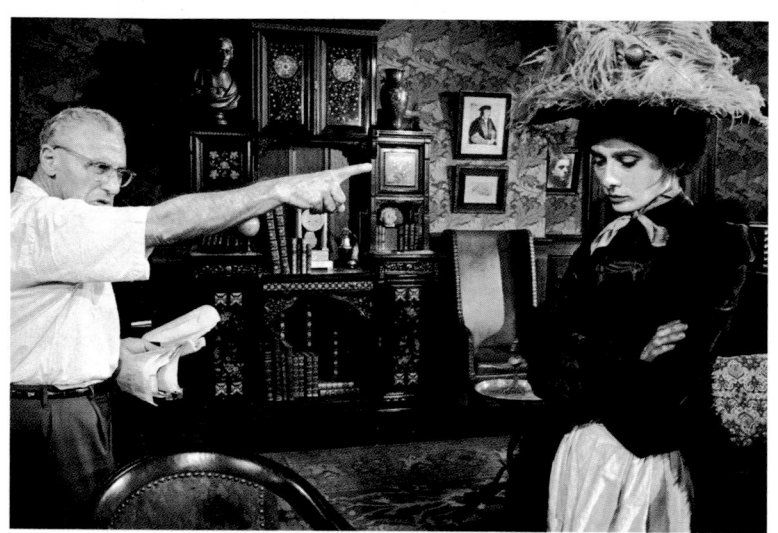

Director George Cukor had a reputation for eliciting strong performances from his actresses, and here, he works closely with Audrey and the actor Jeremy Brett (opposite). Cukor also had a reputation for intensity and focus on the set, and My Fair Lady was a closed production—no visitors, no press, no nonsense. Willoughby is succinct in his appraisal of Cukor: "He was unrelenting."

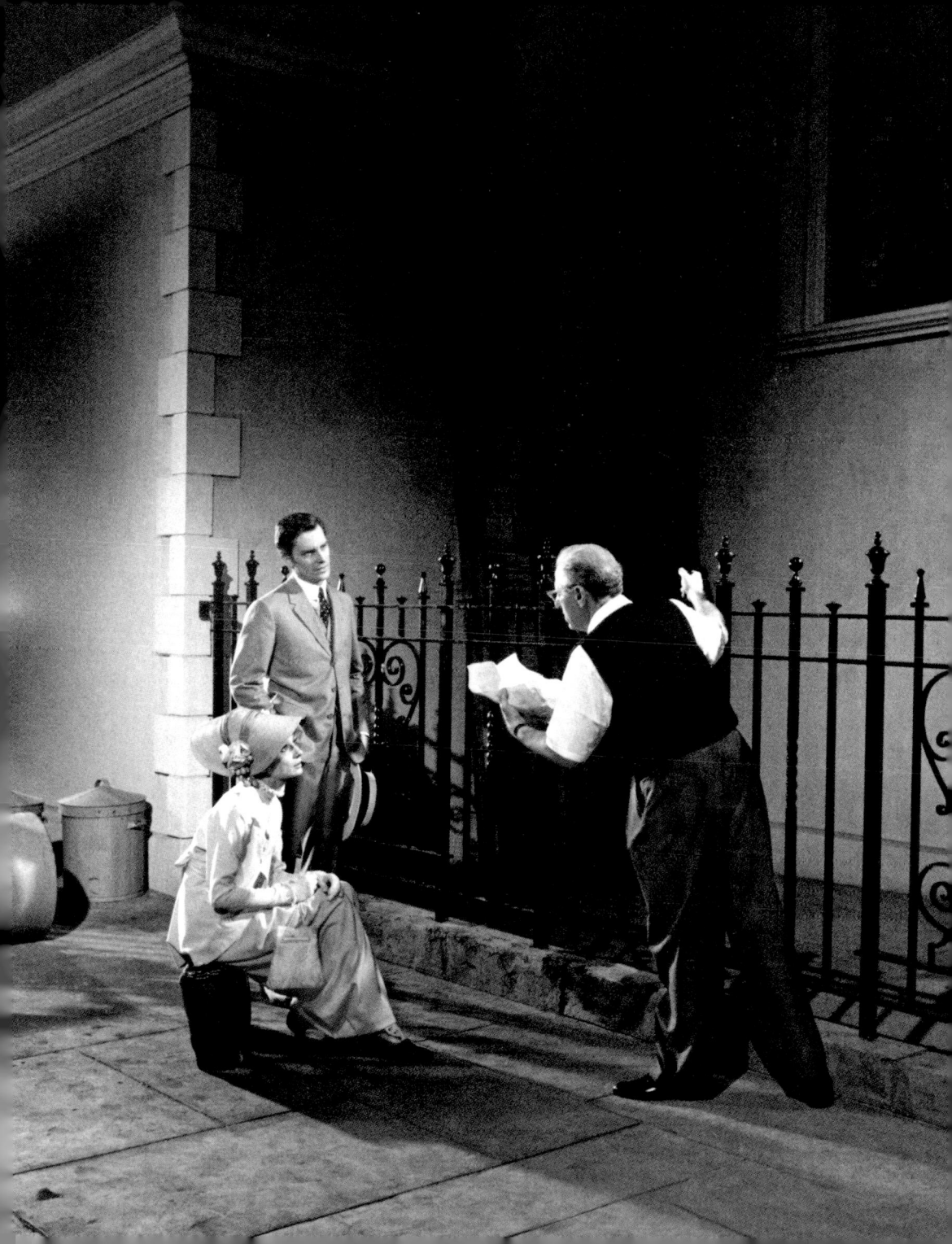

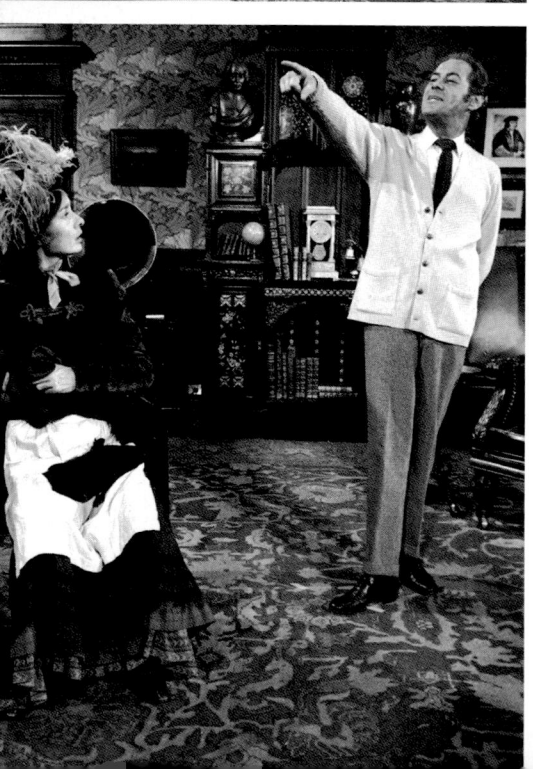

The controlling Professor Henry Higgins was played by the esteemed British stage and screen actor Rex Harrison in a definitive performance. Like Julie Andrews, Harrison had been a smash in the stage production, but Jack Warner didn't want to cast him in the film, either, and at first approached Cary Grant. "Not only will I not play Higgins," Grant reportedly said, "but if you don't use Rex Harrison, I won't even go to the film." Peter O'Toole demanded too much money, and finally Warner acceded to Cukor's appeal that Harrison be signed—for the relatively paltry fee of $200,000 (Audrey was paid five times as much). When the film opened, critics fell over themselves praising Harrison's performance and his unique speak-singing style, which is called recitative. Harrison went on to win the best actor Oscar. Although Audrey was denied even a best actress nomination, Harrison would forever laud her as his most favorite leading lady. When Harrison was knighted by Queen Elizabeth II at Buckingham Palace in 1989, the band played a medley of hits from My Fair Lady. In the photograph on the following spread, Colonel Hugh Pickering, played by Wilfrid Hyde-White, shares a laugh with Higgins while a despondent Eliza looks on.

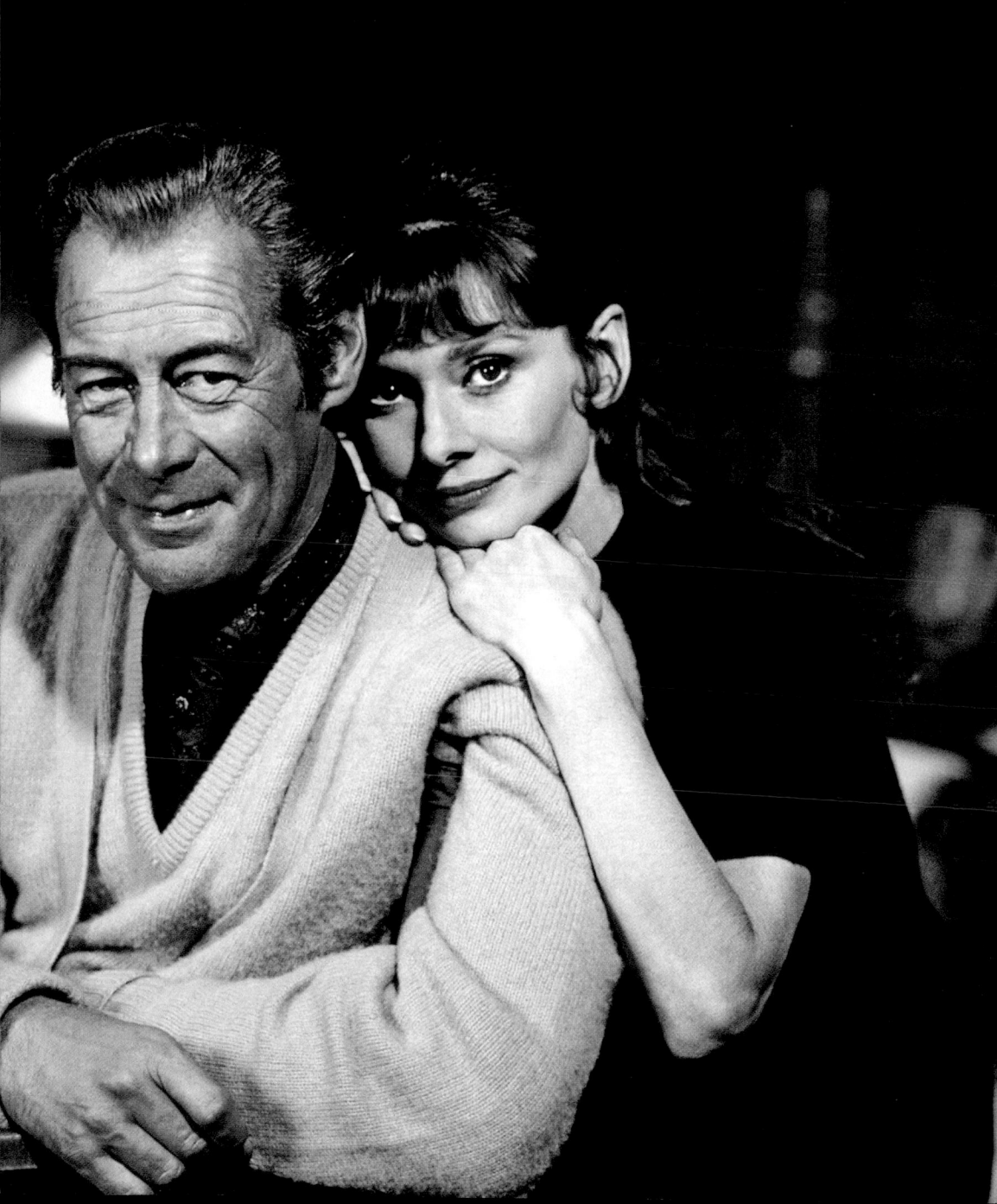

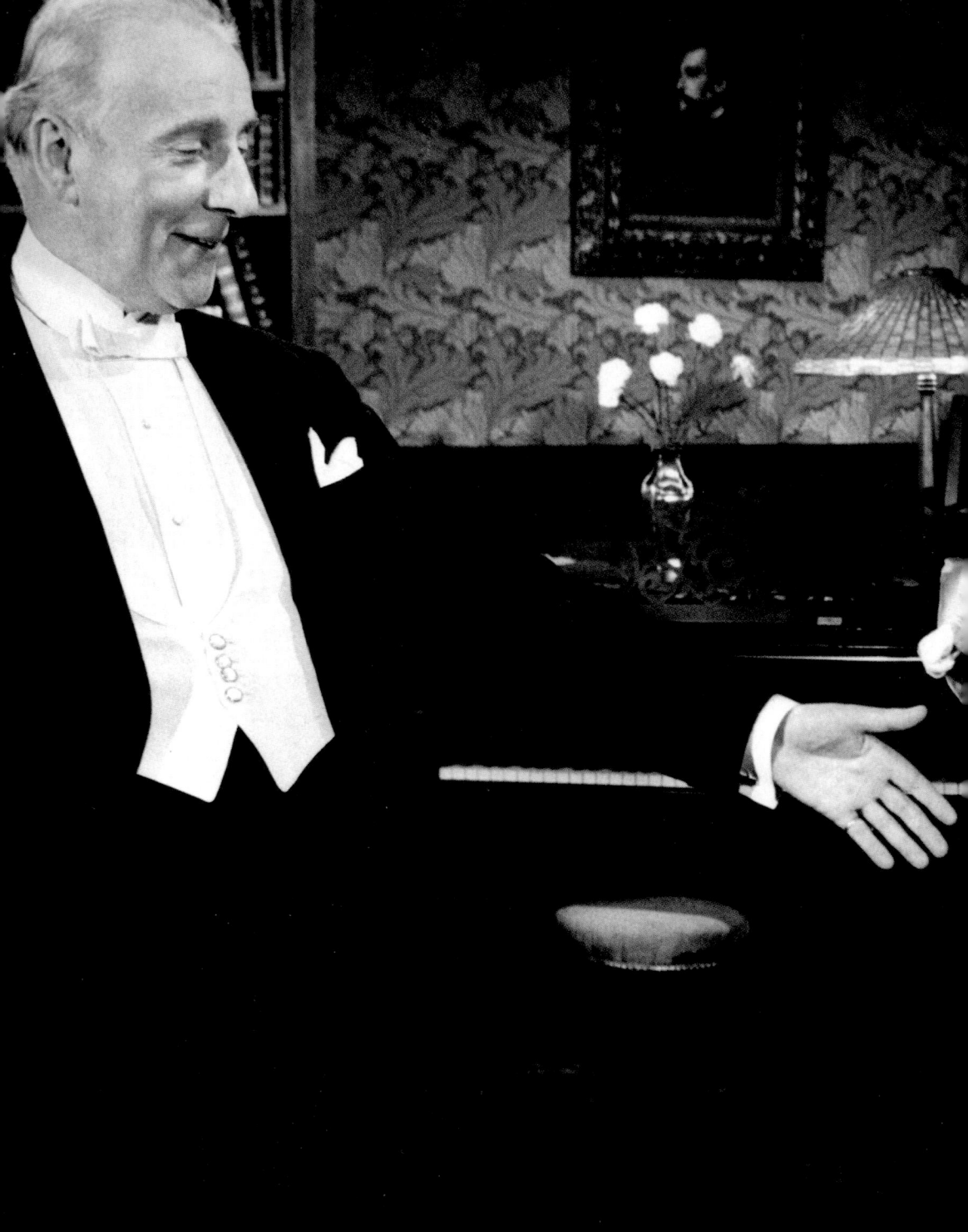

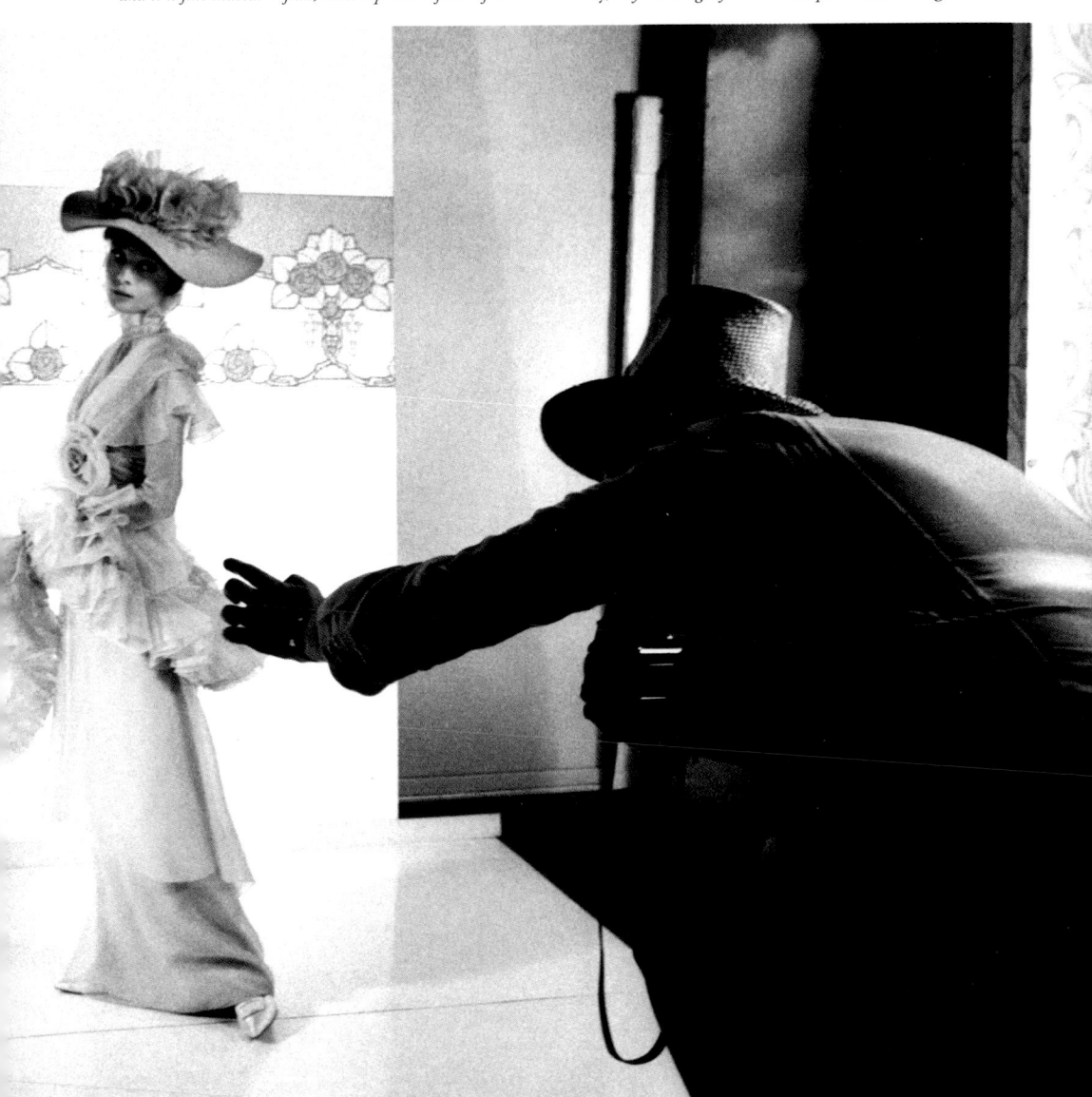

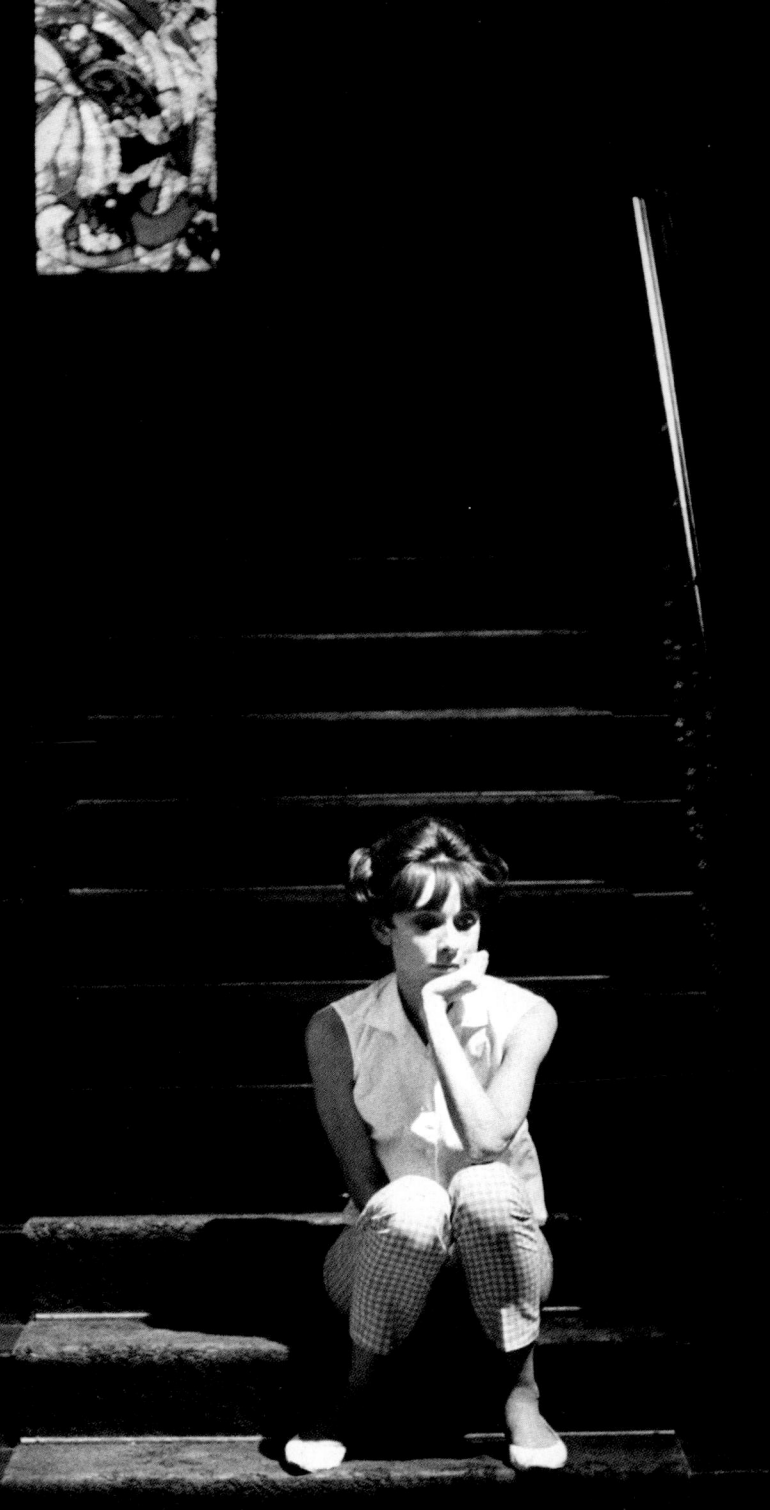

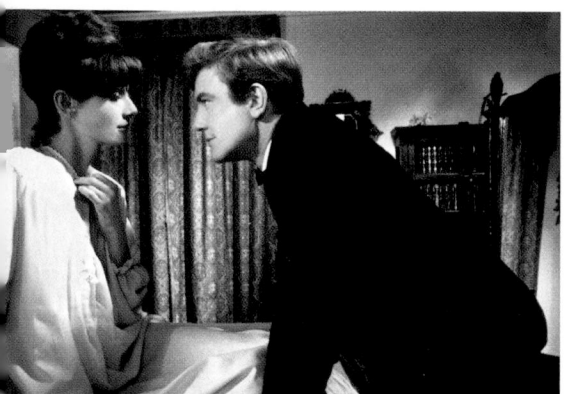

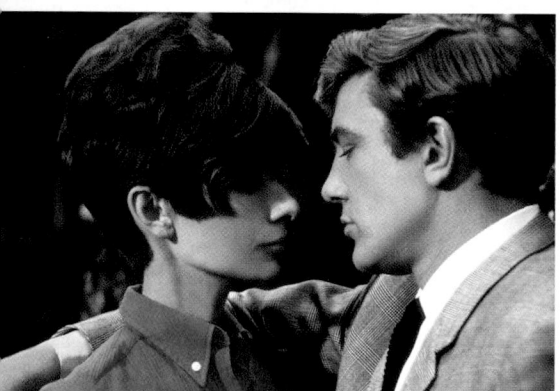

The 1967 romantic comedy *Two for the Road* starred Audrey and English actor Albert Finney, seen above as their respective characters, Jo and Mark Wallace, and at right receiving direction from Stanley Donen. It was Donen's third collaboration with Audrey, after *Funny Face* and *Charade*, and he drew from her a smart, nuanced performance— a performance the director thought was her very best. The film was shot largely in the French countryside, and of the photograph on the following spread, Willoughby recalls, "Walking down the road during a camera rehearsal, Audrey and Albie had an animated conversation. In fact, in the few days that I spent on the film, I don't remember that they ever stopped talking."

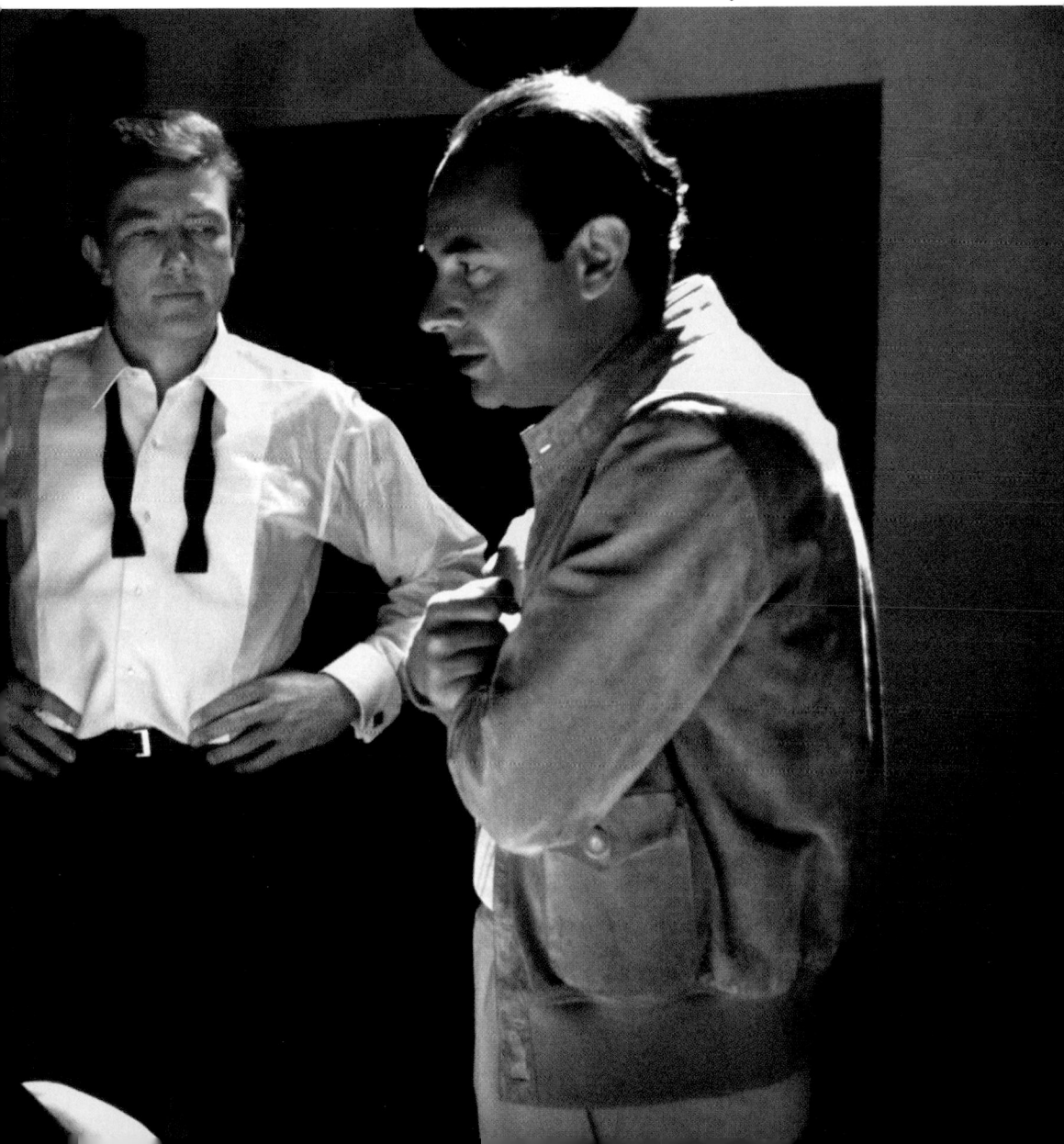

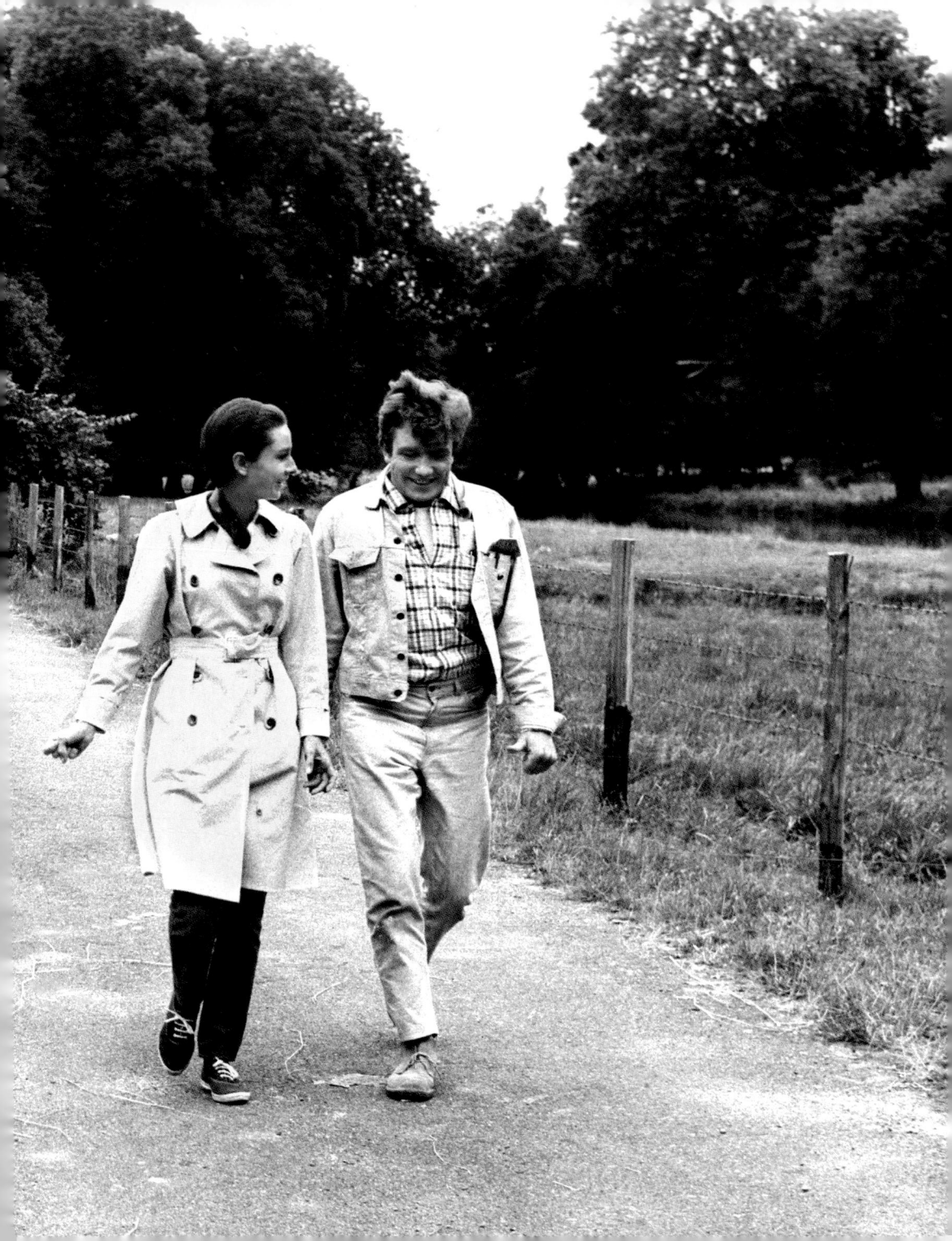

AUDREY
AT HOME

HOME FOR AN ACTOR IS OFTEN the place where one is holed up for the duration of a shoot. But home can also be a state of mind, particularly for someone such as Audrey, who had endured traumatic experiences and was uprooted often during her childhood, only to adopt the vagabond lifestyle of a stage actress as a young adult. Home is where—*wherever*—you can relax with ▶

The Ferrer family poses in Beverly Hills for its 1958 Christmas card. From left: Mel; Mr. Famous, the Yorkie; Pippin, the fawn; and Audrey.

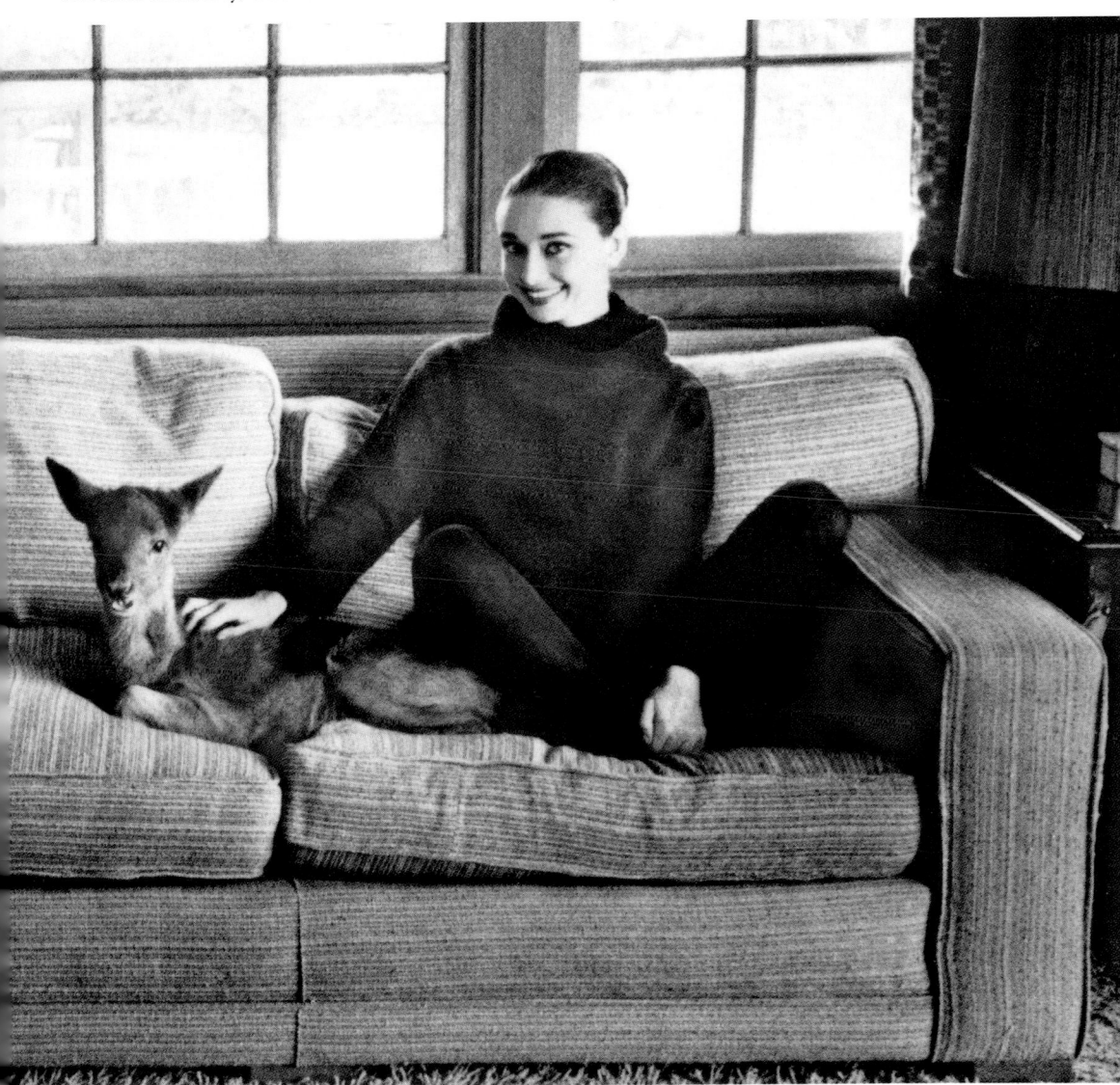

family and friends. Home is where you can be yourself.

In many of these pictures, home is a house in Beverly Hills rented by Audrey and Ferrer, her first husband. They met in London in July 1953 at a party thrown by Gregory Peck for the British opening of *Roman Holiday*. Ferrer, an actor and director, was 12 years Audrey's senior, but the attraction between them was evident from the first. He proposed in Switzerland in August 1954, and he and Audrey wed the next month.

As we've seen, they collaborated professionally—sometimes they acted in the same film, sometimes Ferrer directed

Audrey—during the course of their 13-year marriage. But the best times were at home, particularly in the early years and particularly with their only child, Sean. (They had hoped for more children, but during her time with Ferrer, Audrey suffered four miscarriages—devastating blows that, in each instance, left her profoundly depressed. She would later have another son with her second husband.)

Bob Willoughby was there for the best times and recorded not only a happy family but moments of Audrey alone at home—as safe, as centered and as content as she had ever been in her already tumultuous life.

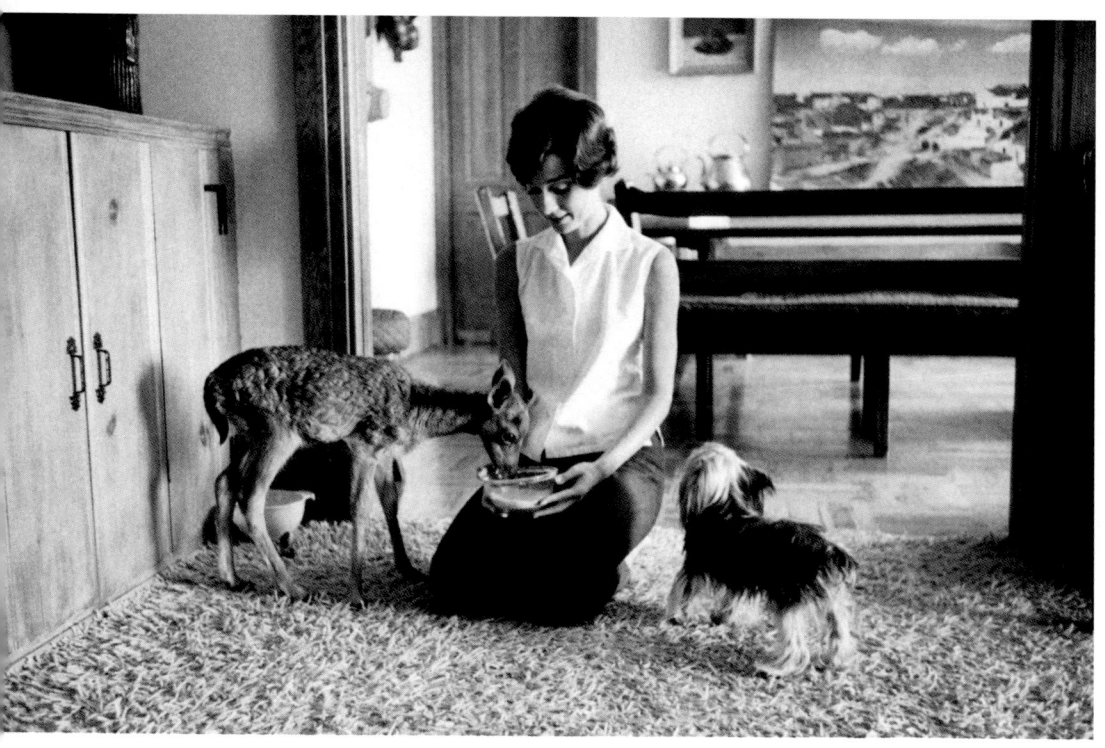

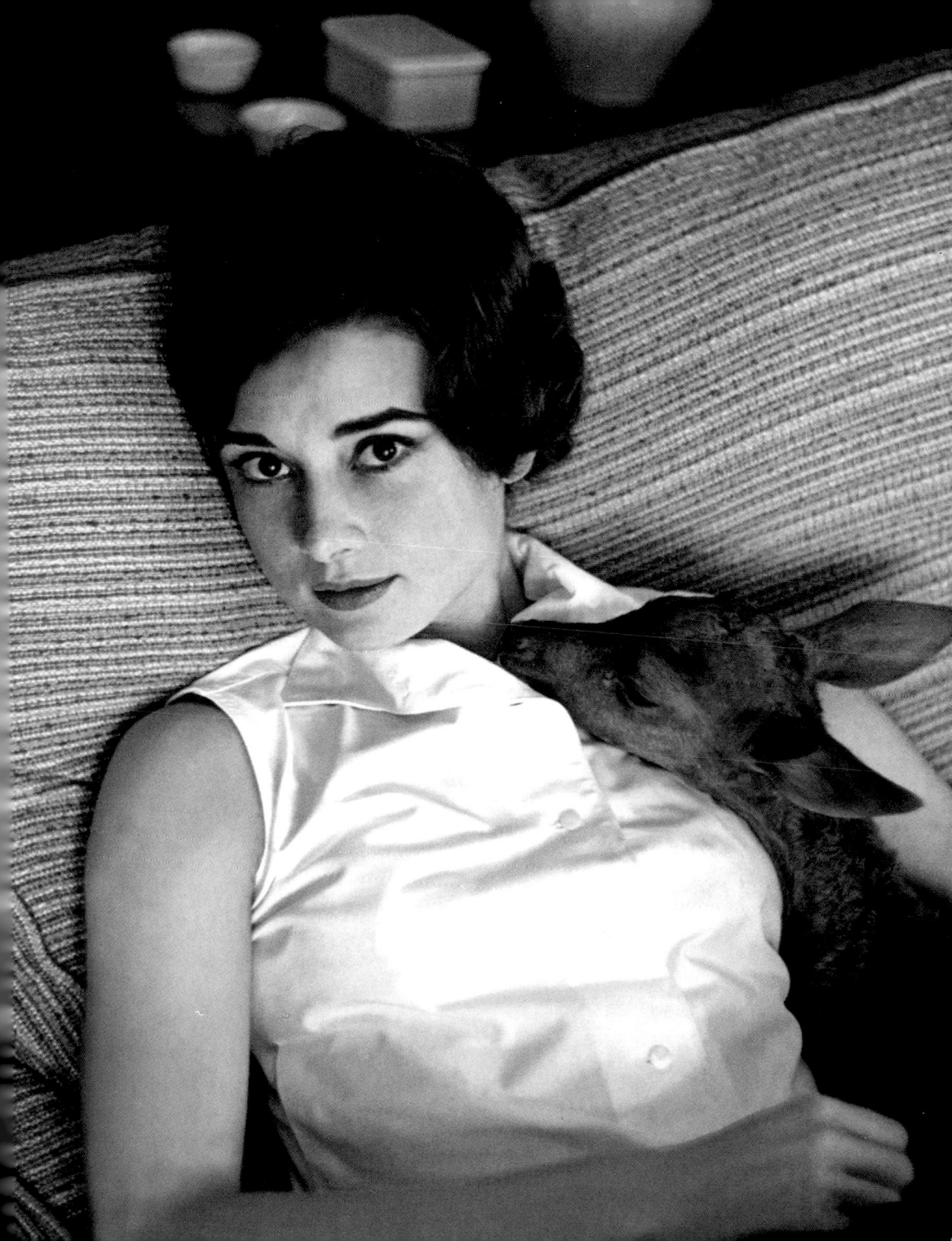

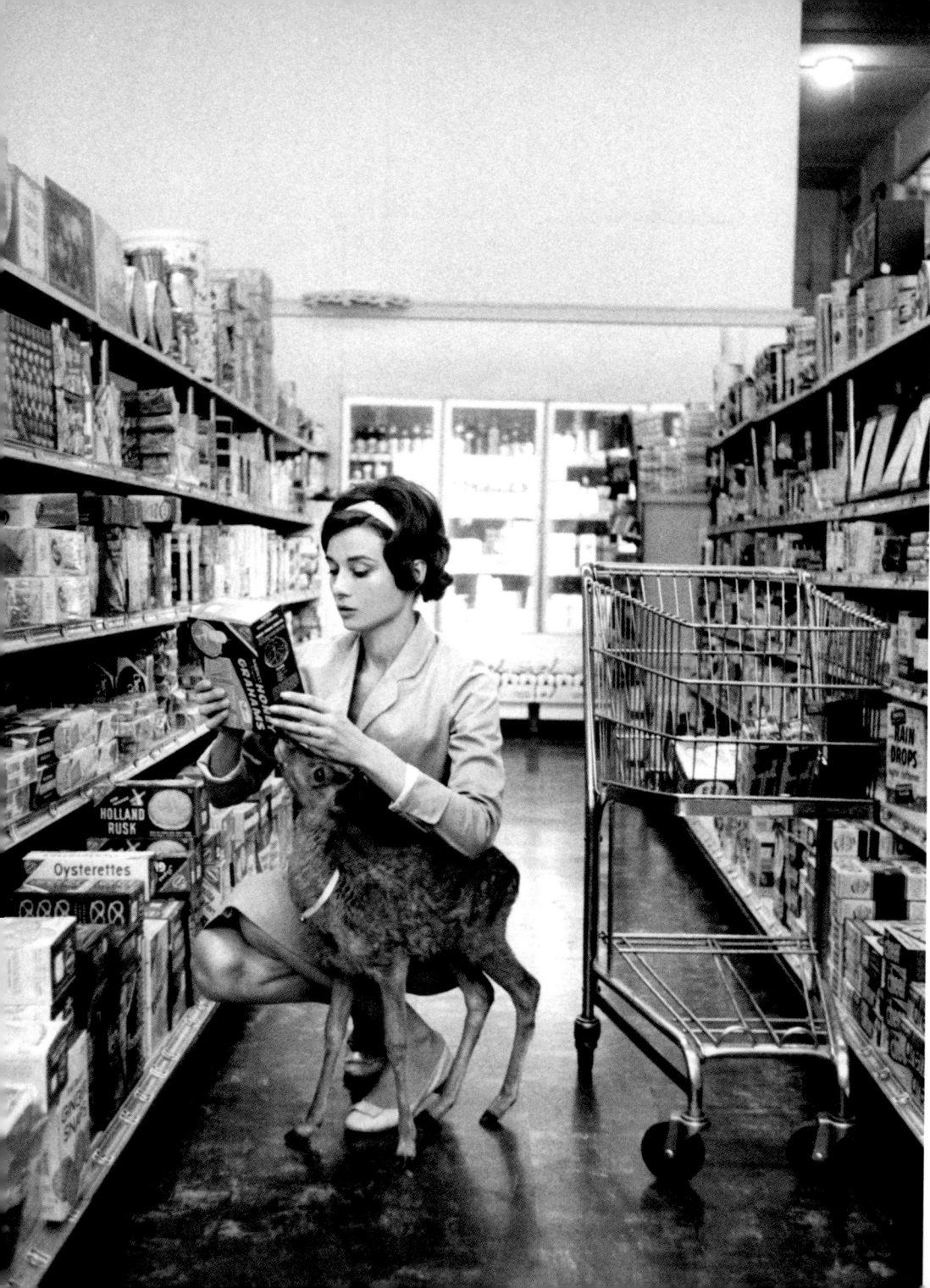

"Audrey took Ip shopping in Beverly Hills, and what a sensation she created," says Willoughby. "Beverly Hills habitués are fairly blasé about what they see, but Audrey being followed around town by this lovely creature stopped everyone in their tracks. What interested me at the time was that though everyone at Gelson's supermarket was interested, not one person crowded in and tried to pet the deer or ask Audrey about it. I can't explain why that was. It was truly amazing to see Audrey with that fawn. Ip would come right up and lie down next to her when she was having a nap and fall asleep with her. While Audrey's maid had been told about the little deer, she could not believe her eyes seeing Ip sleeping with Audrey so calmly. She was shaking her head and just kept smiling." On the following spread: Audrey takes Pippin and Mr. Famous for a jog around the house.

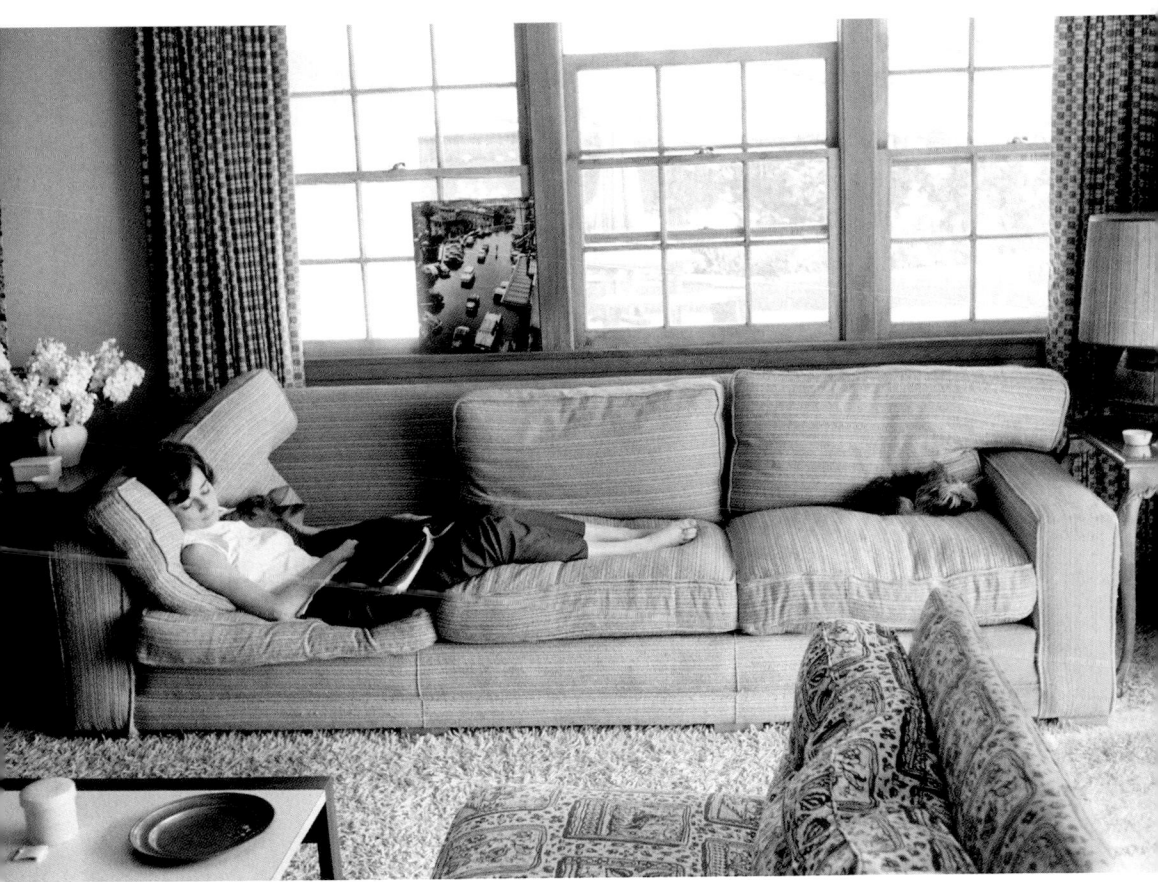

95

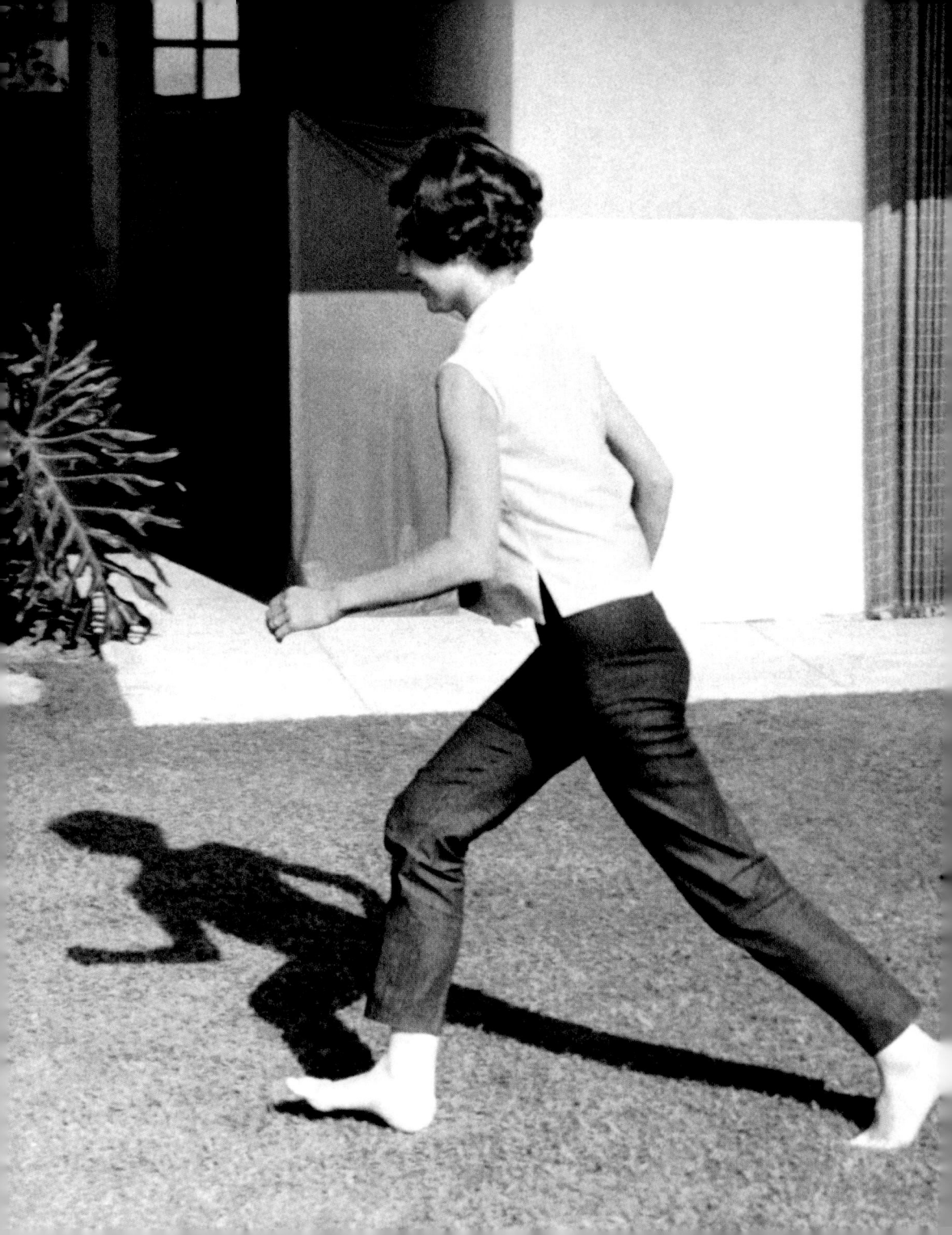

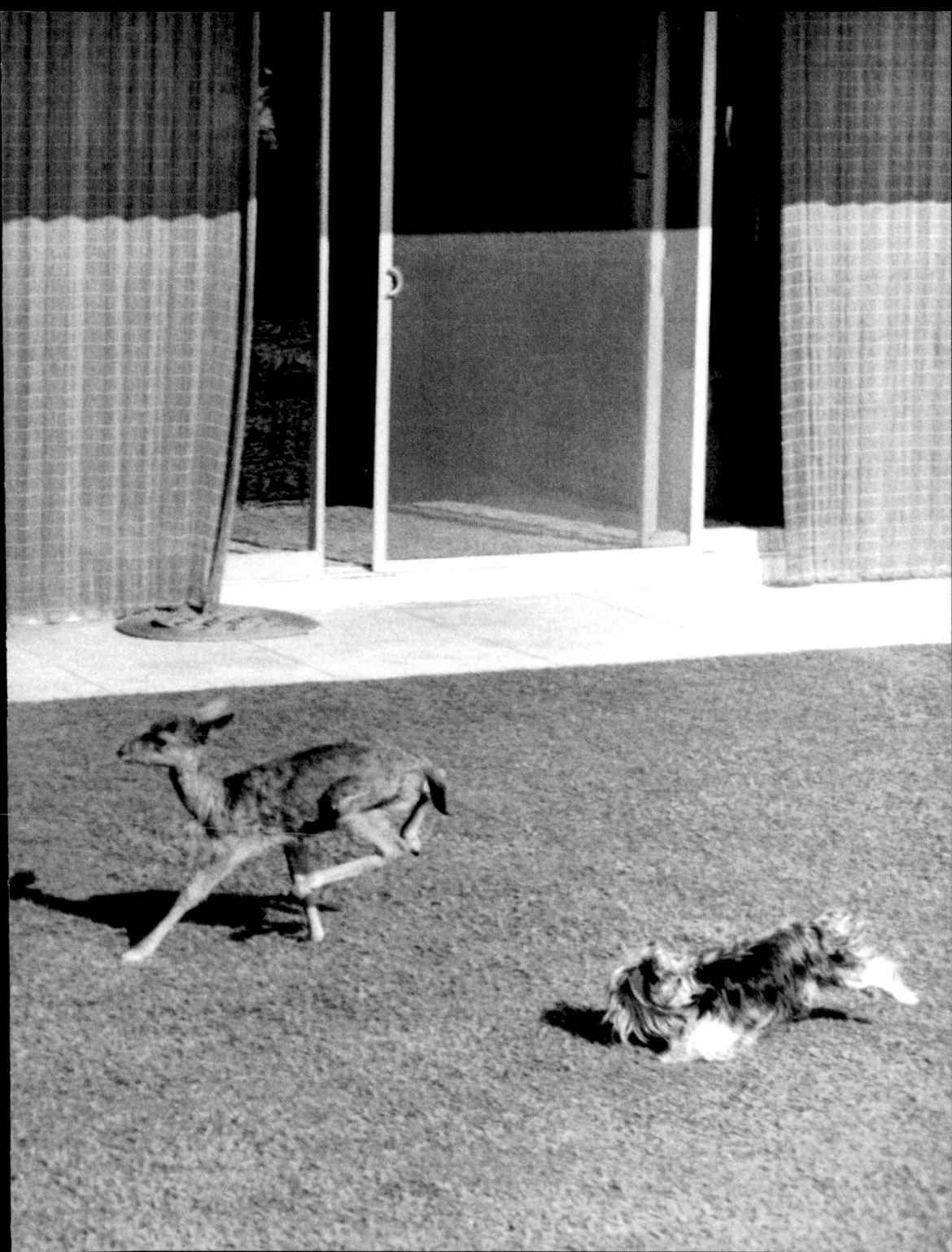

Willoughby remembers that Audrey, who could wear clothes with more effortless panache than anyone else on the planet, always looked sensational—in front of the camera, backstage, relaxing at home, at dawn, at dusk, at any hour at all. She not only looked good but always fashionable and of the moment. The world's greatest designers sought to dress her, and she acceded. Audrey did not keep clothes long; she would wear them for a time, then give them to an aunt or a cousin or donate them—first to charities and later, after her fame had grown, to museums. In this photograph, Audrey is relaxed—and Famous is content that he has his mistress all to himself.

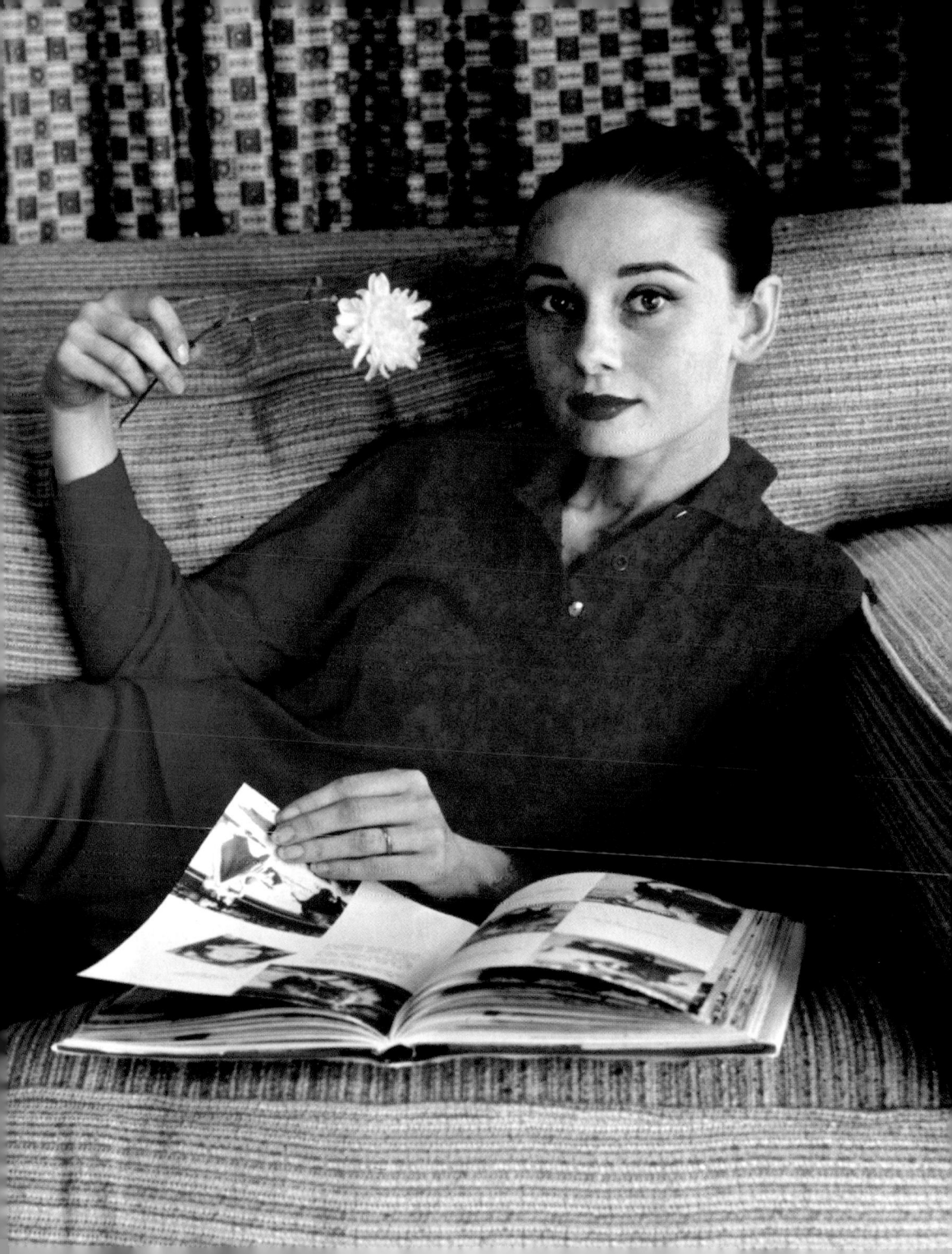

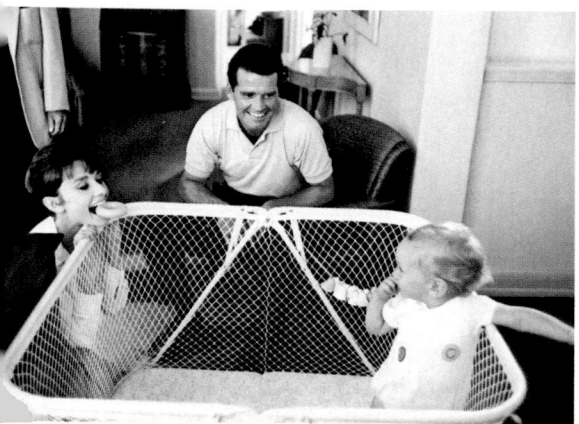

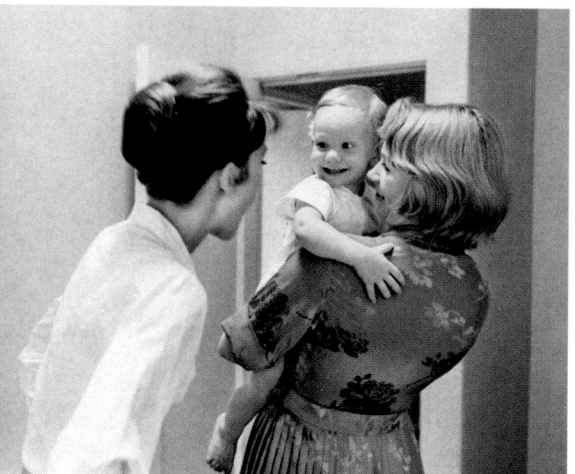

During the filming of The Children's Hour, *Audrey's costars, Shirley MacLaine and James Garner, enjoy a visit with the proud mom and her first-born son, Sean Hepburn Ferrer. Years later, Sean reflected upon a question he was often asked: What was it like growing up as Audrey Hepburn's son? "My answer is something people don't expect: I have no idea. She was a regular mum. She quit doing movies when I couldn't travel anymore [due to school]. In those days, there was no DVD, no VHS. It was later on that I connected that she was an actress, and later [still] I realized that she was a pretty good actress. Only after she passed away did I fully comprehend to what extent she had truly touched everyone."*

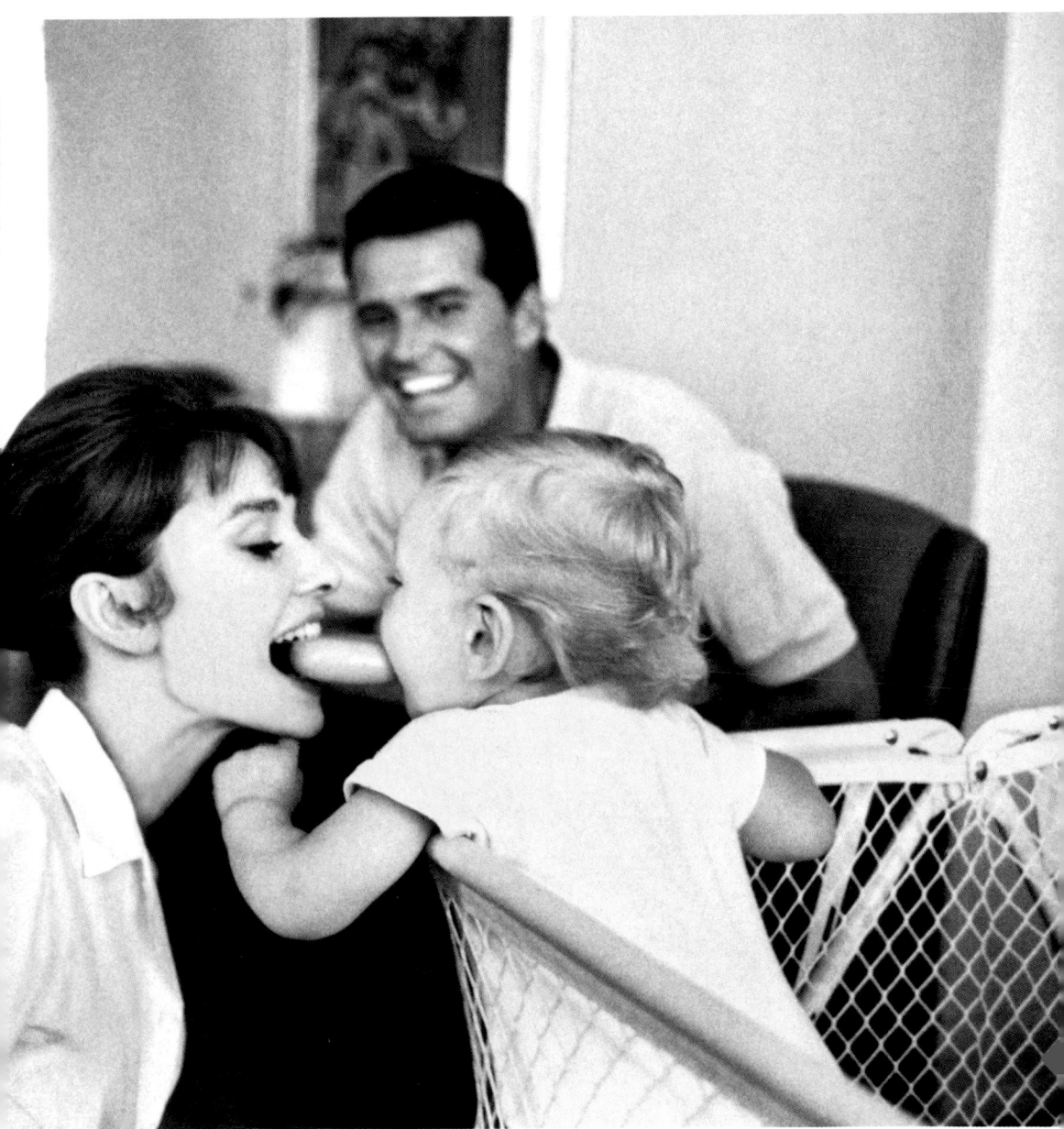

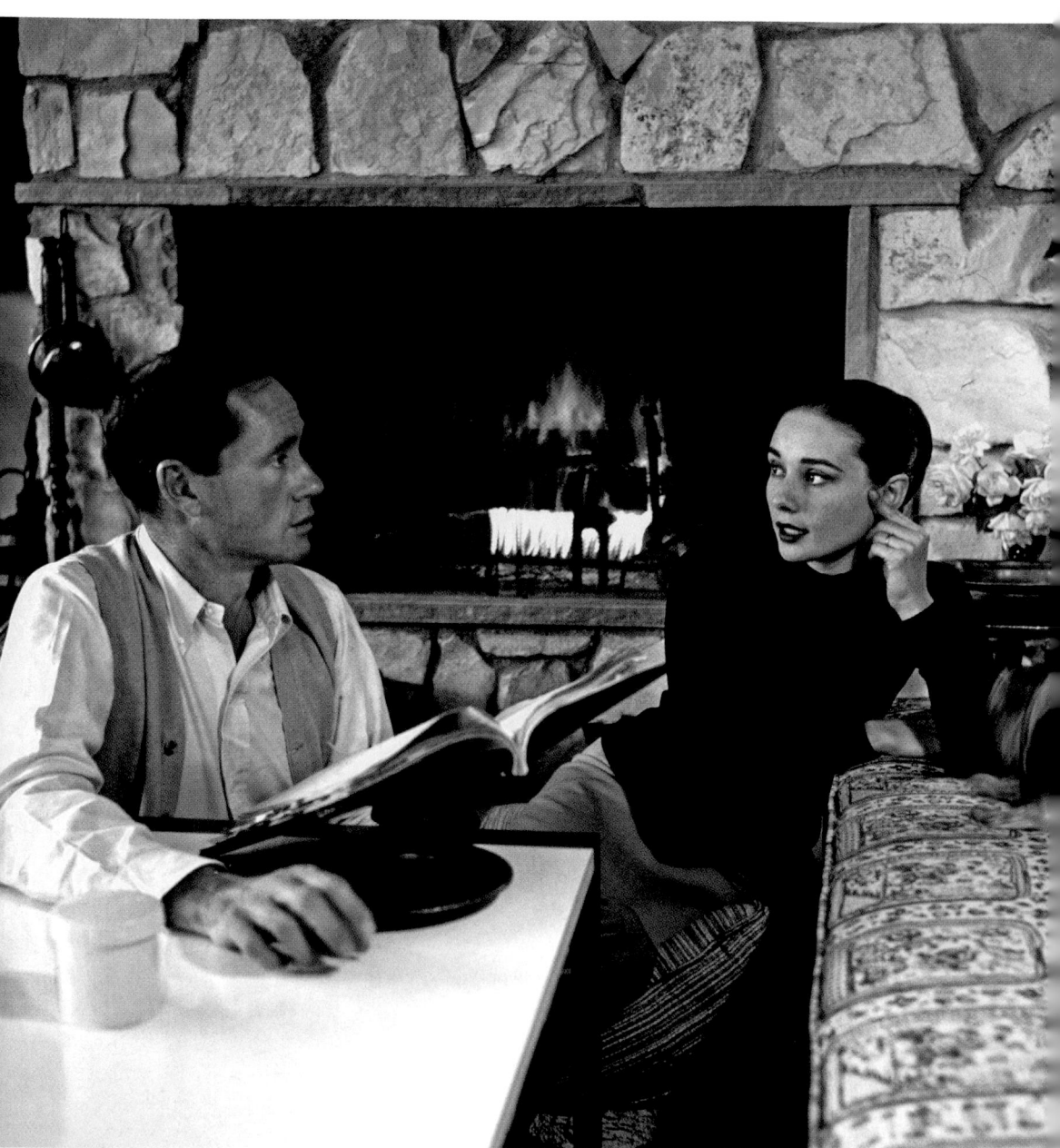

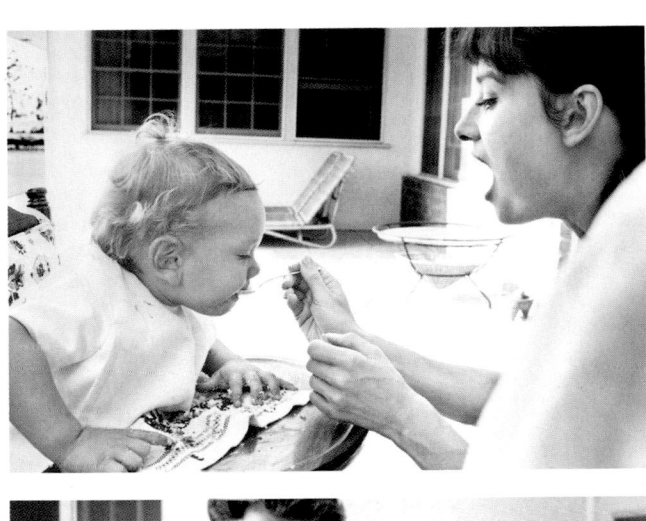

Far left: Ferrer and Audrey enjoy a quiet moment together before their warm hearth. Left, below and on the following spread: Scenes from Sean's first birthday party, held in the bright Beverly Hills sunshine of the Ferrers' backyard. Four decades later, when Audrey was posthumously honored with the Hollywood Academy of Arts and Sciences' Jean Hersholt Humanitarian Award at the annual Oscar extravaganza, Sean accepted on her behalf. It was a moment that touched the hard heart of Tinseltown.

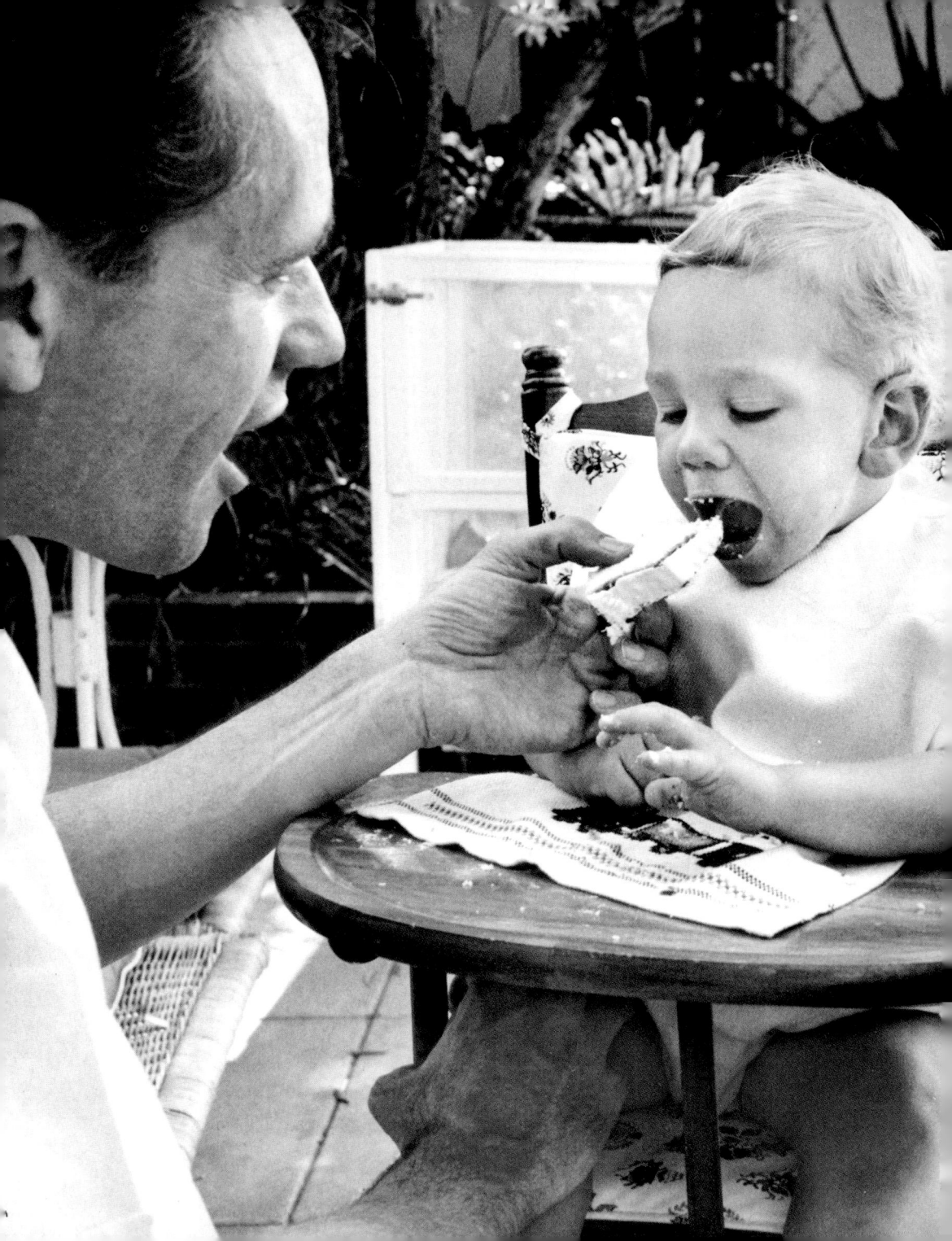

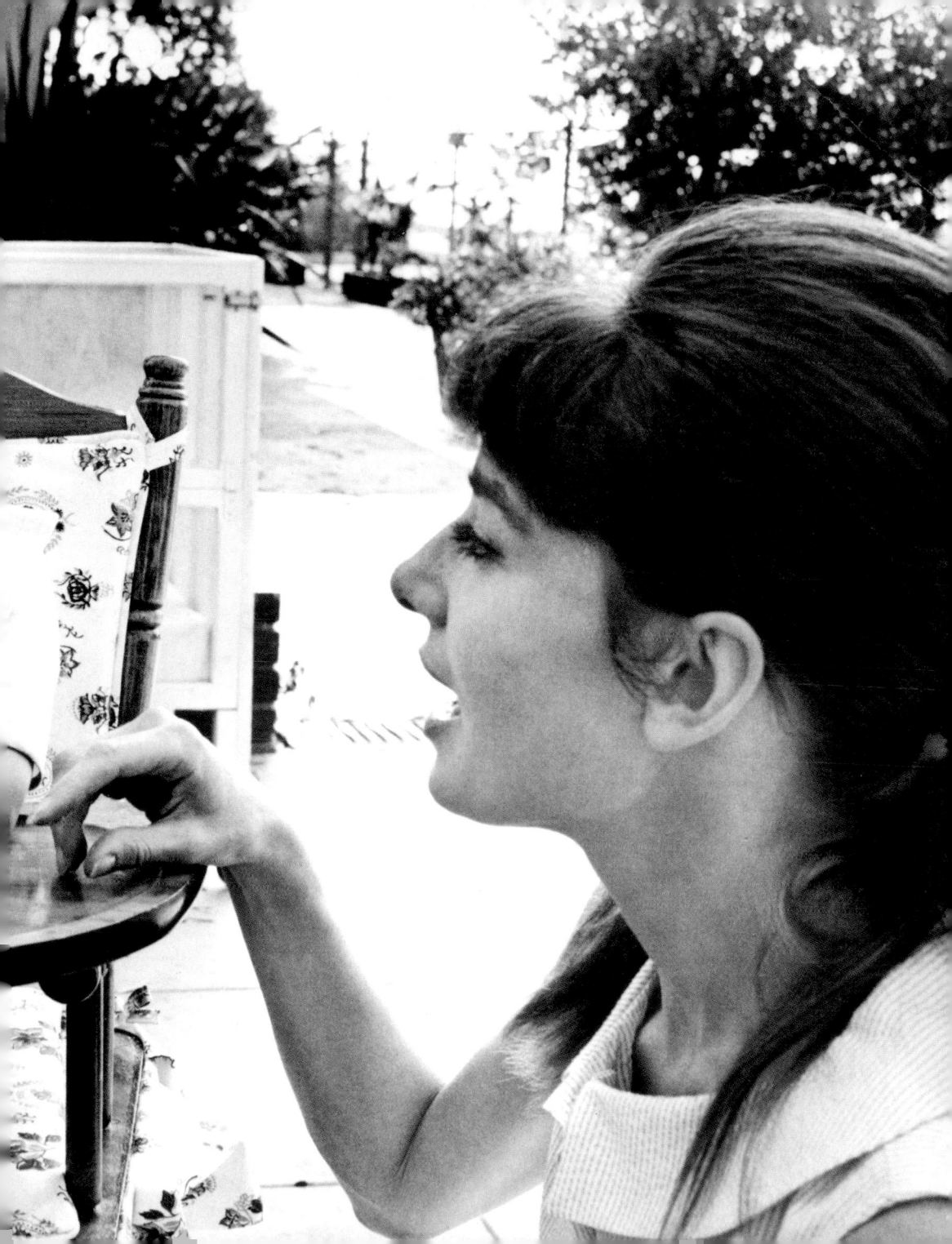

AUDREY
AT EASE

Some actors—no need to name names—were legendary tyrants on the set. Some were storied drunks, and others were divas of the highest order. Audrey, too, was famous for her on-set demeanor. She was, if the many reports are to be believed, the most charming, disarming, altogether friendly and charismatic superstar ever to grace a Hollywood production. Everyone liked Audrey and remained loyal to her. Directors like William Wyler sought to work with her over and over. The very best designers, from Edith Head to Givenchy, longed to create her outfits.

It was said that all her leading men loved her, and this is certainly believable. Particularly close relationships, some platonic and others admittedly more than that, were formed with Gregory Peck during the filming of 1953's *Roman Holiday*, William Holden during the following year's *Sabrina*, Anthony Perkins during the *Green Mansions* shoot, Rex Harrison when filming *My Fair Lady* and Albert Finney during the making of the 1967 film *Two for the Road*. Audrey said that one of her favorite productions was *Funny Face* because she got to dance with Fred Astaire, and Cary Grant was once quoted as saying, "All I want for Christmas is another picture with Audrey Hepburn."

During his time in Hollywood, Bob Willoughby saw all the biggest stars in their public and private moments. None impressed him as much as Audrey did. None had the charm that he captures so well in this final series of behind-the-scenes, unguarded moments.

"She left those who came into contact with her better for having known her," he says. "I miss her to this day."

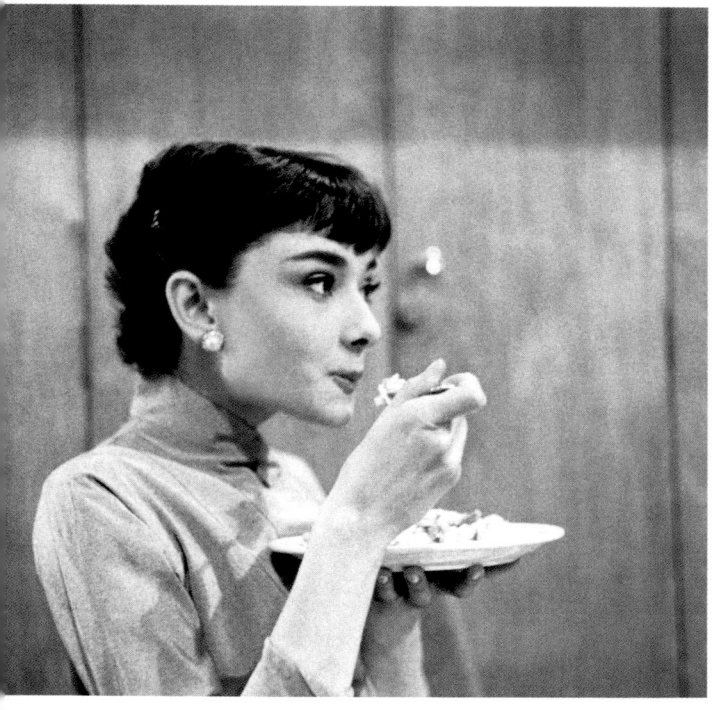

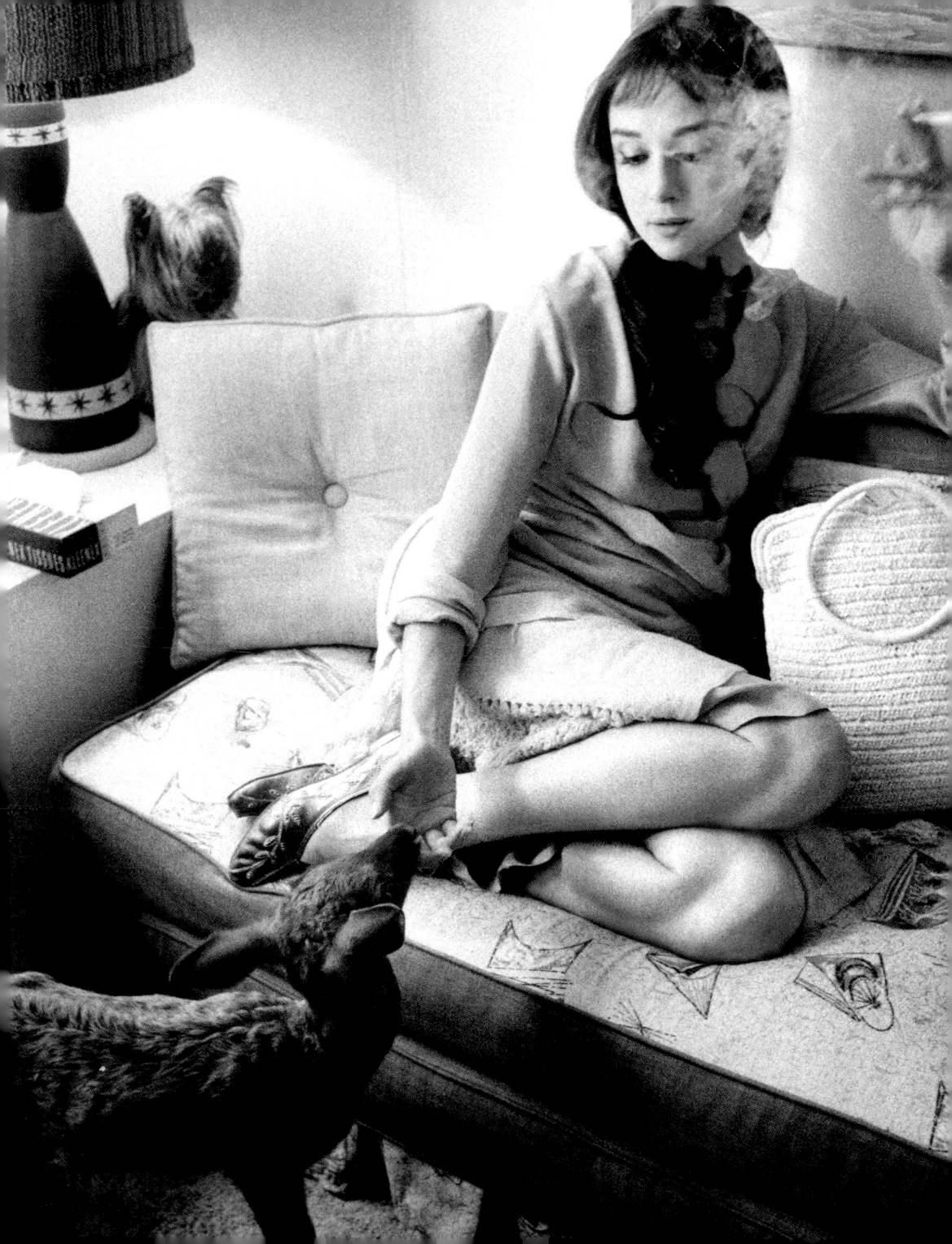

Audrey was always at ease among the screen community. Though Jerry Lewis was less than gallant that first day on the Paramount lot in 1953, Audrey neither wilted nor withdrew and in fact made some fine and funny photographs with Dean Martin and Lewis (below). *She had a far warmer visit that day with Edith Head (opposite), the often-laureled costume designer who had already made Audrey look fabulous (well, even* more *fabulous*) *with the outfits she wore for her breakout turn* in Roman Holiday.

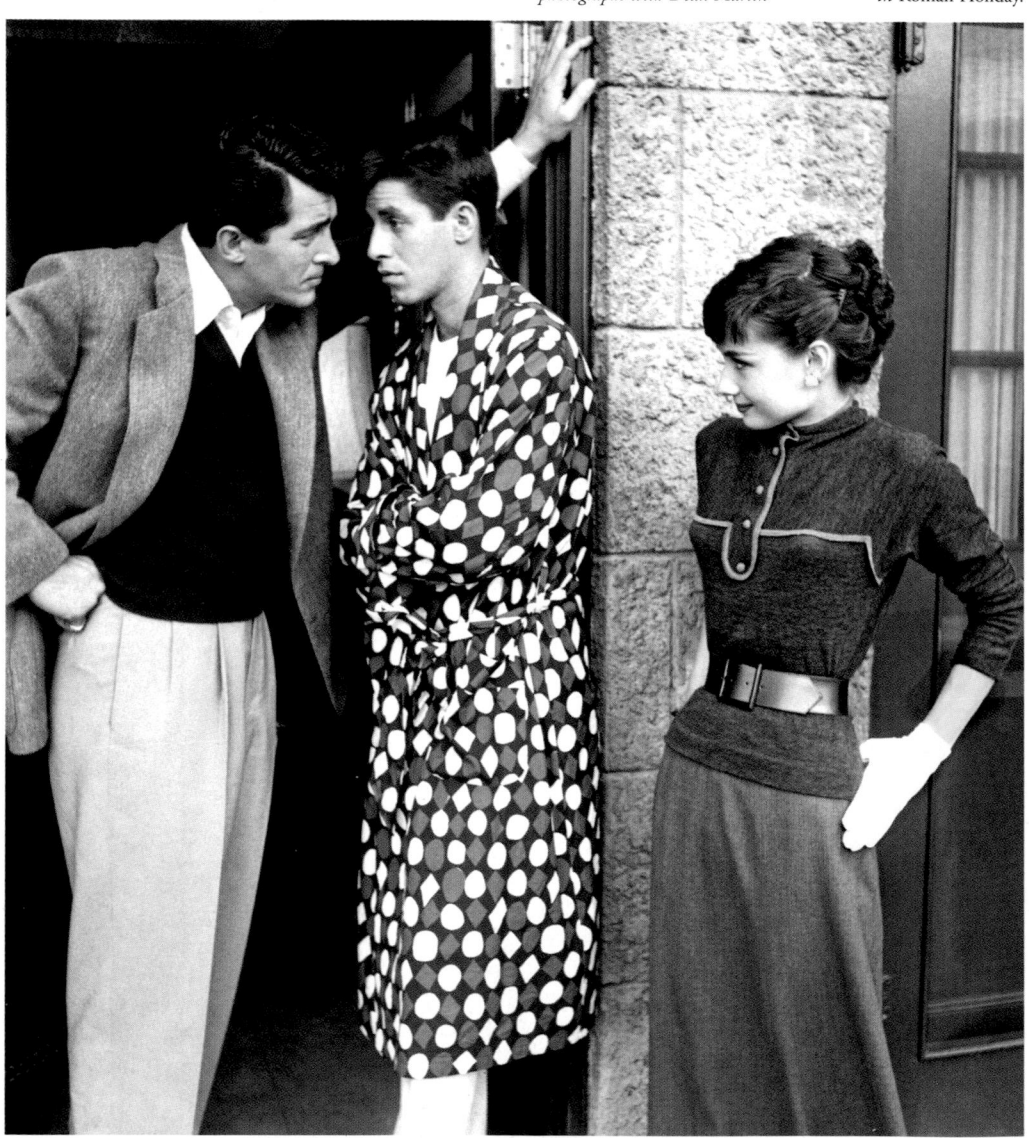

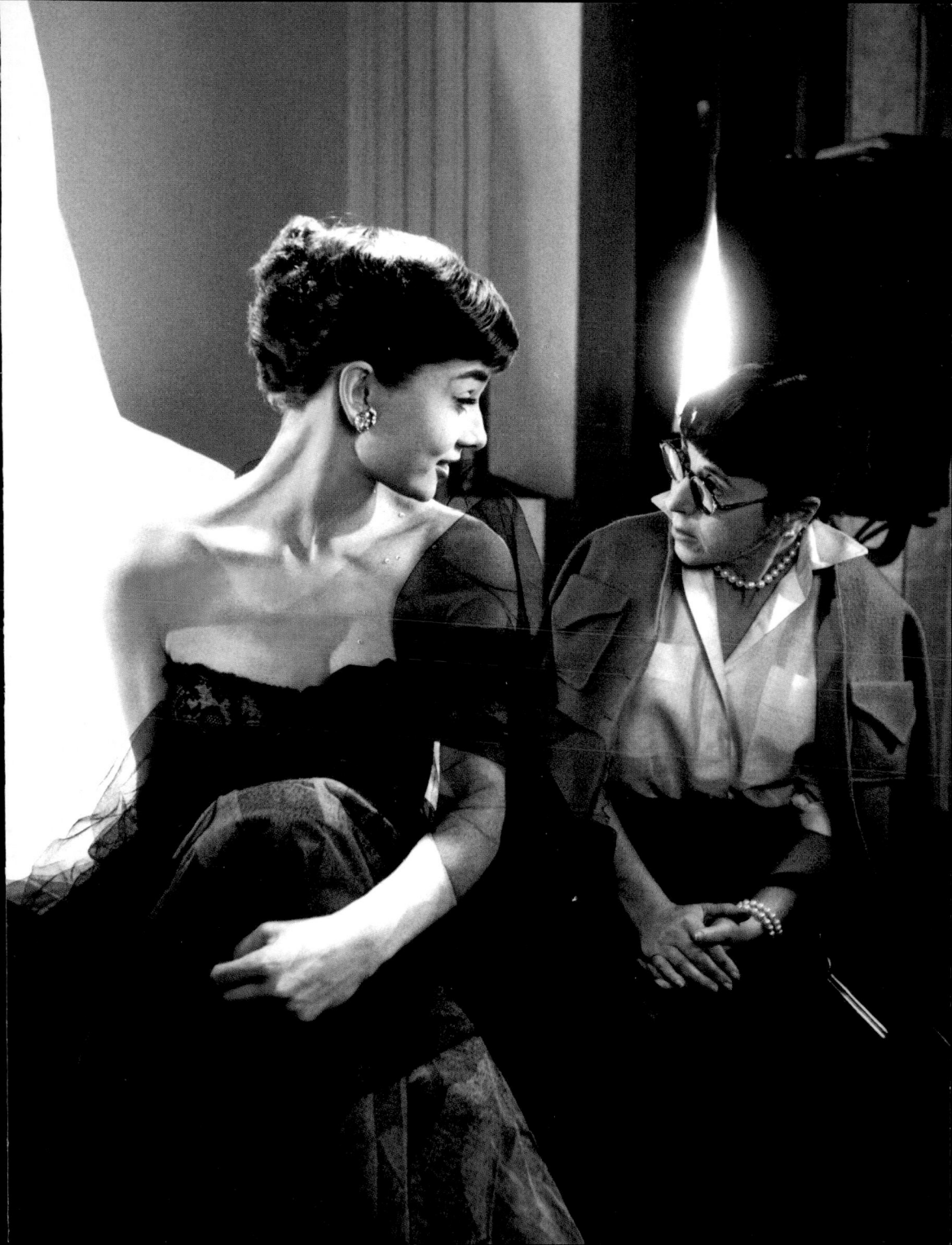

As would any star who is constantly in the spotlight and constantly in demand, Audrey relished time alone. Here, she sags for a bit (right) before doing what must be done and carefully folding the exquisite dress from the wardrobe department. Hotels such as this one in L.A. frequently served as her home. She finally established a real home in Tolochenaz, Switzerland, where she chiefly raised her boys and where she is buried today.

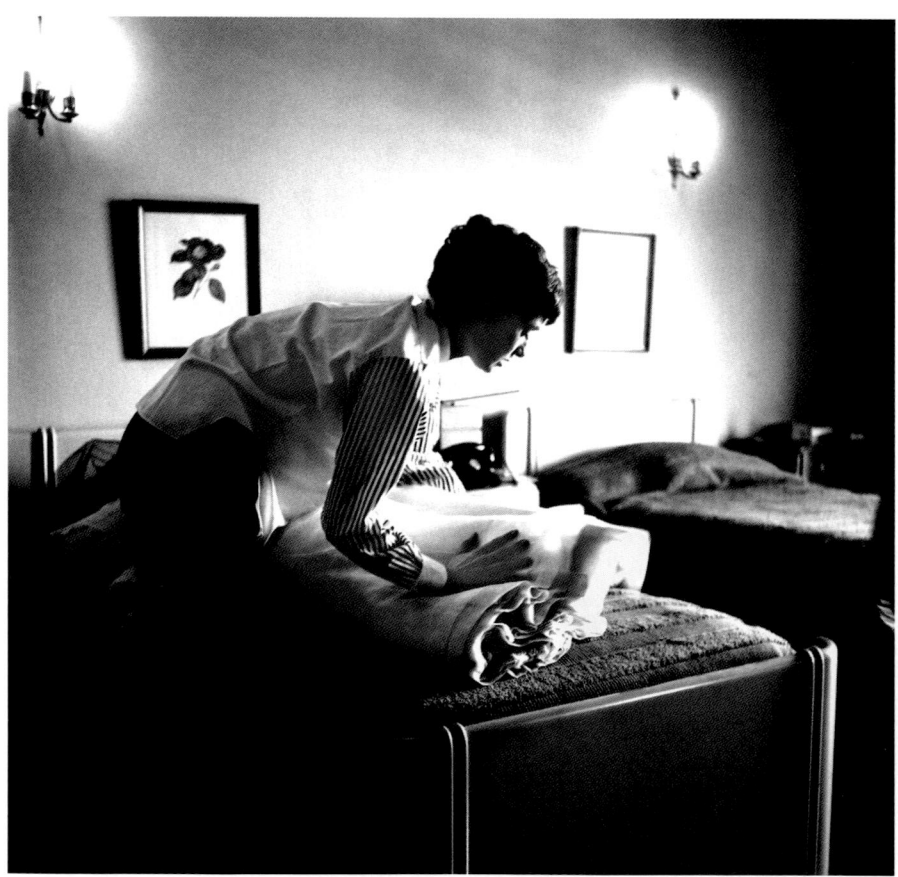

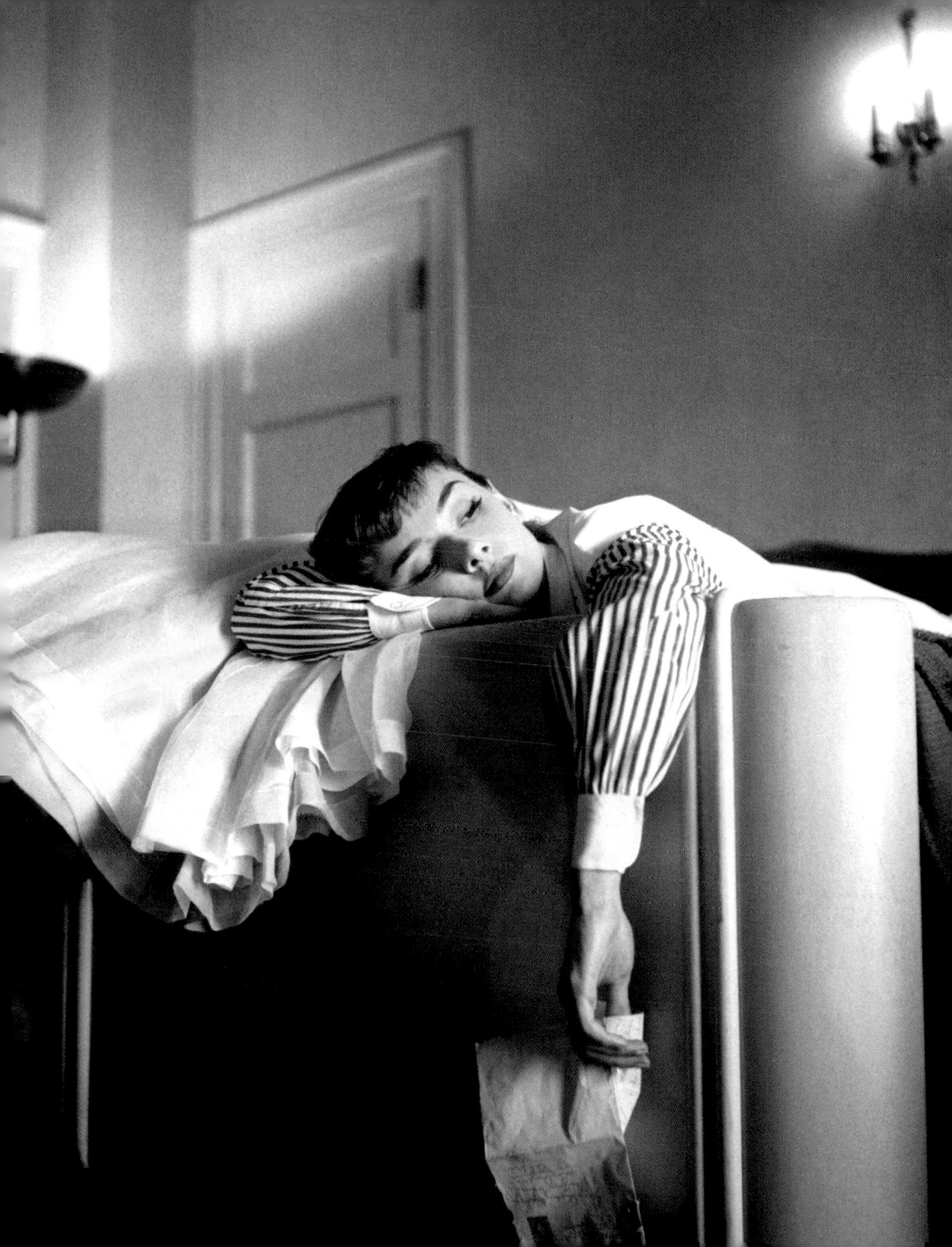

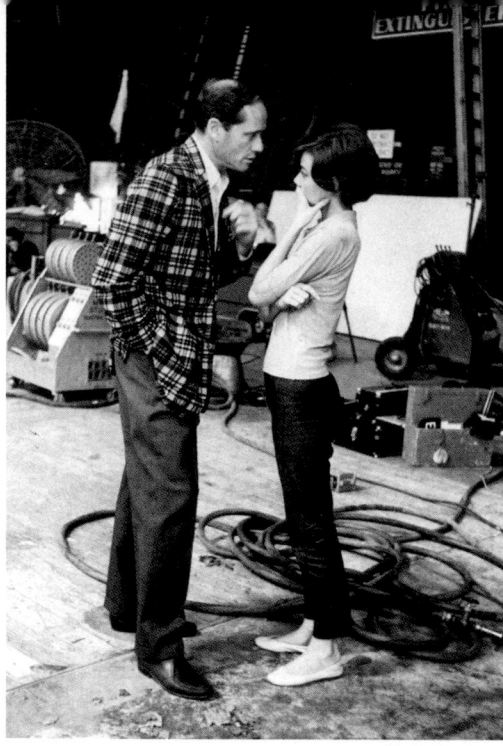

On this and the following spread: Scenes from a marriage. After meeting Audrey at Gregory Peck's party, American actor Mel Ferrer sent her the script of Ondine *along with the suggestion that she should join him in the Broadway production of it. In 1954, Audrey won a Tony Award for playing the water sprite, and Ferrer won her heart; the couple wed that September. It has been written that Ferrer had a temper, that he was controlling of his wife, that he was her Svengali, that he was jealous of her stratospheric success. But some who were close to the couple at the time, including Bob Willoughby, saw real love, and others doubted that Audrey was dominated by Ferrer. "I think Audrey allows Mel to think he influences her," William Holden once said. The marriage ended in 1968, and after this divorce, Audrey would marry once more. She wed a Roman psychiatrist, Andrea Dotti, in 1969. They had a son, Luca, in 1970, and for a time Audrey disappeared from the screen to raise her boys in Switzerland and Italy. Dotti, for his part, was more interested in nightlife than domestic duties, and his name regularly appeared in European gossip columns, linked with those of younger women. Audrey suffered these embarrassments for a while, then she and Dotti divorced in 1982. "She wanted desperately to be loved, and she didn't choose her husbands wisely," Donald Spoto, one of her biographers, has observed, adding, "Actresses often do not." Spoto's appraisal may be correct, but as these photographs make clear, when she was young and stardom was new and the fairy tale was in full flight, she had a Prince Charming in Mel Ferrer.*

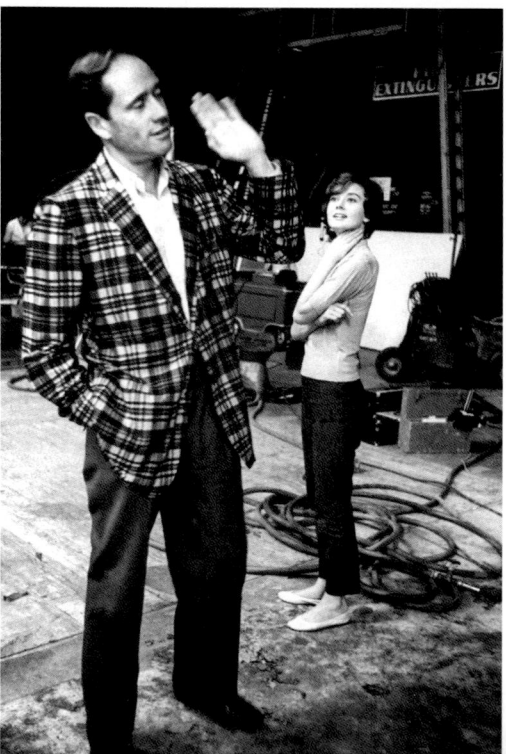

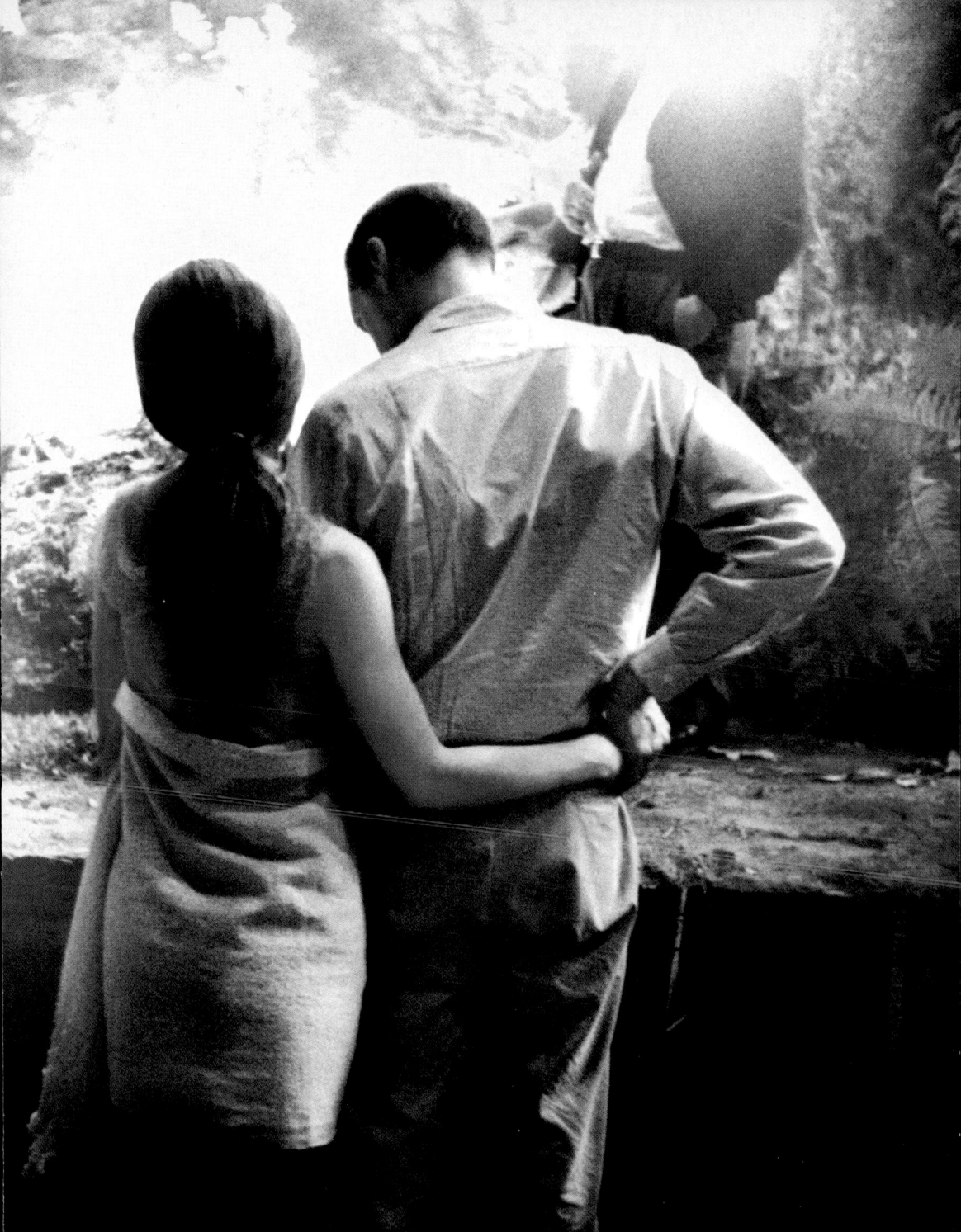

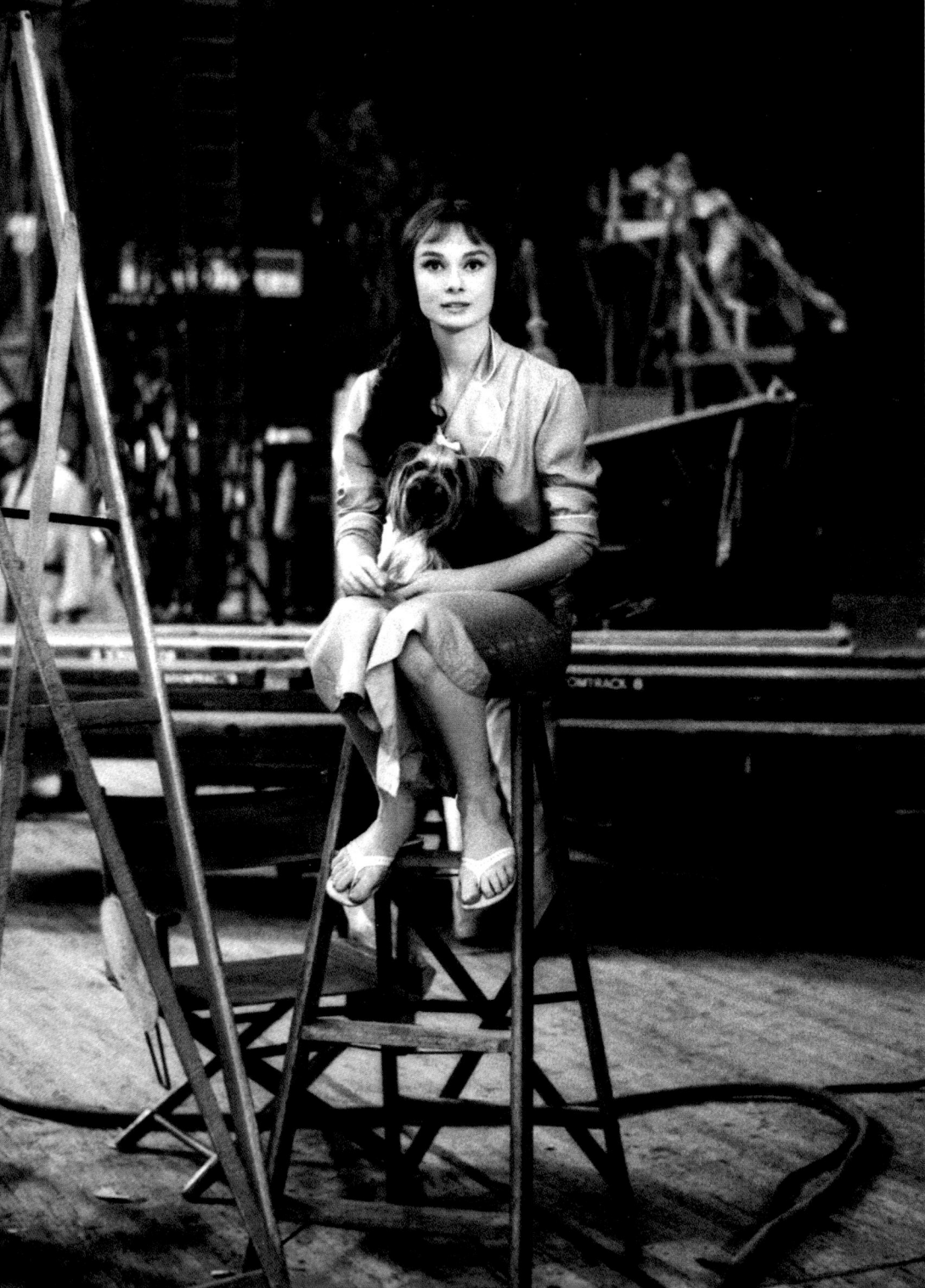

Audrey was soothed by animals. We have seen how Ip took to her and she to the fawn. Here are two portraits with the famous Mr. Famous, her first of two Yorkshire terriers. When he was killed by a car, Audrey grieved, then quickly obtained another Yorkie, Assam, whose more formal name was Assam of Assam. Later, her son Sean owned a beloved cocker spaniel, and Audrey had two Jack Russell terriers at her final home in Tolochenaz. Animals seemed to have an effect on Audrey similar to what she experienced in the company of children. Whether it was their innocence or relative vulnerability, they brought out her loving, caring instincts. They always made her smile.

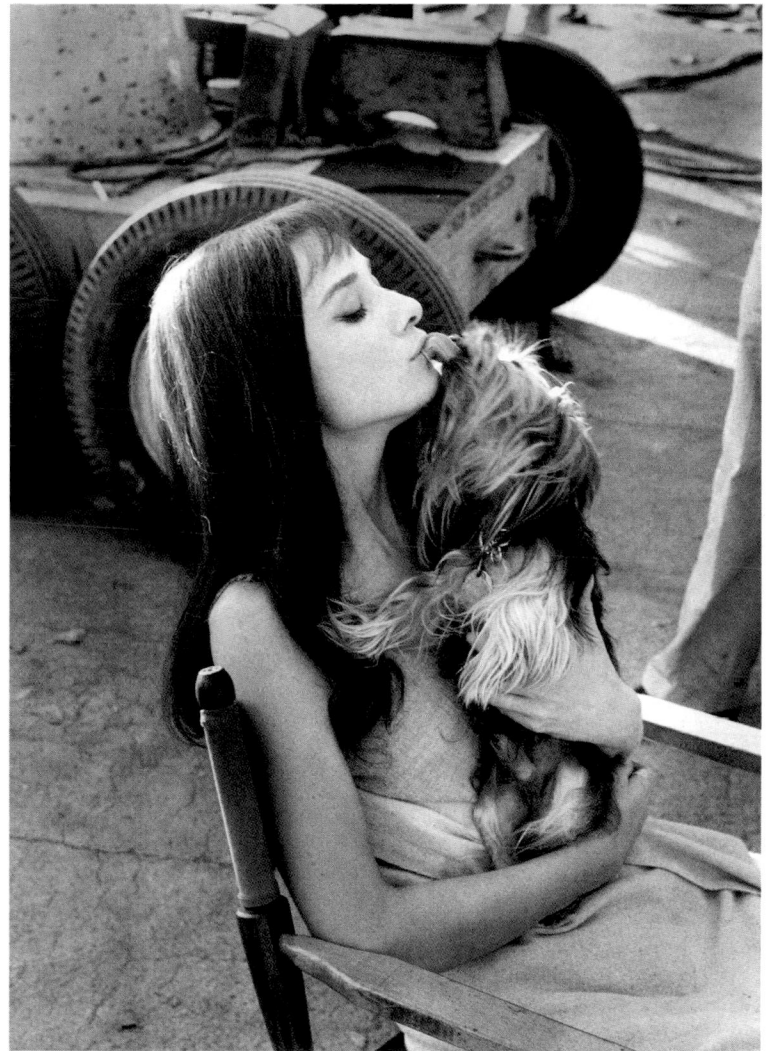

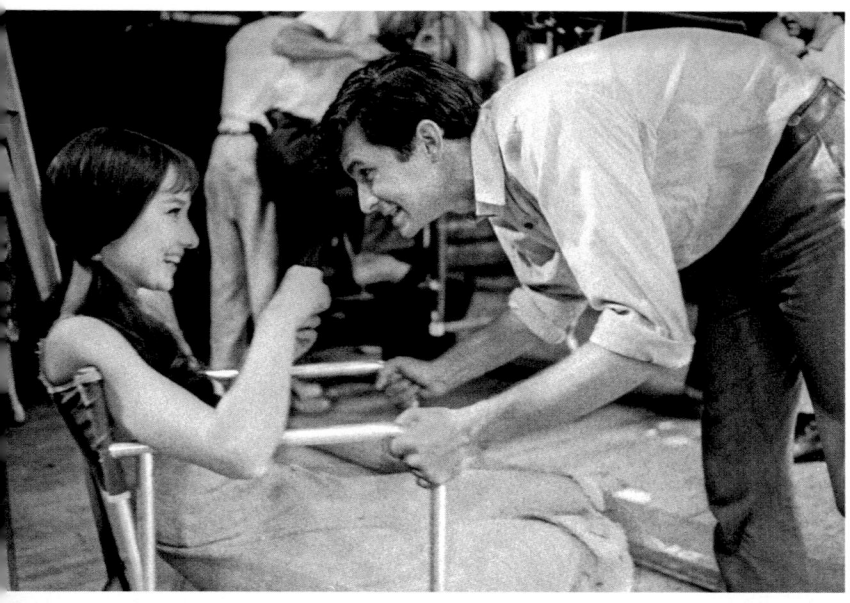

She brightened any set. Even a production that was as fraught with tension and expectation as, say, the ultra-high-budget My Fair Lady *was made lighter by Audrey's presence. In these pictures, taken behind the scenes on the set of* Green Mansions, *Audrey chats and jokes with her costar Anthony Perkins, who was a similarly welcome cast member on any film. "Tony was easygoing," Bob Willoughby remembers. "I had worked with him on a couple of films previously, and he had a gentle personality, ever smiling, never a lot of ego to deal with. He and Audrey developed a really good relationship, and he brought out a facet of her personality that I had never seen before. At times, they acted like two young kids. I would say Tony seemed like a brother to Audrey and watched over her. If he saw her sitting by herself on the set, maybe looking a little sad, he would jump in, shaking her chair until he had her laughing, or getting her a cup of tea, telling her a joke— anything that would perk up her spirits."*

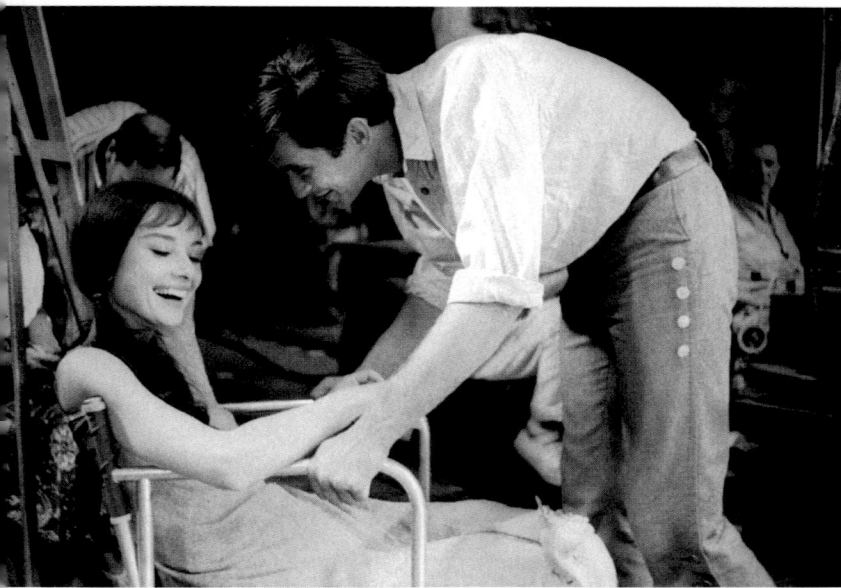

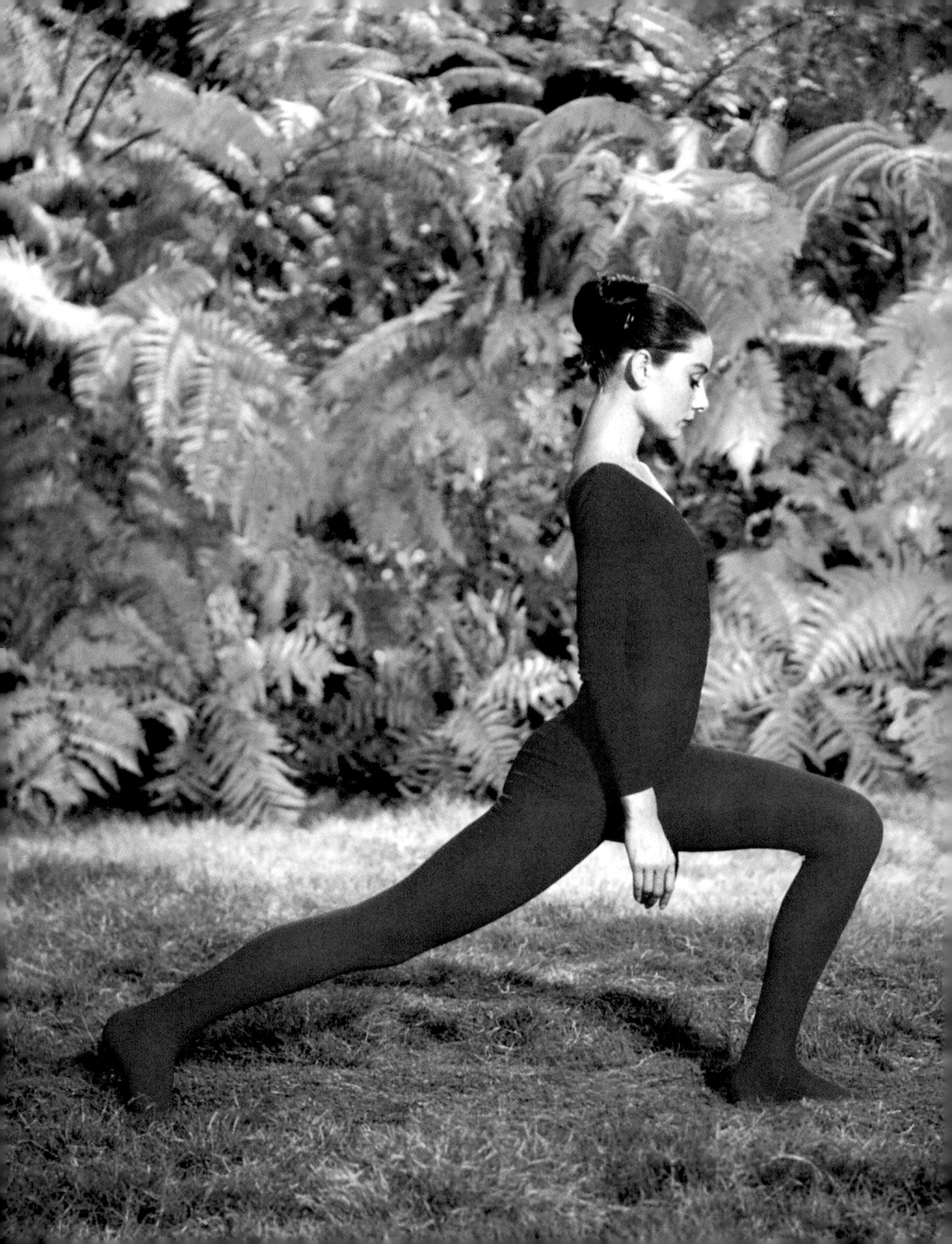

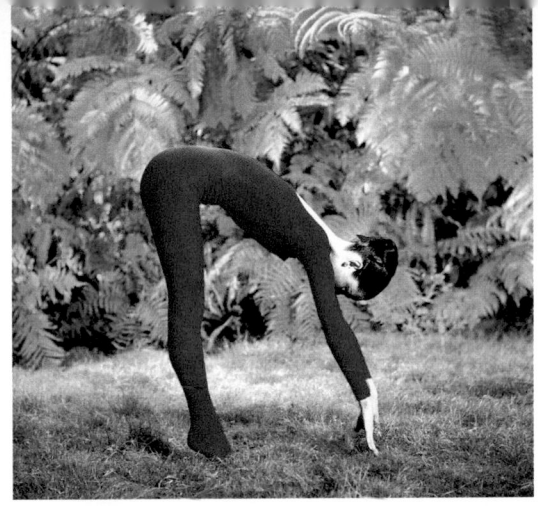
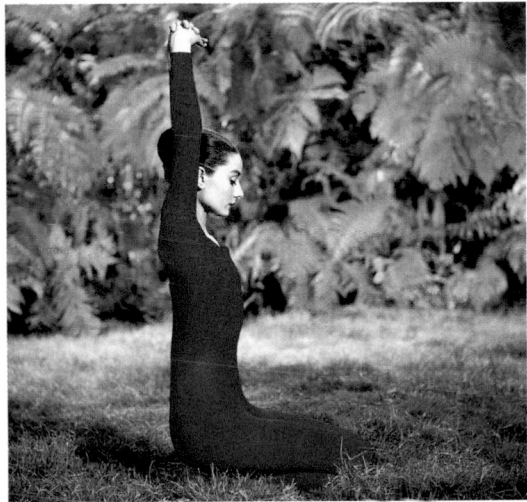
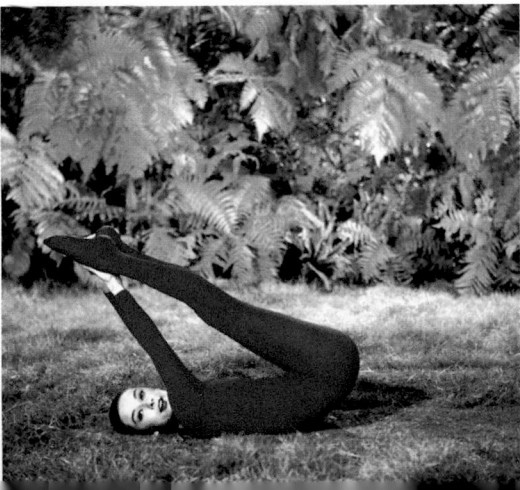

The former ballerina stayed in trim her whole life; she enjoyed exercise and outdoor activities such as gardening. But looks can be deceiving. The severe malnutrition she had suffered during the war left her in frail health thereafter. Furthermore, as the seemingly perfect Audrey freely admitted, thinking of cigarettes: "I have some sins." Indeed, when she was anxious or sad, she smoked incessantly. Audrey was five feet seven inches and 110 pounds most of her adult life, but it has been written that when her marriage to Ferrer was unraveling, she became depressed and was smoking three packs of cigarettes a day, and her weight dropped to less than a hundred pounds. For her part, Audrey did not see health or beauty in a physical way. One of her favorite poems, which she quoted often to her boys, was Sam Levenson's lighthearted "Time Tested Beauty Tips," which begins: "For attractive lips, speak words of kindness/For lovely eyes, seek out the good in people/For a slim figure, share your food with the hungry." The poem's concluding verse avers that "True beauty in a woman is reflected in her soul . . . and the beauty of a woman with passing years only grows." Audrey not only took those words to heart, she personified the sentiment.

121

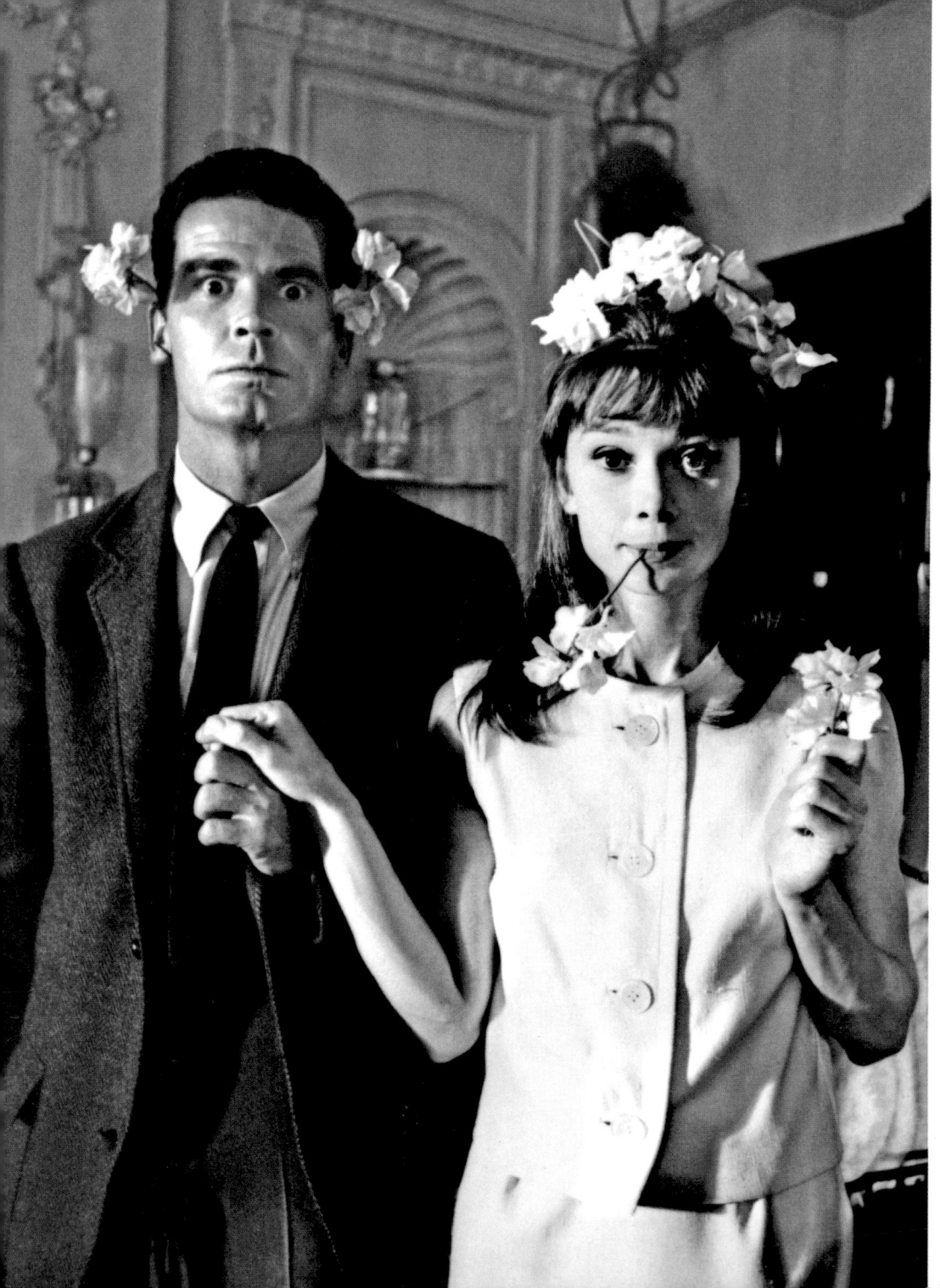

As she had on Green Mansions with Tony Perkins, Audrey developed a fine friendship during the filming of The Children's Hour *with costar James Garner. On that ponderous production, Garner's merry presence was even more crucial. "It was not in Audrey's character to complain, but the* emotional content of the script and the slow pace were taking a toll on everyone," Willoughby remembers. "This was when Jim Garner was at his best. He had an off-the-wall humor, and when things got especially grim, he would say something funny to break everyone up and literally save the day."

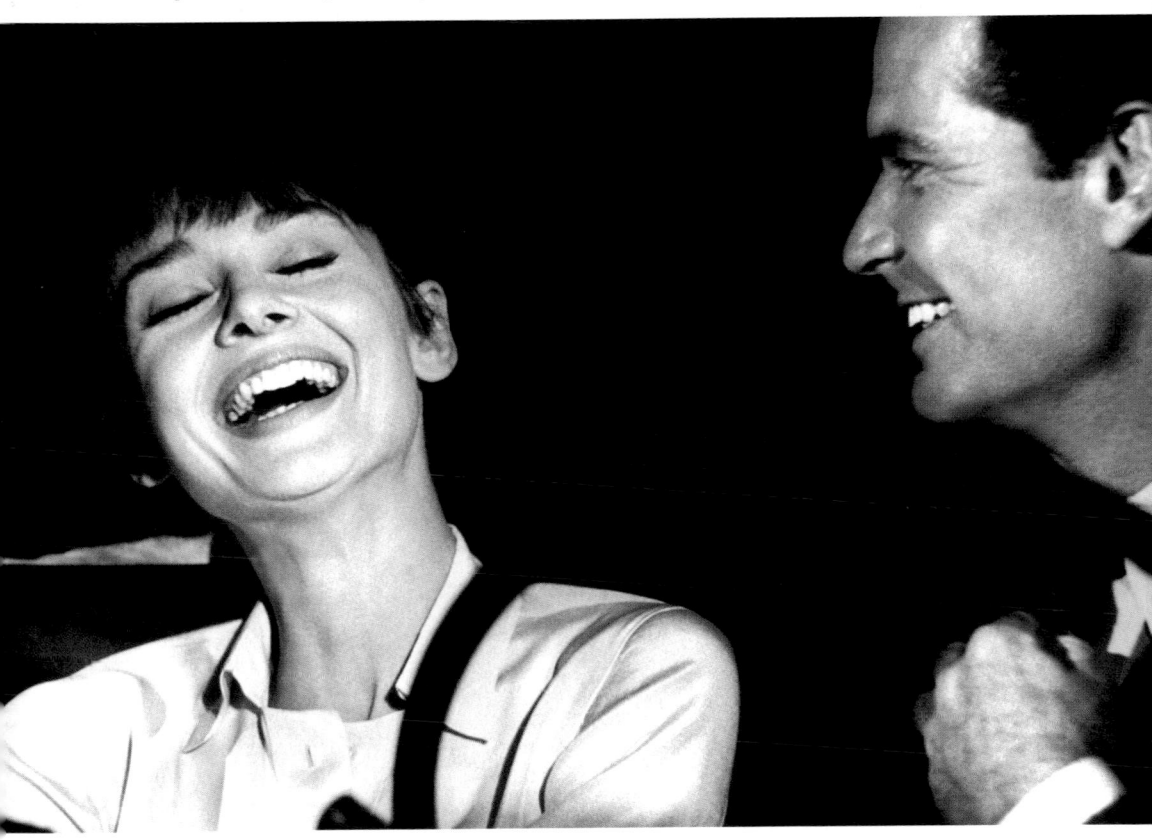

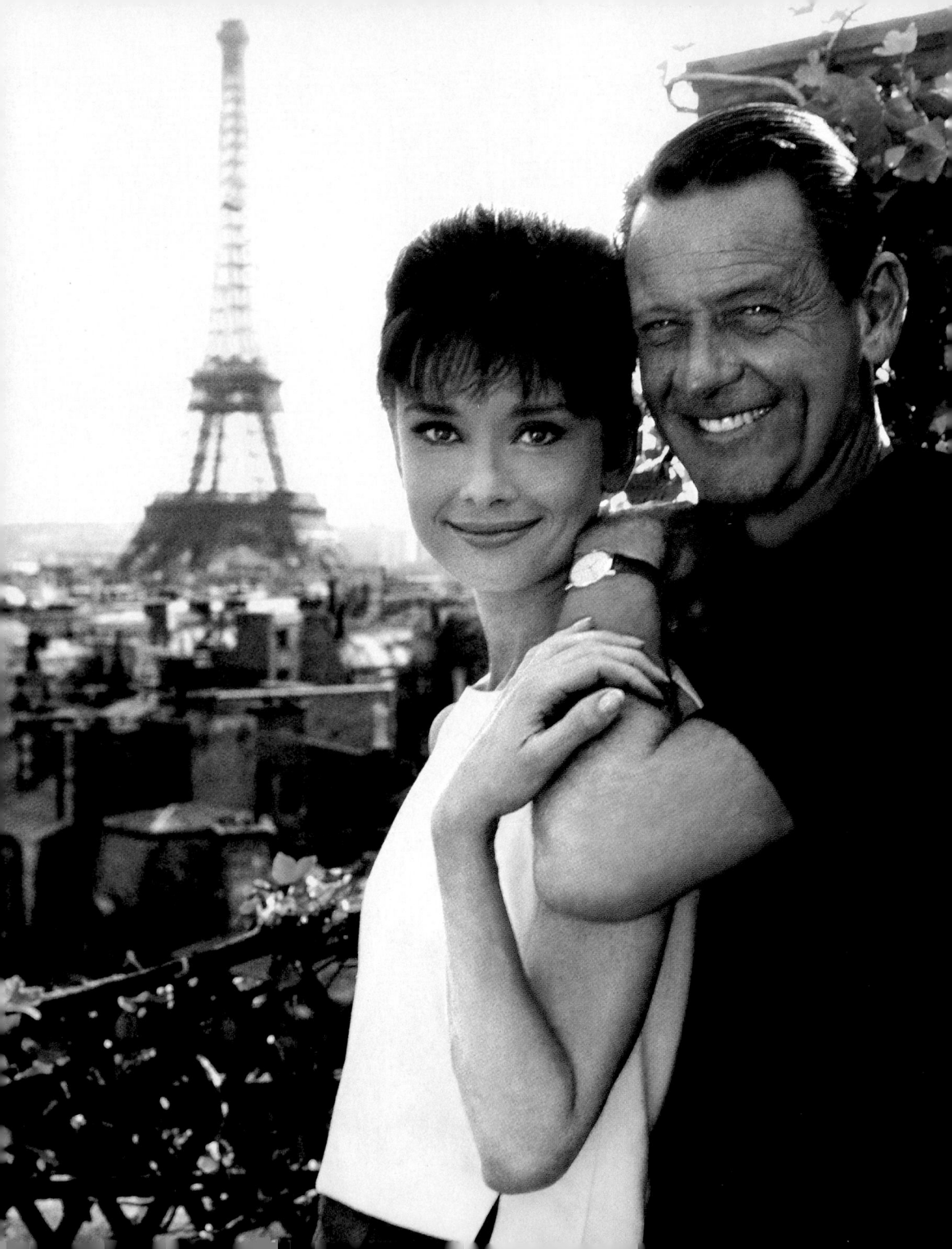

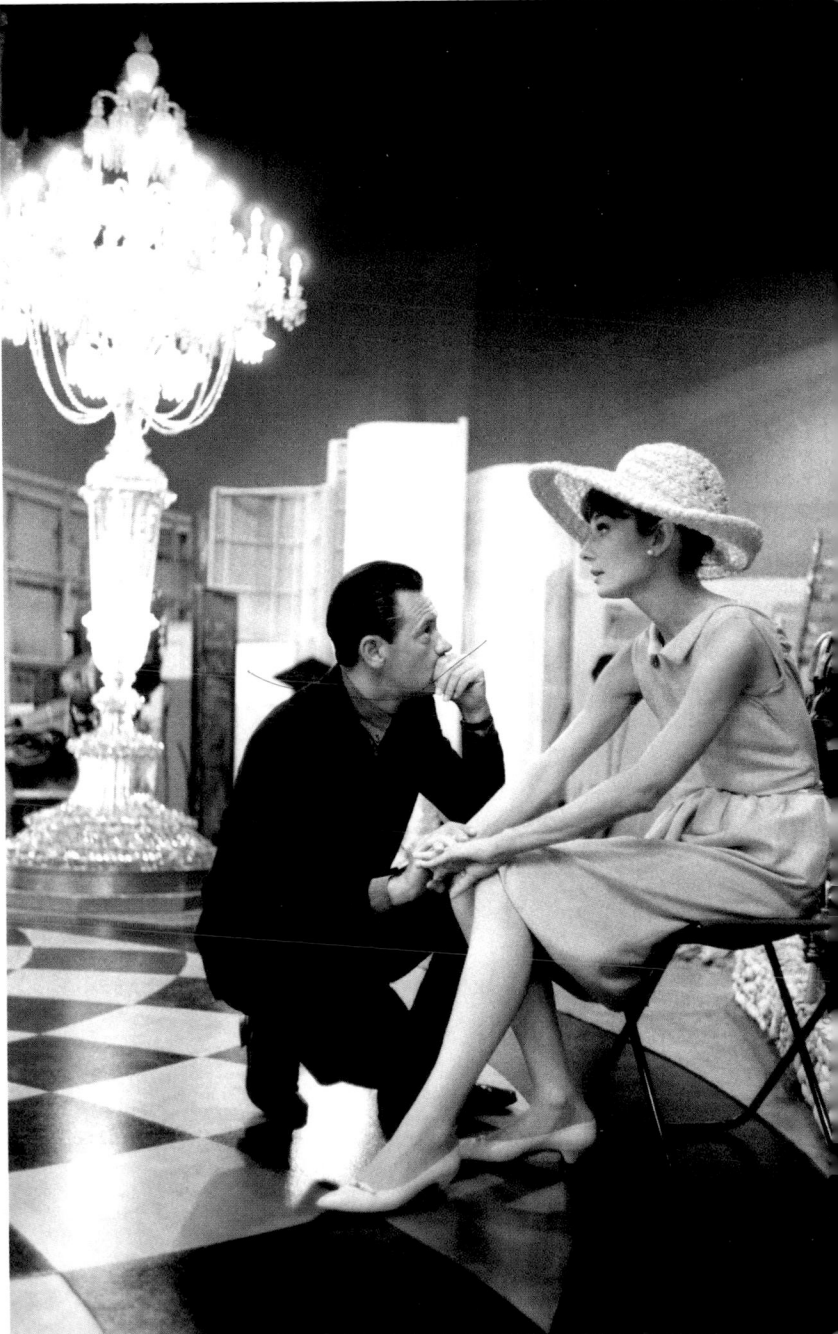

William Holden was, without doubt, one of the great loves of Audrey's life. Their romance during the making of Sabrina *in 1953 was deep and consequential. Holden was a married man at the time, and there was some thought that he would leave his wife for Audrey. But when Audrey learned that Holden had had a vasectomy and therefore could never give her children, she ended the relationship. Nevertheless, the two remained friends for life. The photographs here are from the set of* Paris When It Sizzles, *as is the one on the following spread, of which Bob Willoughby recalls, "Tony Curtis did a cameo in the film, playing an egocentric actor. Here, he's telling Audrey a funny story while waiting for rehearsals to begin."*

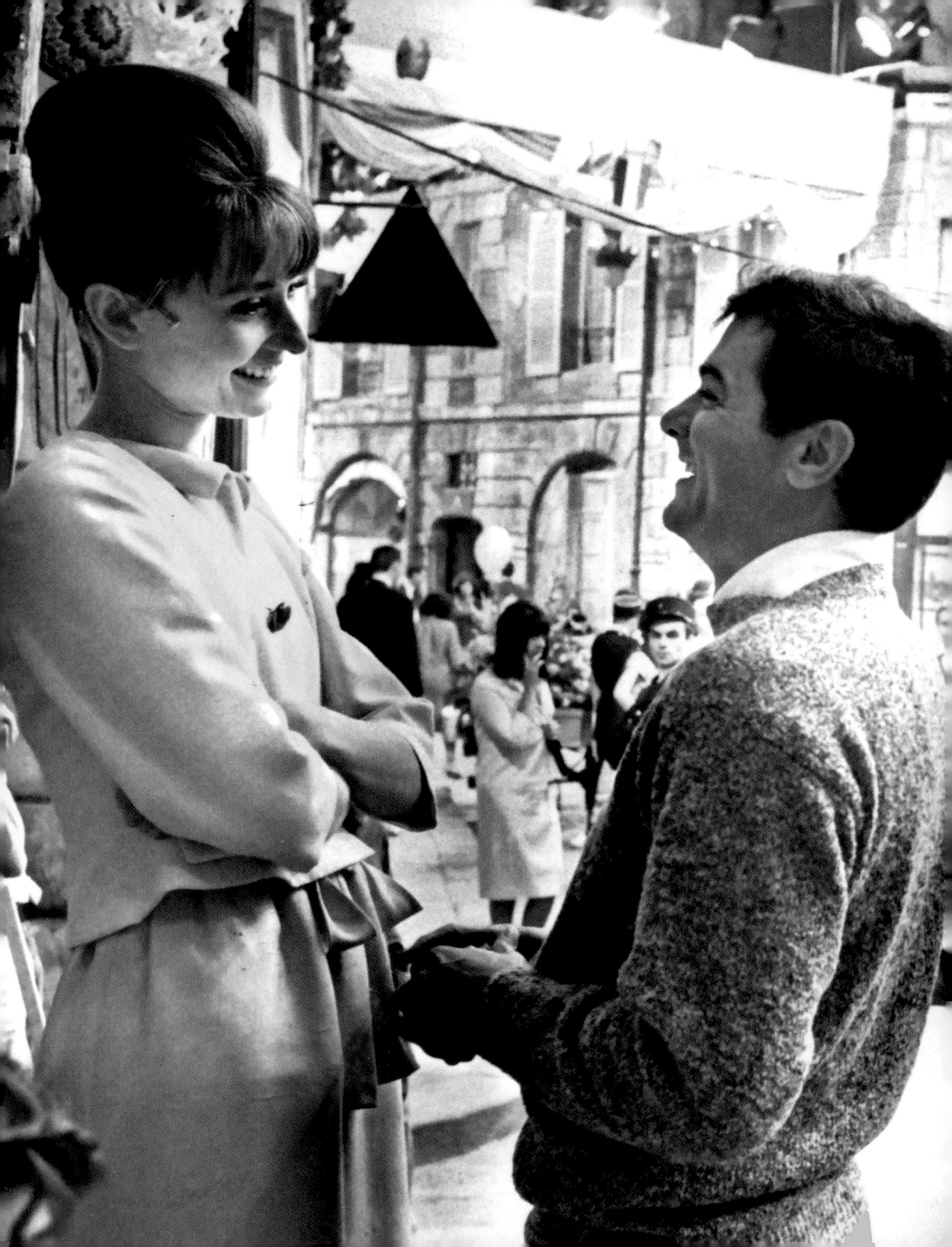

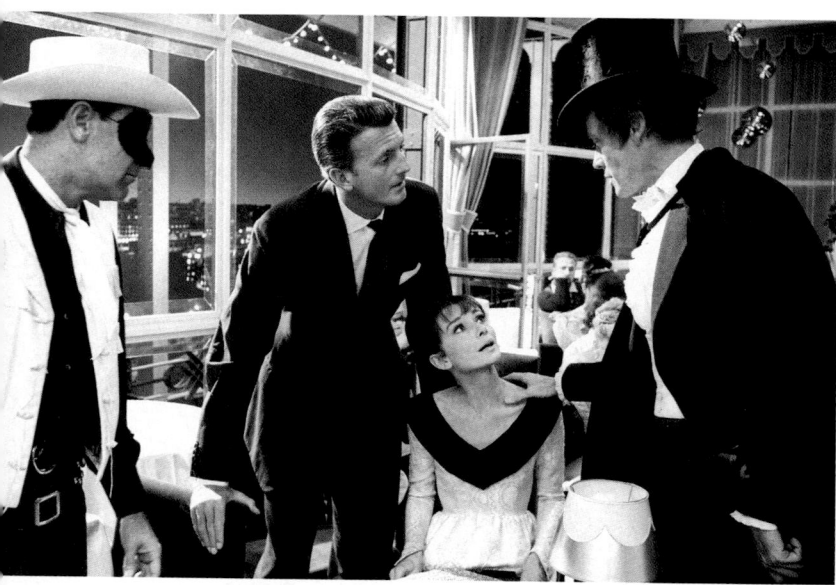

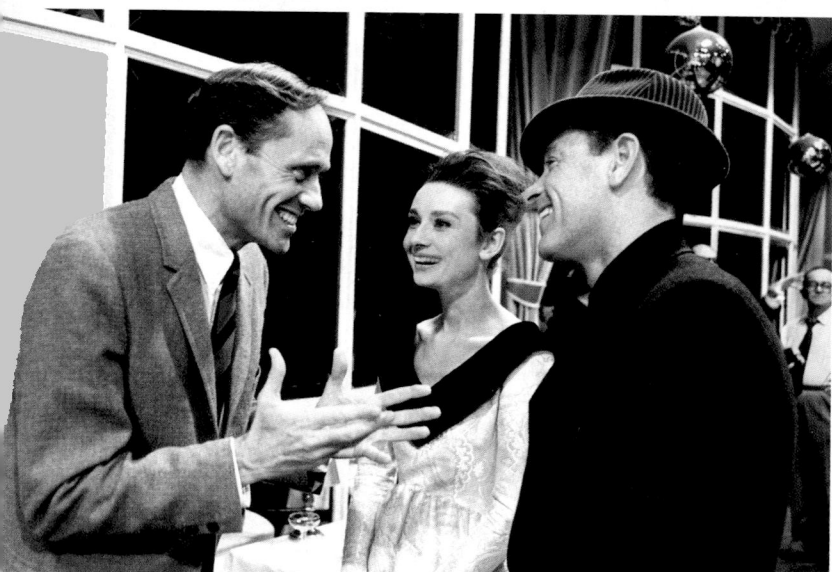

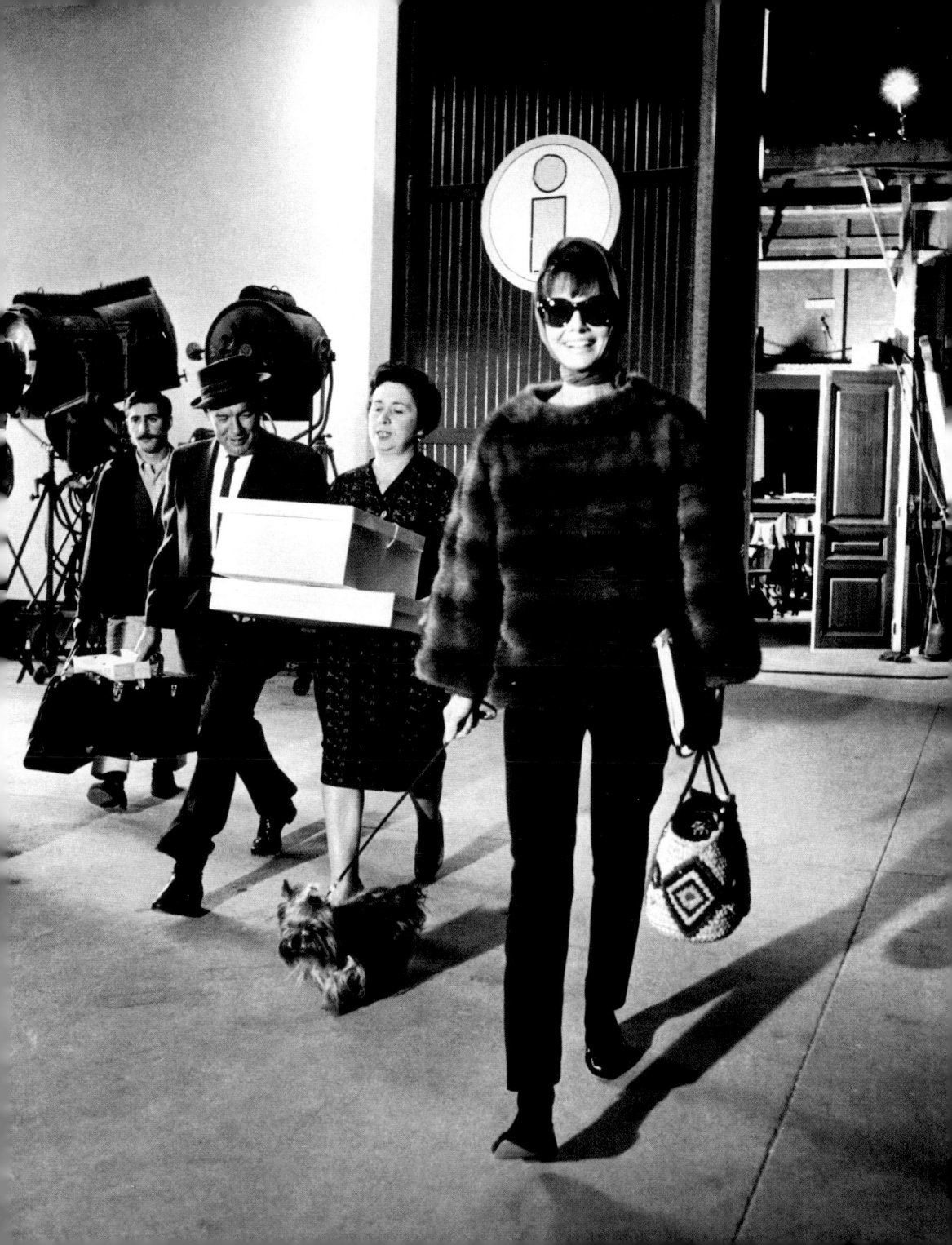

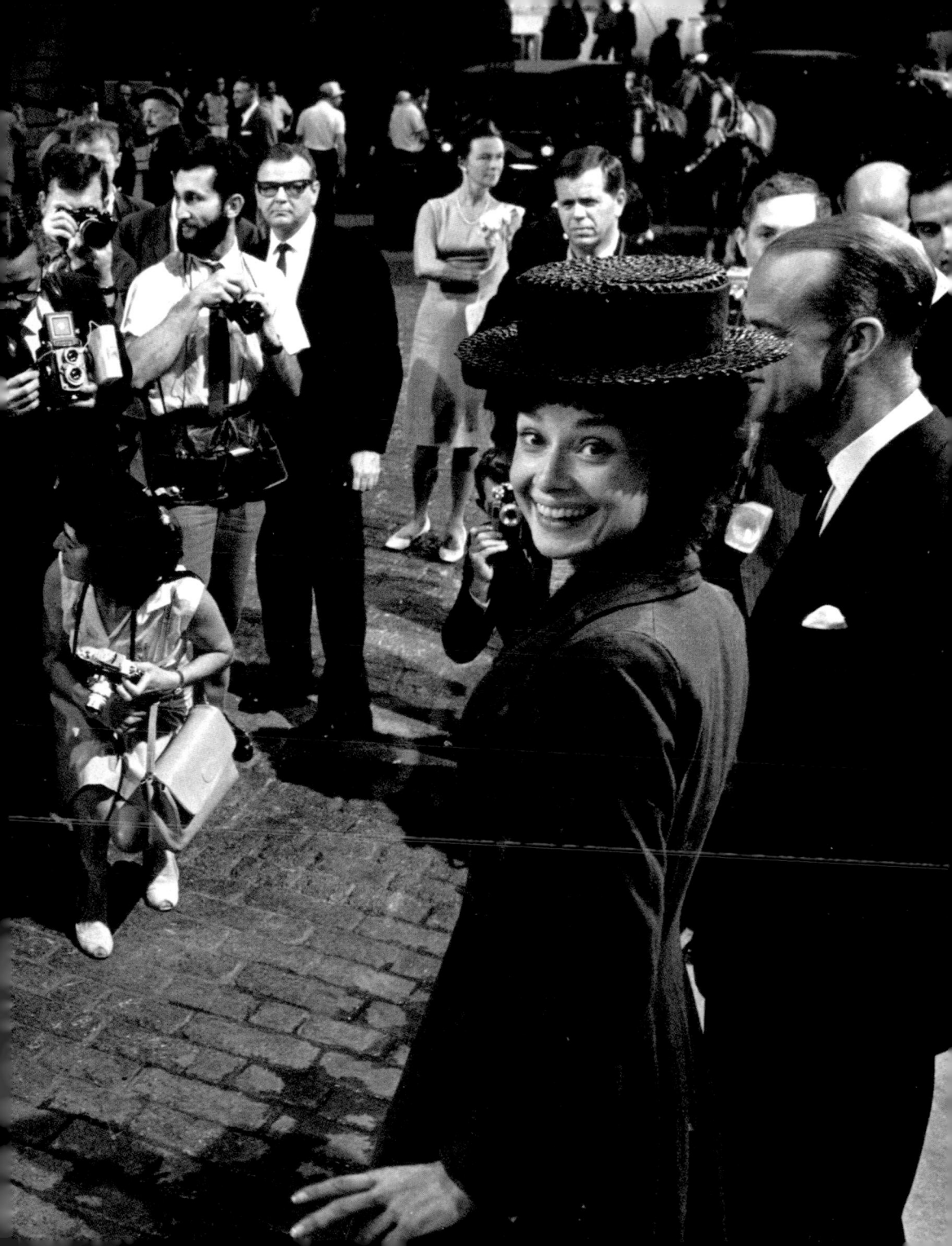

OPPOSITE
On My Fair Lady, *Audrey's mode of transport from her dressing room to the set was a bicycle with a basket that was perfect for Assam of Assam. Whether the nameplate helped Audrey get into character as she went to work is uncertain.*

BELOW
The star and her director George Cukor relax in the soundstage version of London's Covent Garden.

NEXT SPREAD
Ferrer and Audrey enjoy My Fair Lady's *wrap party, content in the conviction that something "loverly" has been created.*

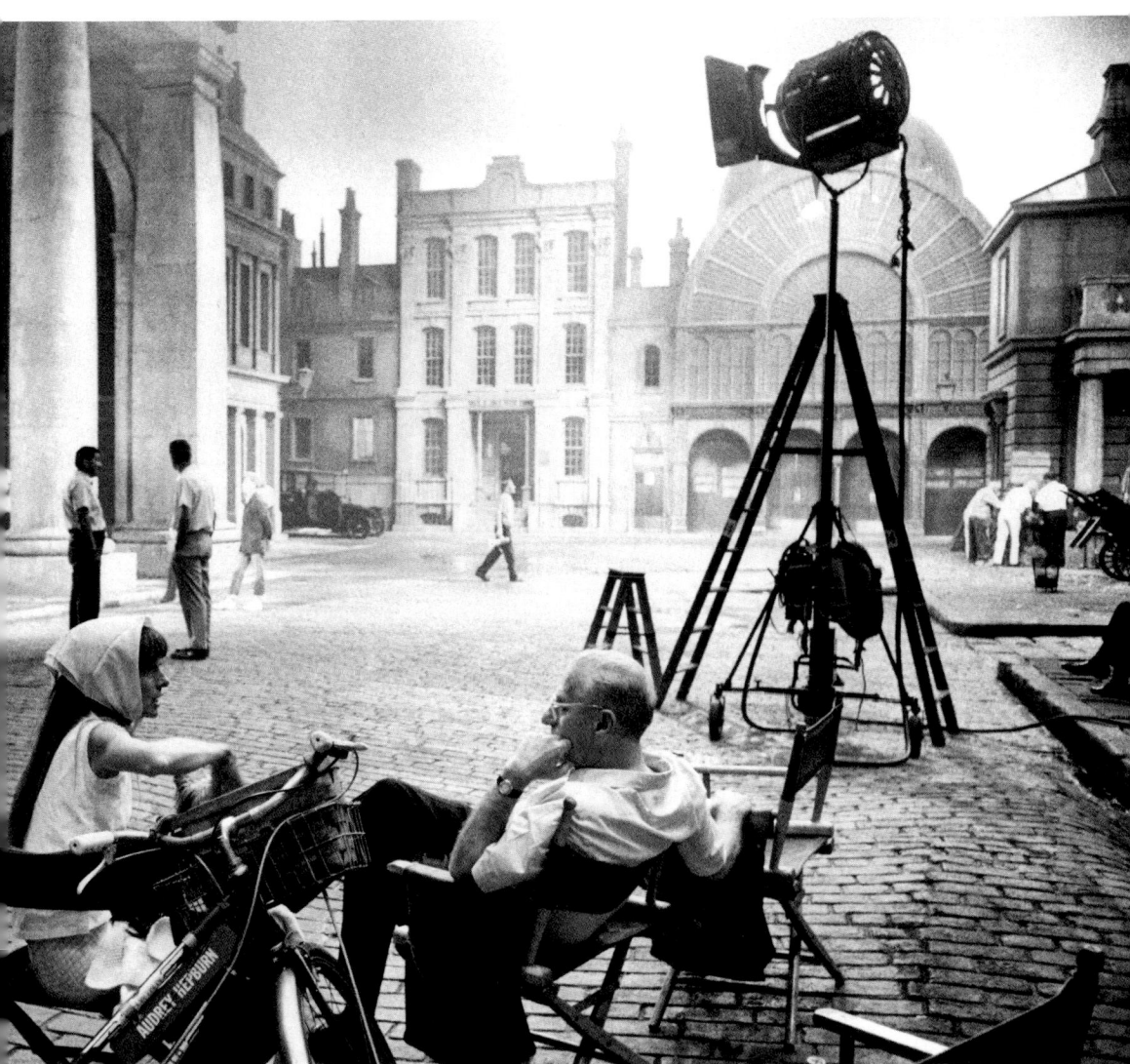

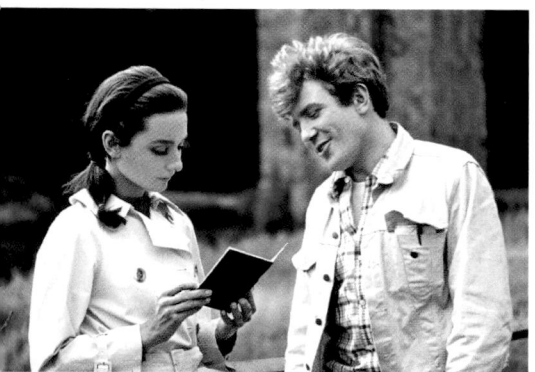
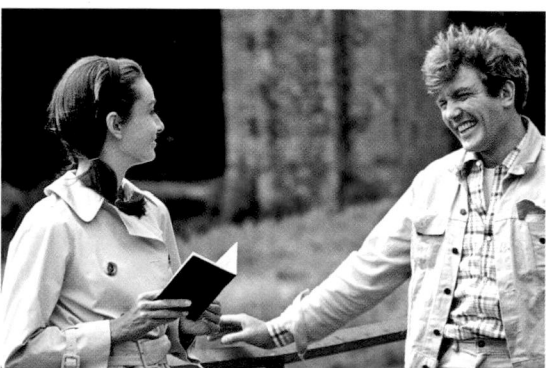

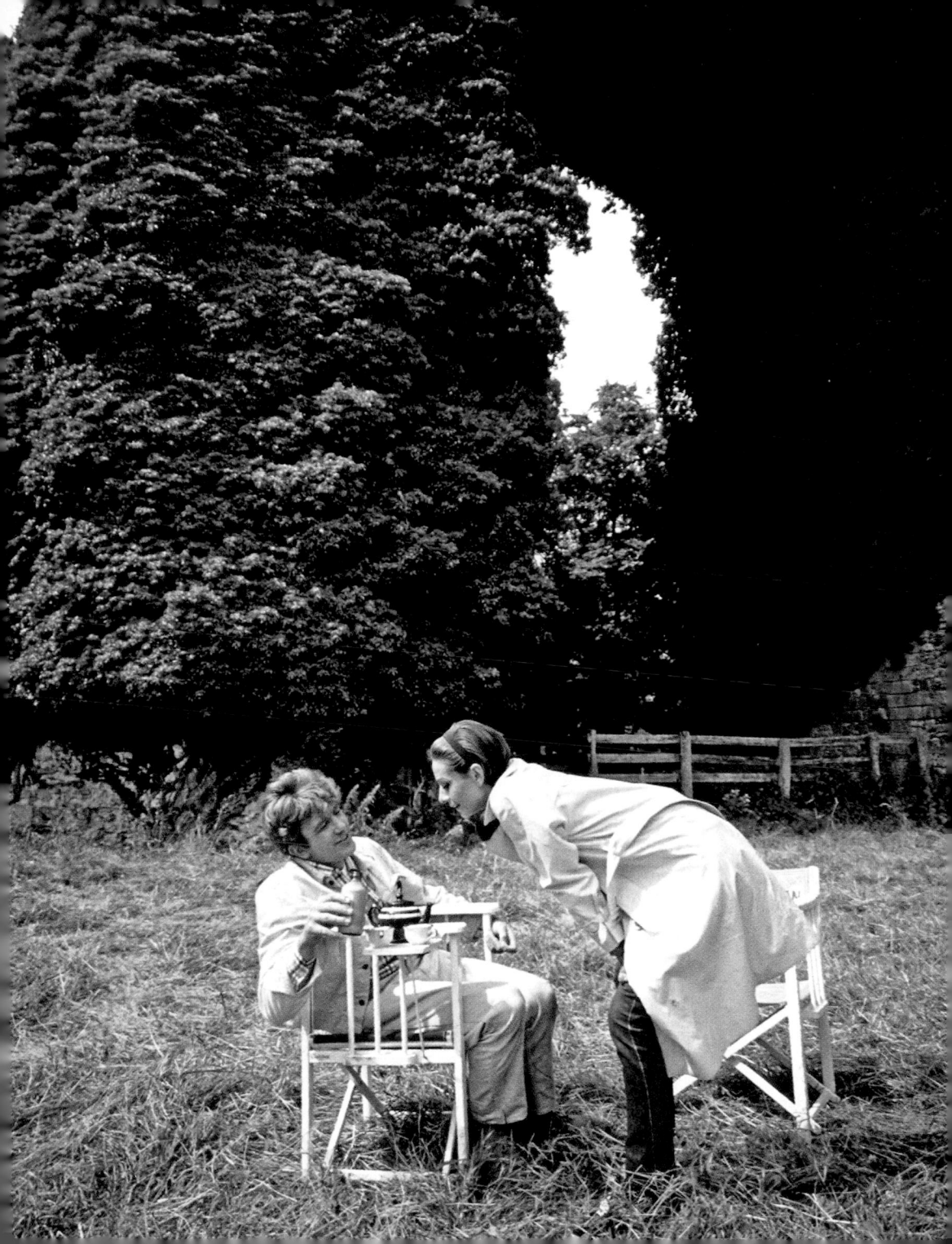

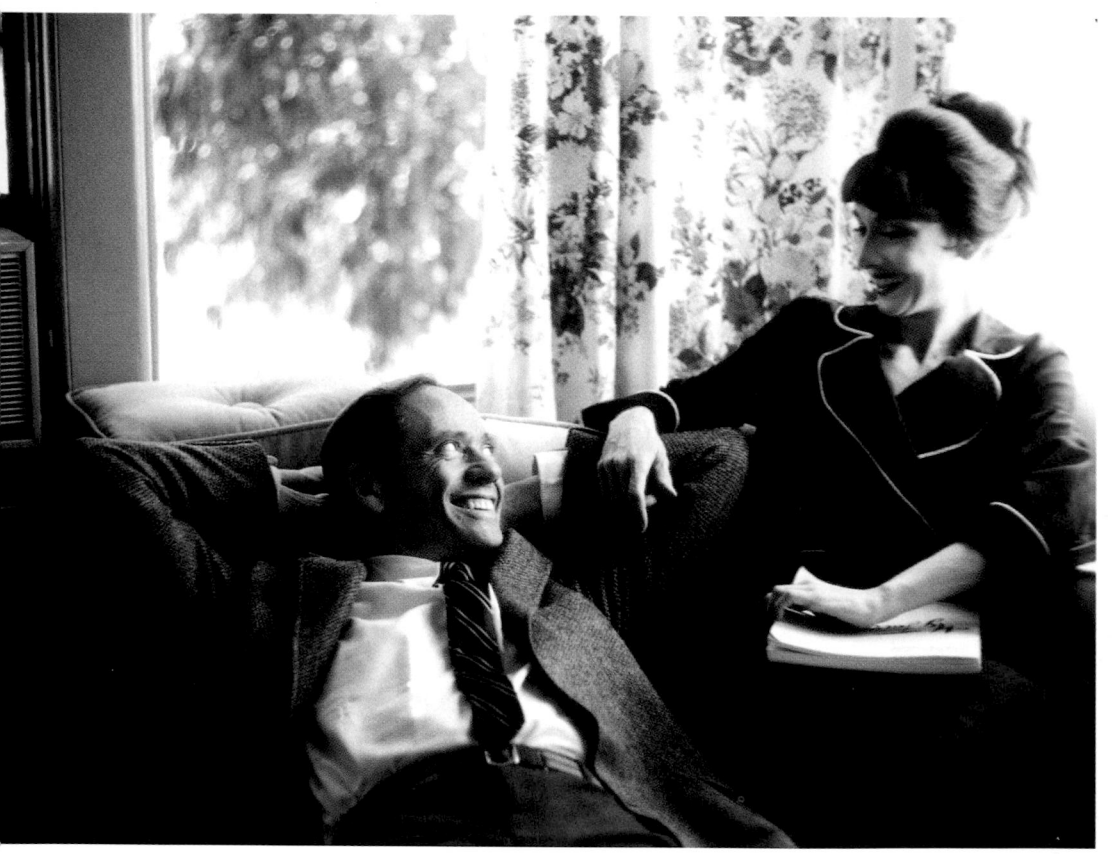

The way they were: The Ferrers,
in their happiest days.

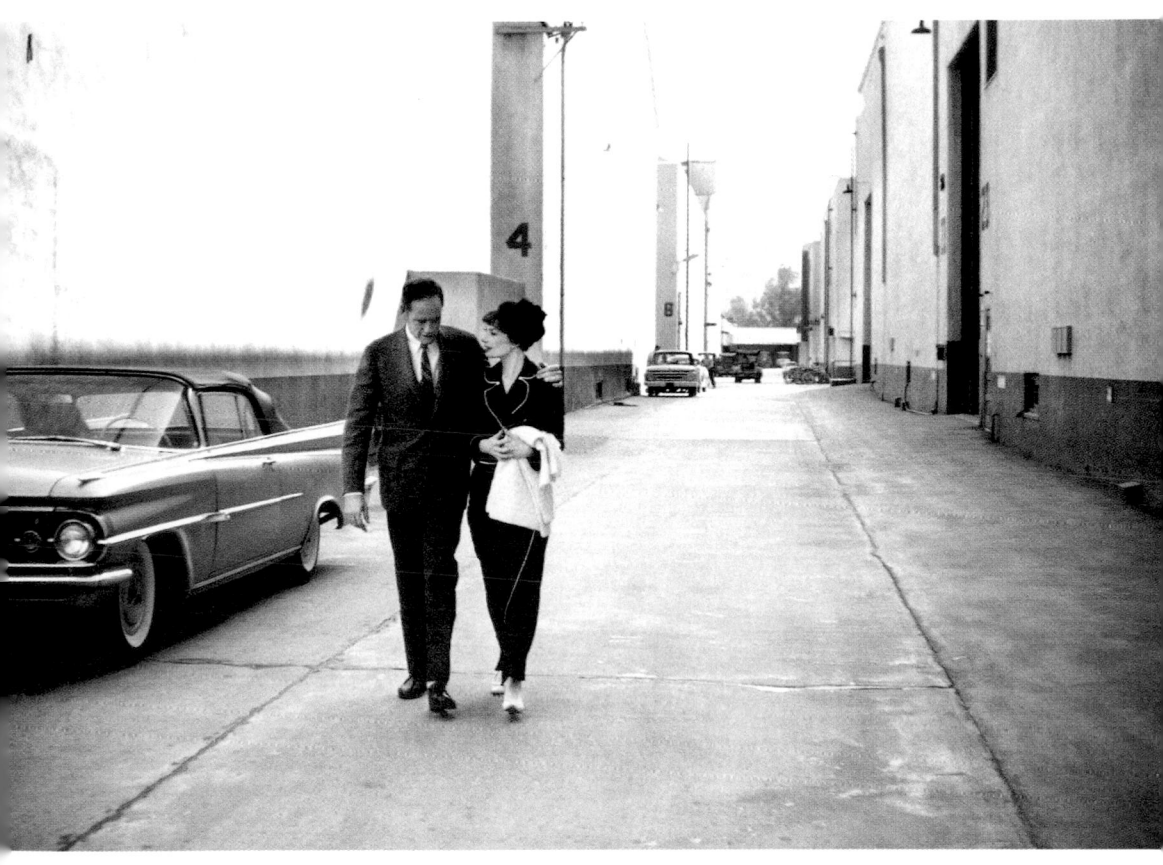

EPILOGUE
AUDREY'S TRIUMPHANT FINAL ACT

AUDREY ONLY DABBLED IN films—and barely dabbled, at that—in her later years. After turning down many projects, she ended her unofficial retirement in 1975 by starring opposite Sean Connery in the charming *Robin and Marian,* a comic imagining of the twilight years of Sherwood Forest's legendary lord and lady. She made an undistinguished thriller a few years later and then, in 1980, took a small part in Peter Bogdanovich's *They All Laughed.* She starred in a movie made for television, *Love Among Thieves,* in 1987. But her great role in her final years would not be on either the big or small screen.

Because of her experiences during World War II, Audrey was on a lifelong campaign to help children who were in danger, either from famine or war. She had first worked with the United Nation's Children's Fund (UNICEF) in 1954, doing radio appeals. Now, with her film career well and truly ended, she threw herself into the crusade. In 1988, she made her first UNICEF field mission to Ethiopia, hoping to draw attention to the plight of children facing famine. "I have a broken heart," she said after her excursion. "I feel desperate. I can't stand the idea that 2 million people are in imminent danger of starving to death, many of them children. . . . I went into rebel country and saw mothers and their children who had walked for 10 days, even three weeks, looking for food. Settling onto the desert floor into makeshift camps where they may die. Horrible. That image is too much for me. The 'third world' is a term I don't like very much because we're all one world. I want people to know that the largest part of humanity is suffering."

She was named UNICEF's International Goodwill Ambassador in '88, and before the year was out, she traveled to Turkey on an immunization mission ("It took us 10 days to vaccinate the whole country—not bad") and to the slums of Venezuela and Ecuador ("I watched boys build their own schoolhouse with bricks and cement provided by UNICEF"). In the next four years, she would participate in more than 50 missions—to Honduras, El Salvador, Guatemala, Sudan, Mexico, Bangladesh, Vietnam, Thailand, Eritrea, Somalia; into war zones and regions decimated by drought or disease—always with hugs for the children and an appeal to the adults for desperately needed funds. Constantly by her side was Robert Wolders, a Dutch actor who was her companion in the last years of her life. As Wolders watched her speak, tears came to his eyes. "I've known UNICEF a long time," Audrey said, "ever since the Second World War, when they came to the

aid of thousands of children like myself. We were reduced to near total poverty, as is the developing world today. It is poverty that is at the root of all their suffering—the not having, [and] not having the means to help themselves." At another point, she confided that there was a second adolescent girl, besides her younger self, who she was thinking of when she dedicated her life to UNICEF. Looking back, she called Anne Frank "a symbol of the child in very difficult circumstances, which is what I devote all my time to. She transcends her death."

Audrey transcends her own death, which came, due to colon cancer, on January 20, 1993, four months before her 64th birthday. She transcends it through the wonderful legacy of her films, of course, which will live forever. And she transcends it through her own uplifting story, left behind to inspire us all. But most of all, she transcends it through UNICEF's Audrey Hepburn Memorial Fund and the Audrey Hepburn Children's Fund, founded by Wolders and Audrey's sons, Sean and Luca. Collectively, the charities have raised millions to save the world's poorest children. They stand as a beautiful last gesture from one of the most beautiful women the world has ever known.

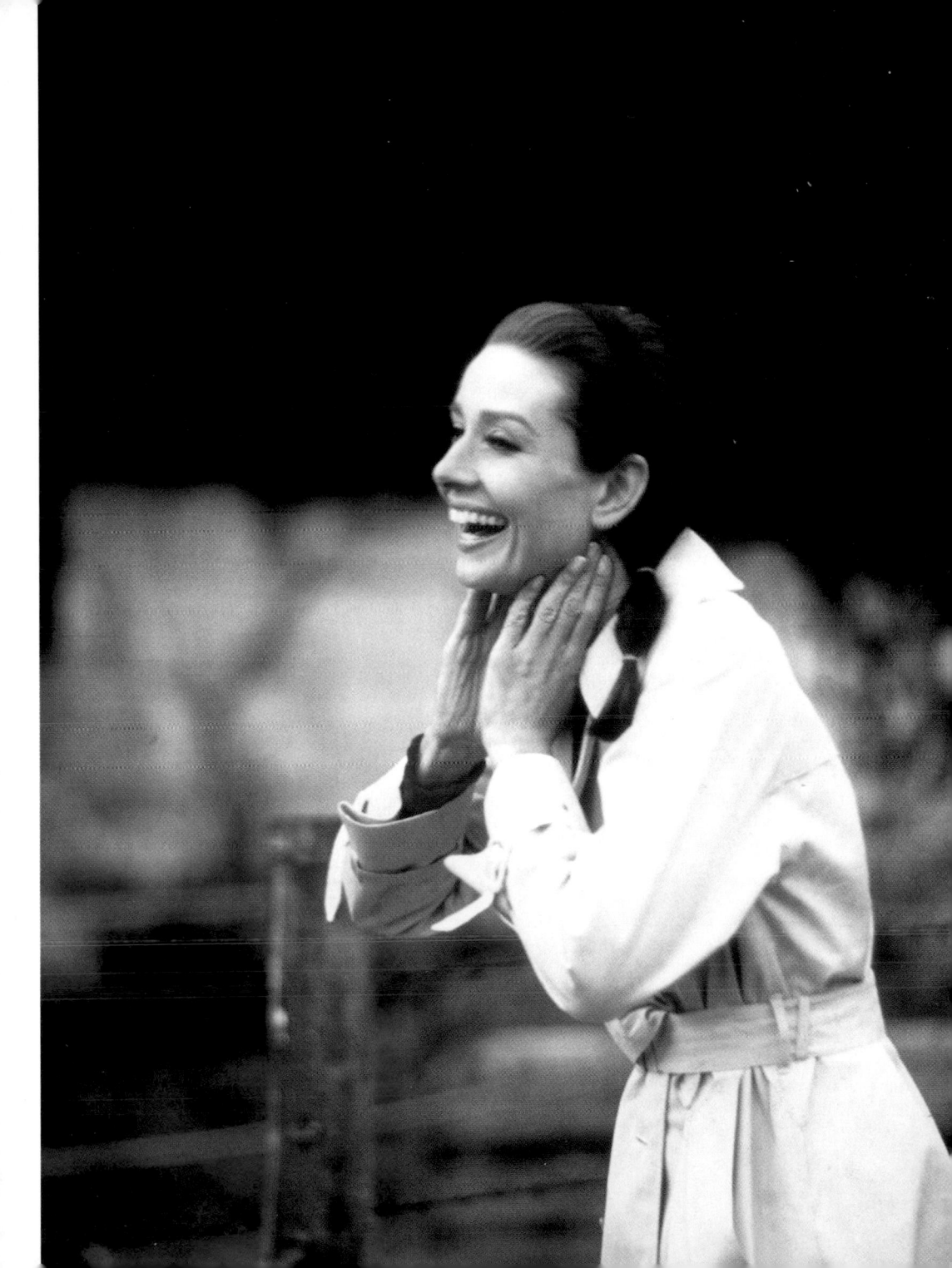

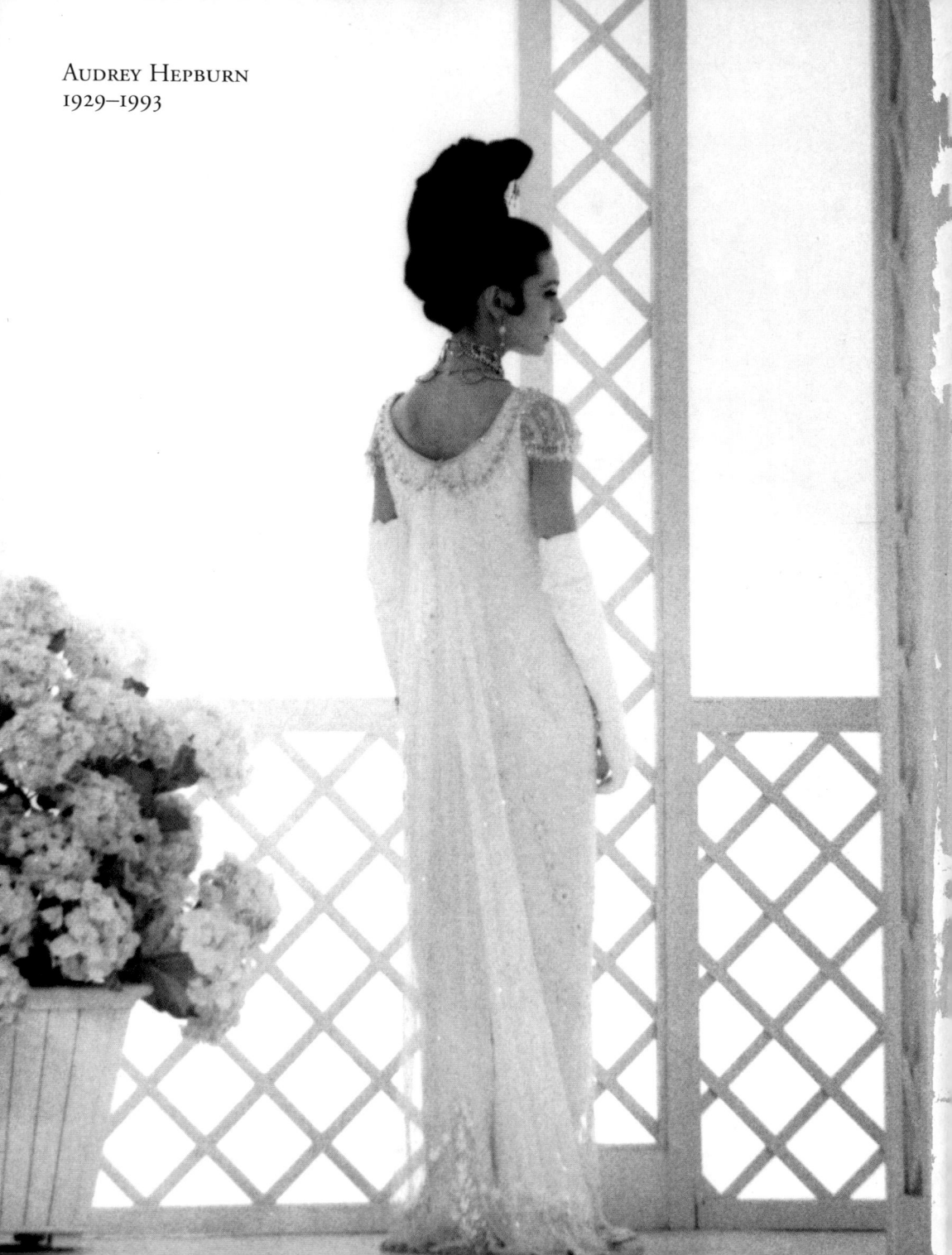

REMEMBERING . . .